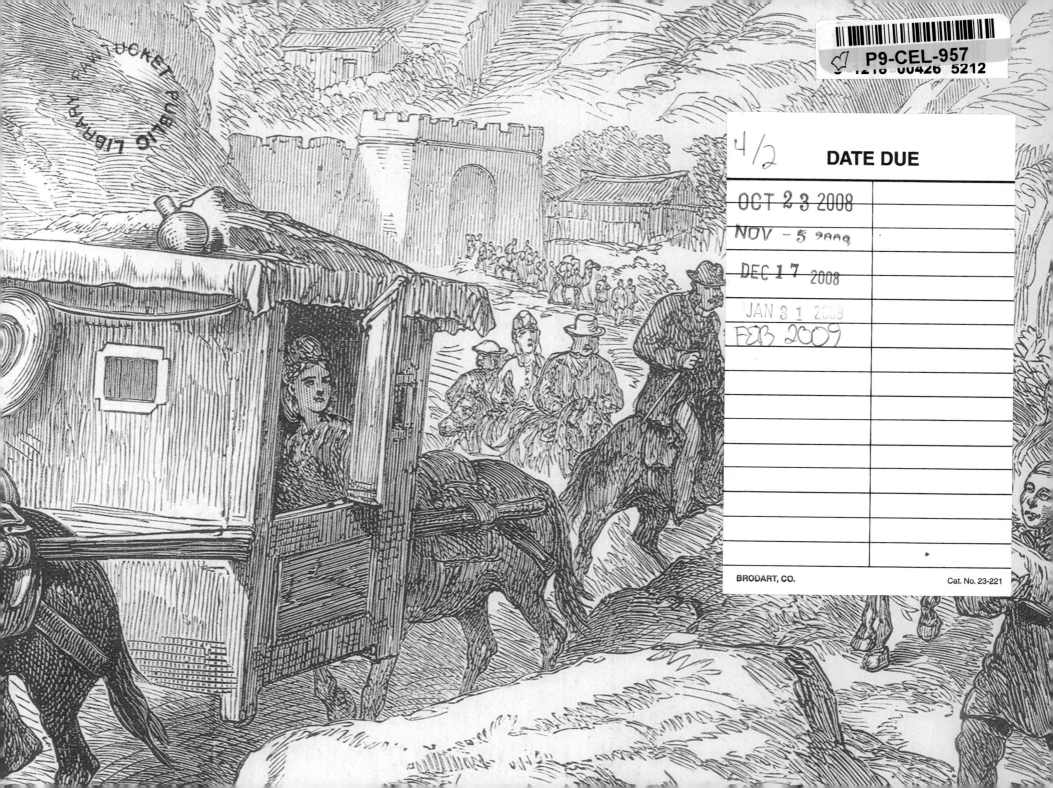

Whatever withdraws us from the power of our senses,
whatever makes the past,
the distant or the future,
predominate over the present,
advances us in the dignity of human beings

Samuel Johnson (1709 –1784)

Revisiting the Great Wall After One Hundred Years, written in the hand of Professor Luo Zhewen

万里长城百年回望

罗哲文 题

THE GREAT WALL REVISITED

From the Jade Gate to Old Dragon's Head

William Lindesay

Harvard University Press · Cambridge, MA · 2008

Copyright © 2007 by Frances Lincoln.
Text copyright © 2007 by William Lindesay

Published in the United Kingdom in 2008 by Frances
Lincoln Limited.

First published in 2007 by China Intercontinental
Press in China only.

Printed in China.

Library of Congress Cataloging-in-Publication Data

Lindesay, William.
 The Great Wall revisited : from the Jade Gate to Old
Dragon's Head / William Lindesay.
 p. cm.
 "This book was first published in 2007 by China
Intercontinental Press in China only."
 "First published in the United Kingdom in 2008 by
Frances Lincoln Limited ... London ... "
 Includes bibliographical references and index.
 ISBN 978-0-674-03149-4 (alk. paper)
1. Great Wall of China (China) 2. Great Wall of
China (China)--Pictorial works. 3. Walls--
Conservation and restoration--China. 4. Walls--
Conservation and restoration--China--Pictorial works.
I. Title.
DS793.G67L5657 2008
951—dc22 2008007122

CONTENTS

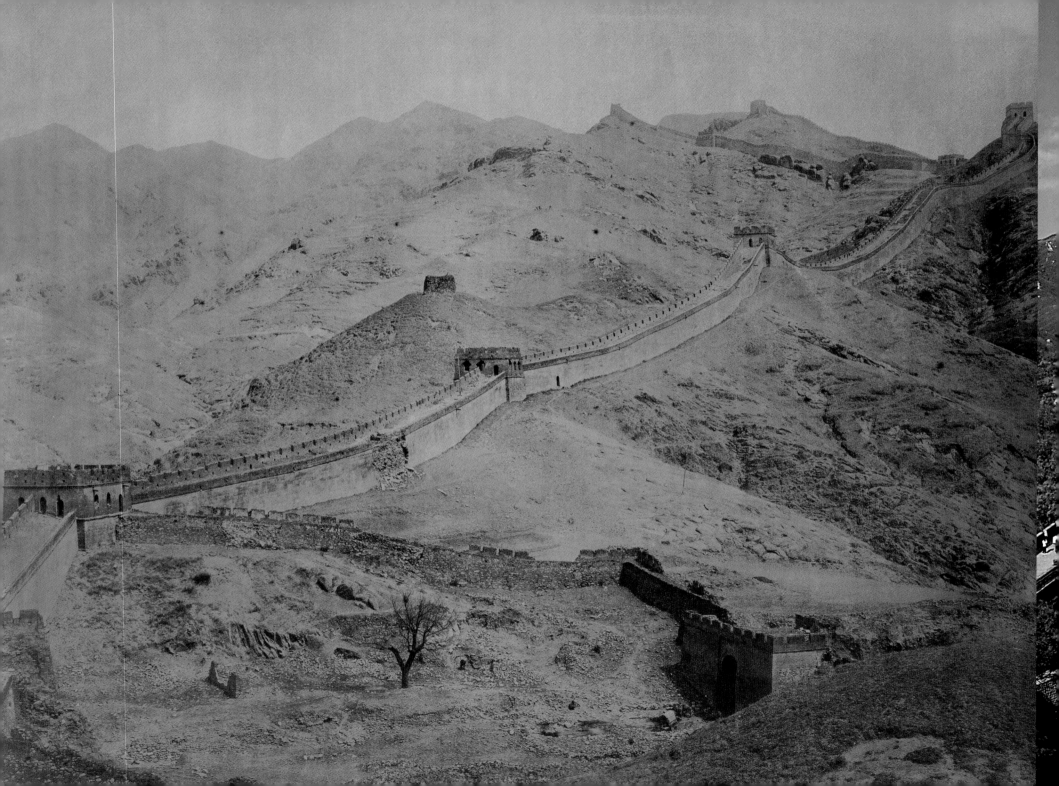

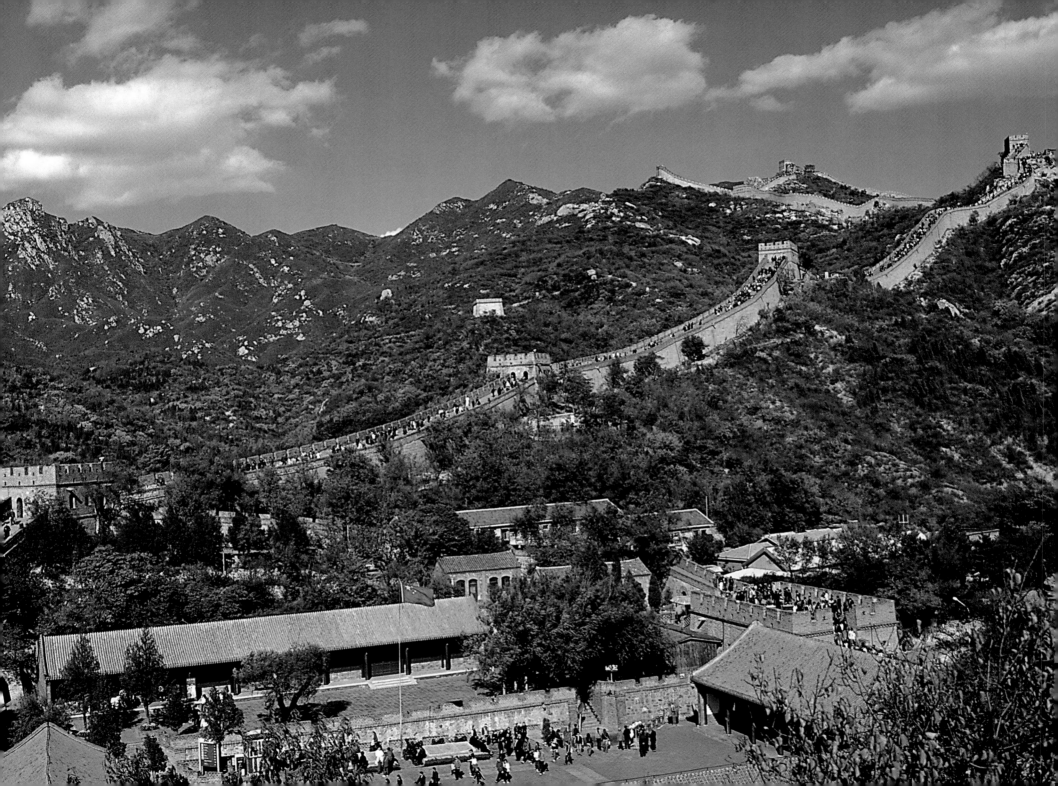

Dedicated to

William Edgar Geil

(1865–1925)

The First Explorer
of
The Great Wall of China
(1908)

PROLOGUE: THE WALL OF TWO WILLIAMS

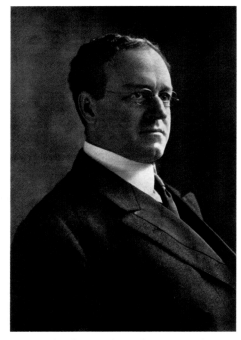

Portrait of William Geil, London, c. 1910 (WL).

Having co-ordinates to key into my Global Positioning System (GPS), and selecting 'go to' mode, a function that permits users to be guided in direction and distance to within two metres of any way-marked location by the wonders of satellite technology, would have made the task much easier. But the only clues that William Geil provided me with in his century-old caption read 'Paishih K'ou, sixty *li* from Futuyeh' in which, paradoxically, both distance and names were riddles. The *li* is simply bizarre; a flexible unit of measurement that has a reputation for being stretchable according to the lie of the land, while all my attempts at pronouncing these place names were met with shrugs and stares from today's Chinese who are unaccustomed to the Wade Giles transliteration method used by foreigners from the late 19th century onwards.

So I scoured my memory and files of my own photographs. The landscape and watchtower architecture photographed by Geil was vaguely familiar, but conceivably I knew I could be way wrong, perhaps days off course.

I hoped that my initial detective work was good enough to get me within a radius of a few kilometres. I usually started by showing off my 'wanted list' of photos in a village, hoping an elder might know of at least one location and point me in the right direction. As a last resort I just climbed towards a panorama point to take in an unobstructed view, to have a look for myself.

Then it was up to my eyes and perhaps imagination, working together, to compute the task of honing in on a target altered, a little or beyond recognition, by the vestiges of time. One moment looking at the view beginning to open up around me – the foreground, the background – the next glancing down at the photo in hand, I edged forward, pressing my way through the bushes, growing in optimism that I was on the verge of finding it: the right place.

The skyline matched almost perfectly, and I became more confident that he must have taken it somewhere along here. With thumbs and forefingers extended on both hands to make a rectangle I mimicked framing the view using his camera's lens, realizing I needed to 'zoom in' a little tighter. Just a shuffle would do it: a couple of metres, and then I sensed I was on the very spot. I stopped, took a deep breath, and holding the photograph at arm's length raised it slowly, up to shoulder height. It seemed to match.

For a brief, magic moment I felt a surge of excitement: I'd caught up with William Geil once again. I was standing precisely in his footsteps. I'd found it: 'A superb view of the Great Wall erected by Emperor Wan Li', as he had written in his book. But I'd arrived too late. The towers that Geil admired so much had been levelled. I could see he hadn't exaggerated, it *was* great.

I steadied my emotions and retook the shot.

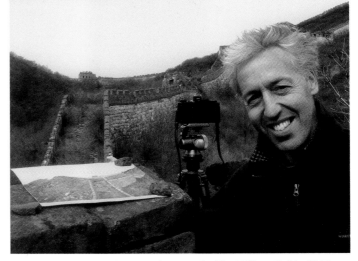

William Lindesay at a location photographed by William Geil in 1908.

FOREWORD BY PROFESSOR LUO ZHEWEN

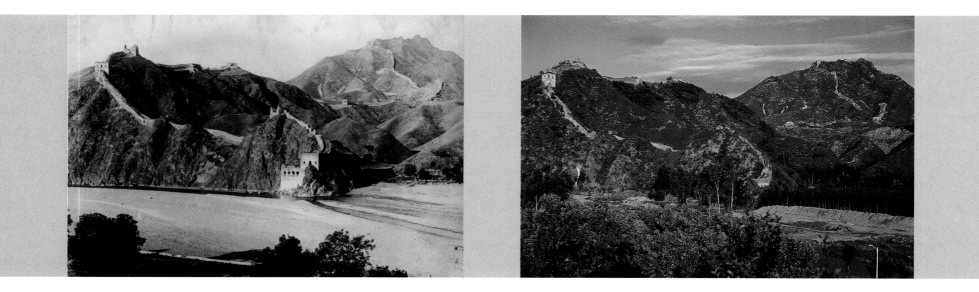

Above, left to right: Old and new views across the Chao River at Gubeikou, 1948 and 2006; Luo Zhewen, emeritus professor at China's State Administration of Cultural Heritage.

I photographed the Great Wall at Gubeikou, 120 km northeast of Beijing, in 1948. Carrying my first camera I was out on assignment for Prof. Liang Sicheng, then dean of the Department of Architecture at Tsinghua University in Peking. Fifty-six years later I returned to Gubeikou with my faded picture in hand, only to realize just how precious one photograph can become.

Using the technique of rephotography, complemented by eyewitness accounts, this project, carried out by William Lindesay, director of International Friends of the Great Wall, with the generous support of Shell Companies in China, and the enthusiastic assistance of the Beijing Administration of Cultural Heritage, the State Administration of Cultural Heritage and the Capital Museum, shows how the Great Wall has changed and presents a moving and scientific approach to its conservation.

Pictures themselves, then and now, side by side, complemented by the observations and anecdotes of early visitors show us starkly what changes have occurred, while contemporary accounts throw light on the reasons – the tragedy of war or revolution, brought by vandalism or tourism development, invoked by old father time or mother nature.

This approach is far more than a romantic look at the Great Wall of yesteryear. It presents a summary of our successes and failures, and we can learn much from the evidence and experience. Revisiting the Great Wall in this way will trigger a lively forum, and the discussions aroused – by seeing how and learning why – will further our urgent conservation efforts.

Luo Zhewen

Beijing, December 2006

AUTHOR'S INTRODUCTION

Writing field notes at camp beside the Wall, Laiyuan County, Hebei.

The Great Wall of China is much more than a place; it's a series of structures that are stretched out across a subcontinent.

Today, it is possible to visit many locations along these lengthy remains which date from many dynasties. The most recent of them, the Ming Dynasty Great Wall (built 1368–1644), alone constitutes the world's largest cultural relic, and its number one tourist attraction. Some sites along its course are hot spots: Badaling, for example, receives almost five million tourists each year. At the other end of the Wall, and spectrum of attention, may be a crumbling and nameless section of rammed-earth Wall out in the northwest's gobi desert, which may witness the approach of only a handful of determined researchers or adventurers during the same period of time.

How is the Great Wall seen by people today – be they tourists, researchers or adventurers – similar to or different from the Great Wall that our great-grandfathers, grandfathers or fathers saw 150 years ago, a century ago or several decades ago, if they had been to the same places?

Without the efforts of the earliest visitors to the Great Wall who bothered to carry the then very bulky wherewithal for photography, we could never be sure. We could only imagine. Their preserved photographs, originally used to show audiences and readers what the Wall was like, can be reused to see for ourselves what it used to be like – providing we can identify the precise location of the original photograph, go there and re-take the shot. This technique is known as rephotography, and it is a powerful formula for evidencing change.

Location: Wohu Shan
from east bank of Chao R
at Gubeikou
Description: (distant view
of sister towers
Original
Photographer: Luo Zhewen
(standing atop Gubeikou
tower wall)
Remarks

March 2004

Location: "20 Li Da Dun"
(Twenty Li Large Tower), 15 km
west of Yumen Guan.
Description: Stein's number IX (9)
Yue Bangshu's No.17. Fine high
tower
ORIGINAL : Aurel Stein
PHOTOG.
Feng sui

Date: April 1907

Comments:

CO-ORDS: N 40° 18' 79.7"
E 093° 37' 22.1"

Alt: 1006 m
Date: October 14th 2006

"Rite in the Rain"

This book presents the findings of a quest to answer the question: How has the Great Wall changed? Using the largest and most diverse resource of vintage photographs in the world, the result of 15 years' photo research, with the specific intention of delivering a poignant conservation message, I have rephotographed more than 150 locations, and chosen half of them for inclusion in this book to present an illustrated report on the current state of the Great Wall.

The title of the book, *The Great Wall Revisited: From the Jade Gate to Old Dragon's Head*, contains an important historical message as well as defining the geographical scope of the study. Revisited means returning to various sites along the Great Wall in the company of its pioneering explorers and determined travellers, not only by holding their photographs, and rephotographing what they once saw, but also revealing what they discovered or thought about the Wall they saw, from researching their books, journals and diaries.

Sometimes my revisits were in the company of contemporary eyewitnesses: a local farmer who led me there, a Great Wall expert who is familiar with the site, or with an official responsible for its management and protection. Hence the book is not only a collection of comparative photographs, but a combination of peoples' stories, historical and contemporary, and pairs of photographs showing and telling how the Wall has changed.

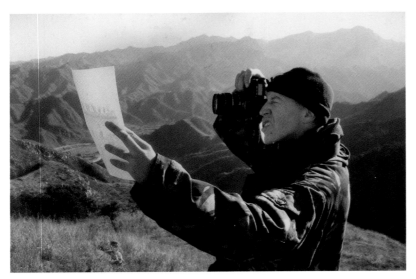

Rephotography at Laiyuan County, Hebei in winter 2005.

In terms of geographical coverage, revisits were made between fortifications in the vicinity of Yumenguan, or the Jade Gate Pass (the most westerly point of the study, 93 degrees east of Greenwich) and Old Dragon's Head at Shanhaiguan, where fortifications of the Wall are washed by waves breaking on the shore of the Yellow Sea (the most easterly point of the study, 119 degrees east of Greenwich).

The vast majority of sites were located in seven regions: Yumenguan, Jiayuguan, Northern Shaanxi Province, Laiyuan County in Hebei Province, Beijing, Gubeikou and Shanhaiguan. There were just a handful of misfits, and they have been added to the closest of the above regions.

Results in this book too are arranged geographically by region, proceeding from west to east, from desert to sea, in the above order. Within each region individual sites are also arranged preferably in west to east order. The exceptions are for a good reason. In Northern Shaanxi the arrangement is in order of discovery. In Laiyuan County, Hebei, the order is dictated by sites photographed by Sha Fei, followed by others. In Beijing the order presents two natural journeys, one proceeding north up the Juyong Pass, the other re–tracing a route in the vicinity of Mutianyu travelled by William Geil.

Each regional grouping is preceded by an historical and geographical introduction, and for each region I have identified a 'milestone' personality, or two, of relevance. However it should be noted that my naming a person as a milestone does not necessarily condone their actions: particularly controversial is the work of Aurel Stein, who excavated and acquired many antiquities and transported them out of China.

I have used *pinyin*, the system used in China since 1958 for the Romanization of the language, throughout the book, except in extracts or quotations made by early eyewitnesses, most of whom used the Wade Giles method, introduced in 1892. There were however many alternative methods both before and after Wade Giles': 'Legeza's List' contains 51 versions. For example Jiayuguan was rendered Chia-yu-kuan, Kiayukwan and Kiayukuan by Aurel Stein, William Geil and Mildred Cable respectively. Transliterations by whatever method are followed by *pinyin* equivalents in parentheses, if correlation is not obvious, and only on first reference. I use Peking when referring to the old city, pre–1949, thereafter Beijing is preferred. I have also retained in extracts antiquated terms such as Chinese Turkestan and Chinese Tartary, despite their political incorrectness in China, purely to maintain the style, right or wrong, of the original author(s).

It should be noted that for succinctness I have used the terms 'The Great Wall of China', 'The Great Wall' and 'the Wall' when referring to the Ming Dynasty Great Wall, because the majority of sites that I revisited for rephotography were of this age. The only exceptions are fortifications in the vicinity of Yumenguan, which date from the Han Dynasty (206 B.C.–220 A.D.). Reference to these is made by the inclusion of the dynastic adjective, Han Great Wall or Han Wall for short.

Various short-forms are used for the Great Wall and its variations: they include border defences, defences, fortifications and ramparts. All convey the same meaning and are used merely for variation.

Reign dates are provided for emperors and kings, while complete life spans if known are given for other important historical figures.

In appreciation that some users read the text and refer to illustrations simultaneously, while at other times they may just look at photographs, captions combine a summary of what may have been detailed in the text and, when possible, provide something new.

As a book of documentary photography, all images are authentic reproductions of originals. Digital retouching of vintage images has been carried out sparingly, to improve contrast or remove excessive blemishes and foxing.

William Lindesay

Beijing, January 2007

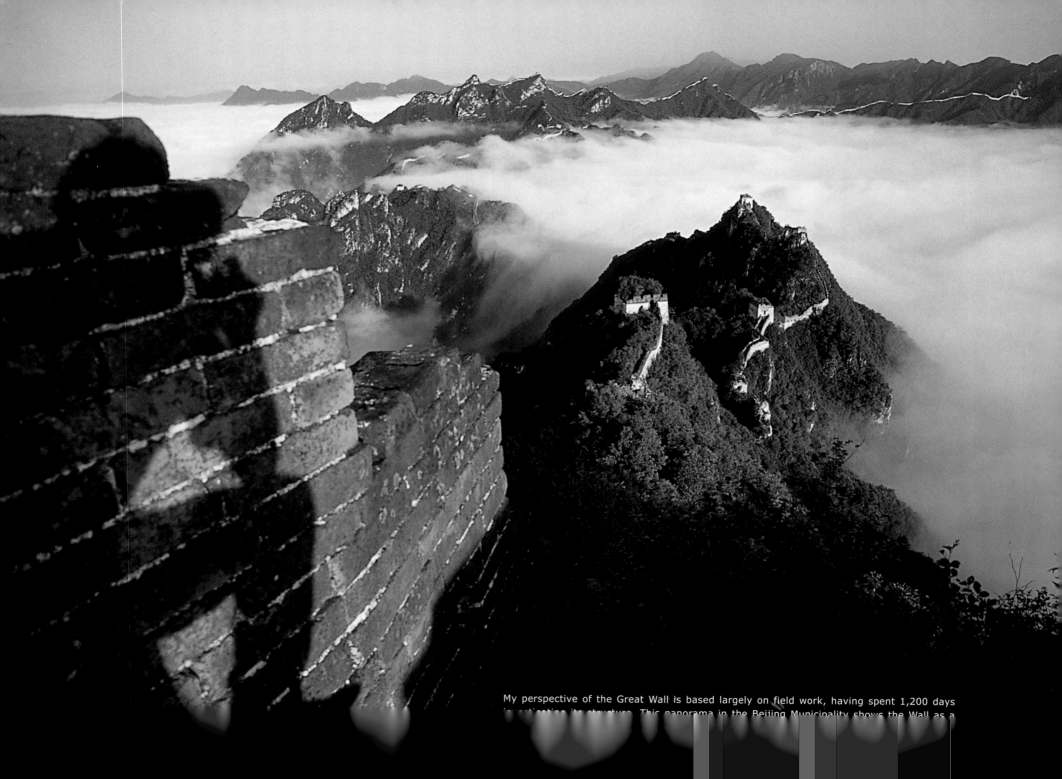

My perspective of the Great Wall is based largely on field work, having spent 1,200 days investigating its structure. This panorama in the Beijing Municipality shows the Wall as a

CHAPTER 1 'THE GREAT WALL': A PERSPECTIVE

This book's focus is change on the Great Wall, told through rephotography, historical narratives and oral histories. Before appreciating the changes, however, we should know what the Great Wall is, and in providing this essential perspective I shall begin not in the field, but with terminology and language, specifically with what the Chinese call the object in question: *Wanli Changcheng* – literally the 'Ten Thousand *Li* Long Wall'.

Failure to appreciate the nuance of this term has led to several basic misunderstandings, specifically with regard to what it describes, encompasses and how long it is. The term *Wanli Changcheng* requires a poetic, not a fiscal translation. At the bank, *wan* is indeed the Chinese unit of ten thousand, but in many other situations it is used to convey not a number in absolute terms, but the sense of being infinite. An enlightened erudition of *Wanli Changcheng* would therefore be 'The Endless Wall'.

The standardized version in English, however, is 'The Great Wall'; in French *La Grande Muraille* and in German *Die Grosse Mauer*. In many other languages the equivalent of 'The Chinese Wall' is preferred. The English, French and German names are much closer to the mark. Nevertheless, there is a considerable difference between 'Endless' and 'Great': the former acknowledges its vastness, extending in space and time across maps and the millennia, something immeasurable, while the latter inevitably invites questions probing its level of greatness, particularly how long it is.

This question is immensely difficult to answer, as testified by the multitude of offerings in encyclopaedias, guidebooks and all other literature relating to the Great Wall. Ever since the first hearsay about the Great Wall was disseminated in Europe in the mid 16th century, people have sought an authoritative reply to the question. Commonly a figure of 5,000 km was assumed, this appearing to be a direct conversion of 10,000 *li* to metric units. A different answer was found by measuring a direct line between the Wall's vaunted termini; another still calculated by adding up the lengths of each section indicated on a map, sometimes including the gaps in between, and sometimes omitting them.

All are incorrect. The first attempt is ignorant of the true (metaphorical) meaning of *wan*, which of course conveys immeasurability in this context. The direct line method ignores the reality of the Wall's tortuous route, twisting and turning. The third assumes that maps must be correct, apart from failing to realize that most contemporary maps show only remains of the most recently constructed Ming Dynasty Great Wall, not remains of Great Walls from earlier dynasties, even less where they may have once existed.

In fact the only right answer is that it remains unknown because the Great Wall has never been specifically measured. In spring 2006 various provincial-level cultural heritage bureaus embarked on state sponsored GPS surveys to ascertain the present position of, and identify the age and length of extant border defence fortifications (Great Wall per se). This project, the most detailed Great Wall survey in history, will be completed by 2009, and should provide an authoritative figure for the current length of existing Great

Wall fortifications. The survey, however, will not provide any further data on how long various dynastic Great Walls originally were, simply because a considerable quantity of each and every one has already disappeared.

Wanli Changcheng – A Series of Great Walls

The name *Wanli Changcheng*, or the Endless Wall, infers that the Chinese perceive 'The Great Wall' as a national defence project – a series of Great Walls – that spanned many dynasties.

It is beyond the scope of this book to embark on a chronological tour of these Walls, the individual lengths of which if added together might approach a figure of approximately 50,000 km. It is more useful to look for similarities, differences, relationships and connections — if any – between these Walls.

The most obvious way of sub-categorizing *Wanli Changcheng* is on the basis of dynastic period of construction. There are 11 undisputed Great Wall constructions in the following chronological order: Zhao State, Yan State, Qin State, Qin Dynasty, Han Dynasty, Northern Wei Dynasty, Northern Qi Dynasty, Sui Dynasty, Liao Dynasty, Jin Dynasty and Ming Dynasty (see chronology on page 286).

All these dynastic Great Walls in the *Wanli Changcheng* have common characteristics of greatness related to sheer mass and geography, to greater or lesser extents, which forms the basis of the next logical sub-category.

Archaeological surveys along the now-fractured remains of the four longest suggest that the Qin Great Wall (221–206 B.C.) was approximately 3,000 km in length, the Han Great Wall (206 B.C.–220 A.D.) approximately 7,200 km, the echeloned Jin Wall (1115–1234) as much as 5,000 km and the Ming Wall (1368–1644) – the most recently constructed, and that marked on contemporary maps on account of it being the best preserved – 6,700 kilometres in length. These could be termed the sub-continental scale Great Walls.

The other seven Great Walls are all of much shorter extents, being limited now to one or two of today's provinces. They could be termed lesser Great Walls.

A further sub-category might contain the Walls of the Liao and Jin dynasties. These were constructed by 'conquest dynasties' – non-Han peoples (ethnic nomads) who invaded China, established governing administrations, and adopted the Han strategy of building insurmountable barriers in the northern parts of their empires to defend their territory from invasion by other nomads.

The dynastic Great Walls built during the above 11 periods and comprising *Wanli Changcheng* as a series spans almost two thousand years of construction, from c. 300 B.C. to 1644 A.D. The component Walls are also separated by hundreds of kilometres from north to south, and possess different morphologies according to what building materials could be sourced or manufactured locally. They do have one major function in common. All were constructed as part of a strategy to defend Chinese land from nomadic incursions.

A well preserved section of the Zhao State Wall, built c. 300 B.C. and extant in the Inner Mongolia Autonomous Region.

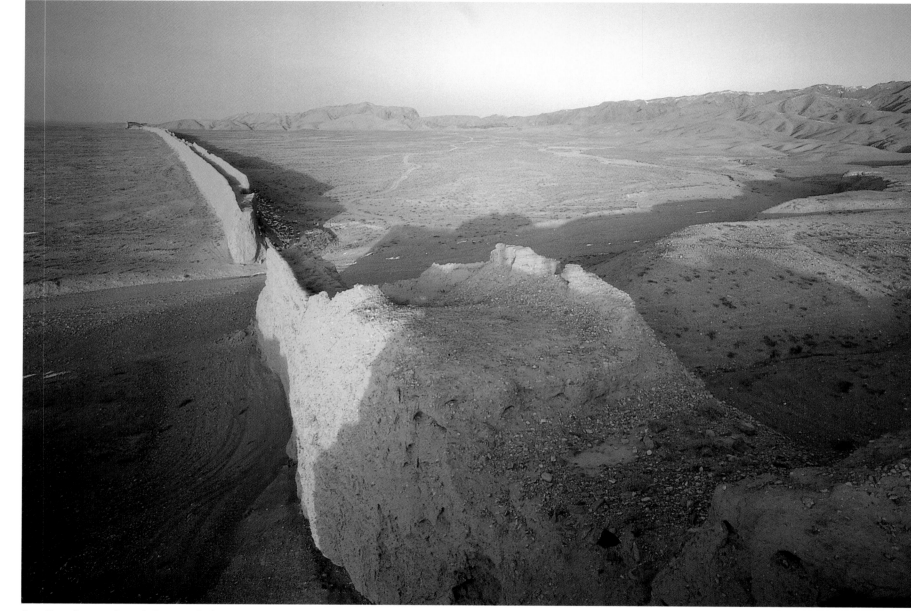

A section of rammed–earth Great Wall of Ming age extant in the Ningxia Hui Autonomous Region.

'Great Wall' Defined

Despite the abundance of Great Wall fortifications, and the uniqueness of these defensive systems to China, there is no definition, at least in the English language, of what 'The Great Wall' actually is. First and foremost 'The Great Wall' is thought of as a place that people travel to, and most destinations have no place in a dictionary, they belong rather to atlases. Yet the gazetteer of the atlas lacks any entry for 'The Great Wall'. Curiously, however, it can be found zigzagging across the map of China therein.

A simple definition that includes and summarizes the essential and common characteristics of the 11 structures follows:

A Great Wall is an ancient Chinese military defensive system, linear and of extraordinary length, built in the north of China, on imperial orders, to defend the empire from nomadic attack.

Excluded from this definition are *changcheng*, or long walls, that did possess the quality of being extraordinarily long, but did not function to defend Chinese land from nomadic attack. Especially worthy of recognition within this group is the Walled Square of the Chu State, built c. 7th century B.C. in Henan Province, south of the Yellow River. It is the oldest long wall in China, and it defended the Chu State from hostile Chinese, and not nomadic enemies.

I should also emphasize that the myriad of city walls that have for millennium been a vital element of Chinese settlements are not Great Walls.

In the Ming Dynasty there were an estimated 4,500 city walls throughout the 18 provinces. These were circular and enclosing, not linear and of extraordinary length. Nevertheless, many early foreign visitors viewed these impressive structures and naturally considered them to be parts of the famous Great Wall.

At this stage of the discourse it is appropriate to clarify whether the many dynastic Great Walls that constitute 'The Great Wall' series transcending the dynasties were linked together.

The latest research and logic suggests that this rarely happened, except in one case: the Qin Dynasty Great Wall was certainly pieced together using pre-existing Walls of the Zhao, Yan and Qin states after the unification of these warring states in 221 B.C. It is believed that upon the fall of the Qin Empire in 206 B.C. all, if not most, of the Han Dynasty's defences were built anew. This practice continued throughout the remaining history of China's border-defence construction.

The reasons for this history of 'use, abandon and build anew' were numerous. One was certainly the advance of Wall building technologies, which rendered centuries' old Walls outdated, in either resilience or design features to improve military performance. Another was wear and tear, much evidence for which is available in this book. A prevailing factor was that the geographic position any new Great Wall was decided with regard to the border defence situation of the time. The size and shape of the empire changed from dynasty to dynasty, so inherited Walls were not necessarily in the right place at the right time. Subsequently the landscape of China's north

is rich in the remains of 1,800 years of border defence works of various ages, ranging from barely discernible debris to well–preserved sections.

Each segment presents itself as very tangible evidence of a protracted and violent cultural conflict that raged between China and neighbouring *mabei guojia*, or states on horseback. But was the sole purpose of each Great Wall military defence? They did have other important functions, a major one being communication of military information (see below). But perhaps the psychological need for the Chinese to live behind walls is equally as important.

Origins of Wall Building

Early settlements in China developed along the middle reaches of the Yellow River Valley, the so-called Cradle of Chinese Civilization, and possessed three functional characteristics. They provided shelter under roofs, sustenance with food production, and collective safety behind an encircling wall. The Chinese character for 'city' and 'wall' is one and the same pictograph – 城 (*cheng*), stressing that in the Chinese mind a settlement was a safe place behind a wall, and a wall was a structure to safeguard a village, town or city.

The leap from construction of relatively short walls enclosing settlements to linear structures of several hundred kilometres in length running across open country was an enormous one, made possible by an industrial revolution. Enclosing walls of perhaps several hundred metres' length were manageable projects, even with primitive tools made of wood and stone. Most were rammed-earth walls, or 'soft walls', evidenced by archaeological excavations and also by the use of the *tu* radical 土 (a root component of a

Chinese character) at the left-hand side of the *cheng* character 城.

Extraordinarily long walls of several hundred kilometres, some of them in whole or part made of stones – 'hard walls' – only became feasible during the first century of the Iron Age, c. 500 B.C., with the emergence of many regional centres producing cast iron. This metallurgical breakthrough revolutionized the scale of wall building by making available large quantities of iron tools. Placed in the hands of hundreds of thousands of labourers, axes to cut rock and shovels to move earth made it possible to build in a much quicker time.

The first new-scale defensive works were initiated by the kings of states who retained the paternal obligation to provide their populations with safety behind walls, whatever the investment in manpower. During the third century B.C. at least seven *changcheng*, or long walls were constructed, three of which functioned as defences against northern nomads. After the Qin unification in 221 B.C. the three northern walls of the Zhao, Yan and Qin states were of continued use, although the gaps between them needed filling in. As for the others further south, now the heartland of the new empire, they were redundant barriers, but potentially useful installations to rebellious factions that might in future attempt to split the new empire. Hence they were dismantled.

Over the ensuing centuries Great Walls were generally constructed when the empire was stable and unified. What can now be found marked on county maps within provincial atlases are pieces of the large jigsaw that have been easily identified by map makers in the field. Personal field experience has shown me that there are often remains of Great Walls unmarked on such

maps. And only historical atlases attempt to show where Great Walls may once have been routed.

In recent years there has been some doubt cast on the continuity of Great Walls, even when they were functional at their zeniths. Concerning the Ming Great Wall, for example, did it actually stretch unbroken from desert to sea? Those for whom field work forms their primary resource in Great Wall Studies, myself included, will confirm that even 360 years after the abandonment of the Ming structure as a national defence, very long continuous sections remain to this day, such as rammed-earth Wall in Shandan, Gansu Province, and classic mountain Wall in Huairou in the Beijing Municipality or in Funing in Hebei Province.

Before the ravages of time came into play, unbroken sections would surely have been longer, and perhaps linked up to have been more continuous. It must be noted that once the Ming Wall was abandoned in 1644, as time progressed its crumbling and overgrown remains came to conflict more and more with contemporary life in a China of rapidly increasing population. As a utilitarian construction, unlike a religious, imperial or funerary building, it did not claim self preservation. It ran through everyday life, crossing peoples' farmland, posing limitations on the growth of villages and towns, inevitably in the way of new roads, railways, power-lines and pipelines, and not least of all, presenting itself as an easily accessible quarry for the supply of high-quality building materials.

Yet, given the piecemeal evolution of border defences throughout the Ming Dynasty, it should be noted that even after 276 years of work, a solid shield never ran right across the northern frontier. One reason is the frontier that required defending was incredibly long, and the manpower effort required to barricade its full length was massive, even for a China whose population c. 1550 was in the order of 150 million, 0.7 percent of which may have been preoccupied annually with building border defences. Construction in many places was still proceeding by the time of the dynasty's collapse.

Early efforts had prioritized the defence of vulnerable locations – weaknesses in natural landscape defences. By the late Ming, building had reached precipitous mountain terrain, by which time the principle logic of the defence plan to incorporate high mountain ranges had been achieved.

Forcing the enemy onto high ground that was impossible to advance over, adeptly including mountains as components of the defence layout, was an integral part of the northern frontier strategy. As I will explain in the following chapter, the earliest map in the West to depict the Great Wall showed and described it blockading land 'between the banks of hills'. Maps produced as a result of Jesuit surveys (see page 37) also illustrated this strategy.

A further consideration on the question of the Great Wall's continuity that has gone unappreciated is that physically linked or not, the system overall was connected by the 'software' of the period, an advanced signalling system that enabled military information to be relayed by smoke, sound or flag-waving, from watchtower to watchtower, a distance of 1,000 km in 24 hours. This capability united the Ming Wall's commanders with the Ministry of War and imperial court in Beijing.

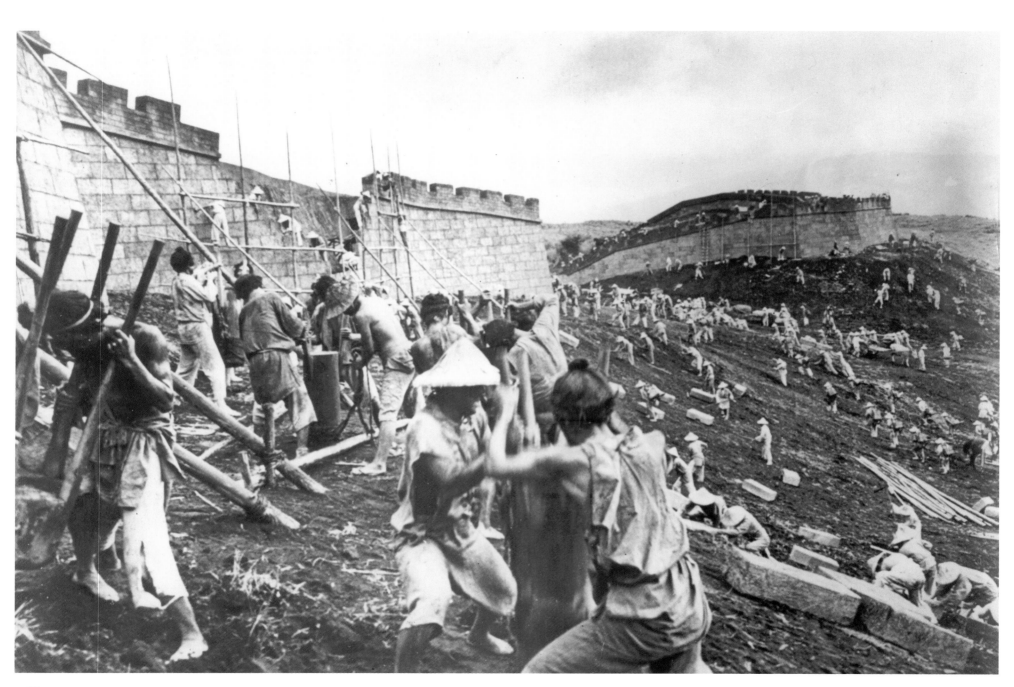

The collection of photography in chapter four will portray many faces of the enigmatic Great Wall which I have tried to introduce here from my own viewpoint. Though presented to illustrate change, this portfolio also shows that the Great Wall is not a single place, but an infinite number of places distributed across a sub-continental swathe of north China.

It is also more than just a 'wall'. Its components include blocky watchtowers, fortified checkpoints, granaries for provisioning the army, openings in the Wall for the passage of troops, high gate-towers for observation and inscribed tablets marking the inspection visits of military officers. The Great Wall is therefore a diverse assemblage of many architectural components.

Crossing gobi-type and sandy deserts, rolling hills, loess plateaus, mountains, river valleys and a coastal plain, in every part of China the Great Wall shows itself as something more than a building, but a succession of varied landscapes, more than history alone, but part of the country's geography that has attracted the attention of cartographers for centuries.

The Ming Dynasty Great Wall which evolved piecemeal from 1368 to 1644 is the most labour-intensive, material- and time-consuming construction project in history. Although a photo of a movie scene, wall–building in reality indeed involved many labourers working with primitive tools and equipment (WL).

CHAPTER 2

A GREAT WALL IMAGE HISTORY: MAPS, DRAWINGS AND PHOTOGRAPHS

Since early and significant photography of the Great Wall was carried out almost exclusively by foreigners, it is appropriate to summarize the historical emergence of various Great Wall images outside China – in Europe – prior to the advent of modern photography.

In the early 1580s, an illustrated manuscript was delivered to the Antwerp atelier of the renowned cartographer Abraham Ortelius (1527–98). According to the manuscript's purveyor, Arius Montanus, a Benedictine monk and one of the cartographer's most trusted informants, the document had come from Luis Jorge de Barbuda, a brother in the Society of Jesus and a prominent Portuguese geographer. On the chart, Barbuda had summarized collected hearsay and observations made by Jesuit missionaries in the Far East since the establishment of Portugal's trading post at Macao in 1557.

Chinae, olim Sinarum regionis descriptio (Description of China, Formerly Sinarum), the first published Western map of China to clearly show the Great Wall: a hand coloured copperplate engraving by Abraham Ortelius, 37 x 47 cm, Latin edition, printed in Antwerp in 1584. The map is oriented with *Occidens*, west at top to fit the atlas format of the *Theatrum* (WL).

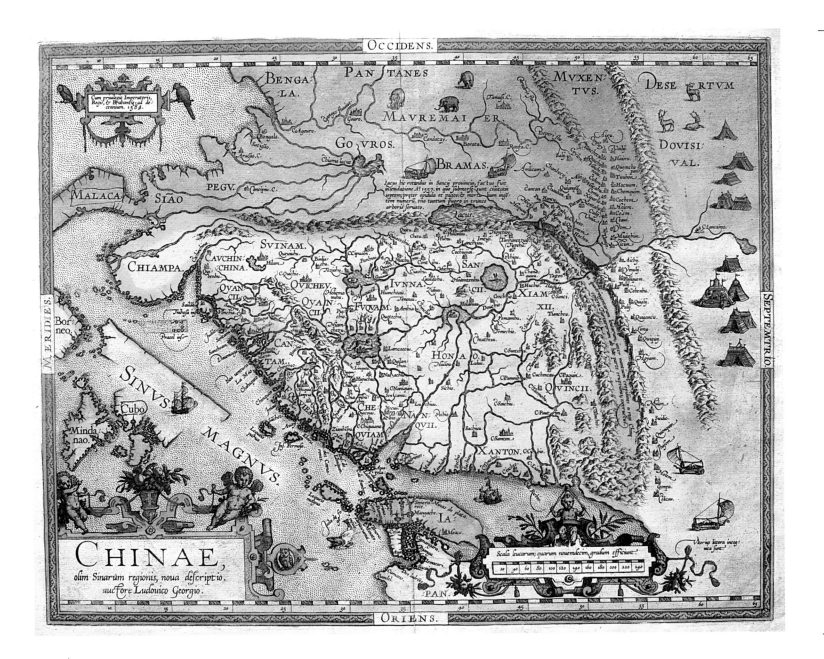

OCCIDENS.

MERIDIES.

SEPTEMTRIO.

ORIENS.

BENGALA

PAN TANES

MVXENTVS.

DESERTVM

DOVISIVAL.

MAVREMAIER

GOVROS.

BRAMAS.

MALACA

SIAO

PEGV.

CHIAMPA

CAVCHIN CHINA.

SVINAM.

QVICHEV.

QVANCII

QVANCII.

IVNNA

SAN

CII

XIAM

XII.

FVQAM.

CANTAM.

HONAO.

QVINCII.

CHE

NAN QVII.

QVIAM.

XANTON.

SINVS MAGNVS.

Cubo

Mindanao.

Borneo.

IA.

PAN.

Scala leucarum; quarum nouemdecim, gradum efficiunt.
20 40 60 80 100 120 140 160 180 200 220 240

CHINAE,
olim Sinarum regionis, noua descriptio.
auctore Ludouico Georgio.

First Published Image of the Wall

Ortelius included a re-drawn version of the chart – the first map of China published and offered for sale to the public – in the 1584 edition of his *Theatrum Orbis Terrarum, or Theatre of the Whole World*. Regarded as the world's first atlas, the map of China printed on page 117 of the mighty tome provided European royal families, its nobility, literati, scholars and would-be explorers with a tantalizing glimpse of a bizarre structure. It was drawn as a segmented rampart blockading land between mountain ranges and crowned with five turrets, beside which to the south was an inscription in Latin: *Murus quadringentarum leucarum, inter montium crepidines a rege Chine contra Tartarorum ad hac parte eruptions, extructus* (A Wall of four hundred leagues, between the banks of the hills, built by the king of China against the breaking in of Tartars on this side).

There is no record of the reaction that this reference to the Wall stirred among the learned men of Europe at the time, perhaps because the *Theatrum*, a radical summary of the latest geographical knowledge in an ongoing age of discovery, was a book of the credible and incredible. Some maps featured saurian monsters lurking in the seas, while the land of China was defended by something that surely to many map readers may have been just as far-fetched: a Wall with a purported length of 1,200 English miles.

The significance of the cartographic debut of the Great Wall of China on a map published in Europe cannot be over-emphasized: it marked the arrival of the structure's attributes on the other side of the world. It was, however, set for much greater fame. In 1590 the scale of the Wall described on Ortelius' map convinced the Venetian cartographer Giacomo Gastaldi that he should mark it on his new map of the world. By doing so, Gastaldi elevated the

Detail of the Ortelius China map showing the strategic placement of border fortifications between natural defences, with yurts on the Mongolian steppe to its north (WL).

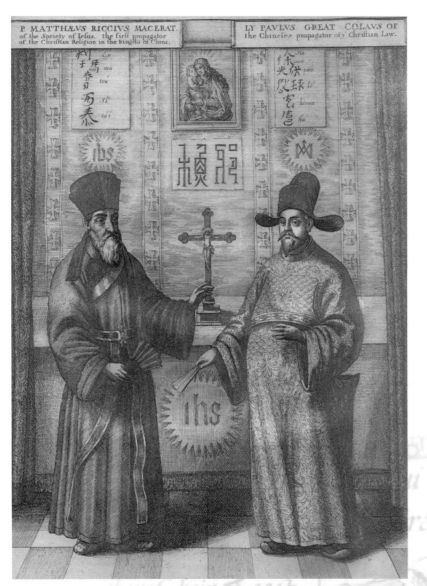

P. MATTHÆVS RICCIVS MACERAT.
of the *Society* of Iesus. the first propagator
of the Christian Religion in the Kingdo of China.

LY PAVLVS GREAT COLAVS OF
the Chinese propagator of y Christian Law.

Matteo Ricci with a Chinese convert to Christianity: a copperplate engraving from Nieuhoff's *History of China*, 1669 (WL).

status of the structure from mere building and landmark to the earth's largest and most geographically-striking man-made feature.

Belief in the now world-famous building was soon to be reinforced by further reference and reliable scientific survey. The most prominent of Jesuit missionaries, Matteo Ricci (1552–1610) spent half his life in China, from 1583 onwards, recording his experiences there in journals only discovered after his burial in Peking, where he resided from 1601. In describing the name, location and extent of the Chinese Empire he wrote: 'China extends to 42 degrees north latitude, to the great northern wall, which the Chinese built to divide their territory from Tartary, and which serves as a defence against the incursions of those peoples'. He elaborated that the empire is 'well protected on all sides, by defences supplied by both nature and science'. Writing of the north he noted 'precipitous hills are joined by an unbroken line of defence that is a tremendous wall, four hundred and five leagues in length'.

Ricci's statements are believed to have been based on his familiarity with Chinese-made maps which, over the centuries of course, had always included the empire's border defences. A particularly influential map in the late-Ming period was produced by Luo Hongxiang in the *Guang Yitu*, or *Enlarged Terrestrial Atlas*. It may have provided the basis for a manuscript map that Ricci produced, which was carried back to Europe on his behalf and eventually used there as template for improved maps of China.

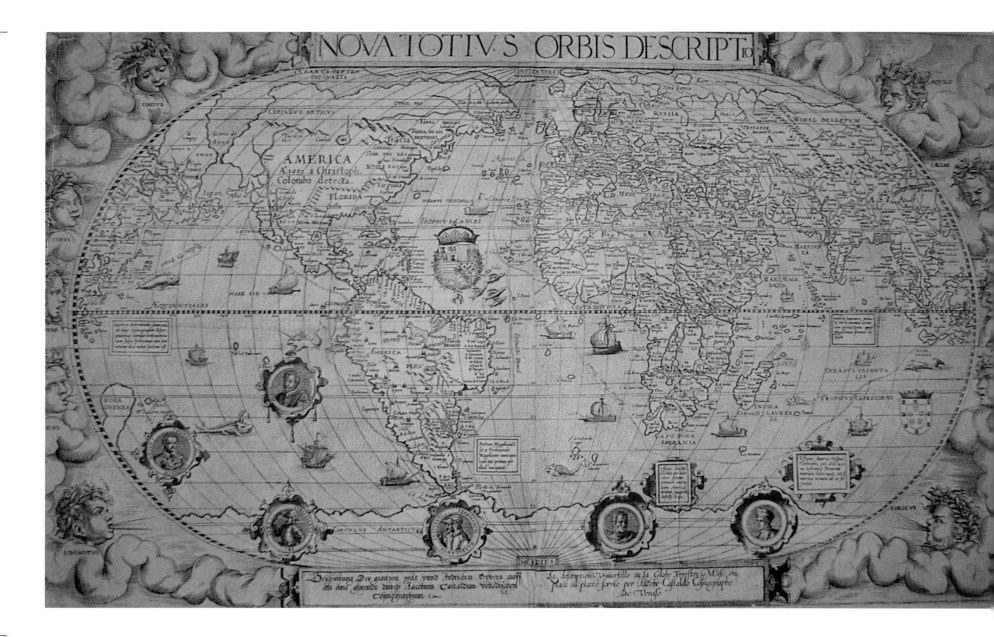

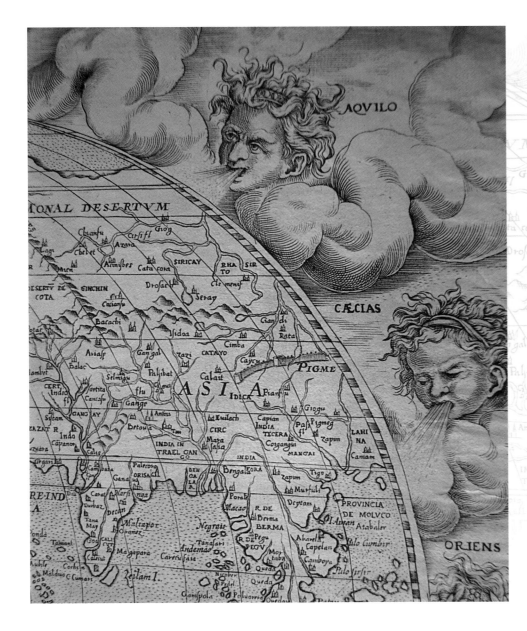

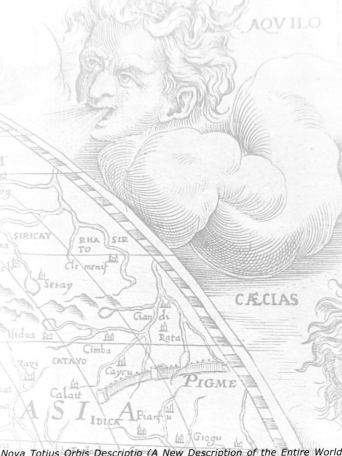

Nova Totius Orbis Descriptio (A New Description of the Entire World), the earliest-known world map to clearly denote the Great Wall, drawn c. 1590 by Giacomo Gastaldi, cosmographer to the Republic of Venice, and thought to have been printed in Antwerp. The map, which is unique and perhaps a proof copy that was never published, measures 81 x 48 cm, shows recent maritime explorations, specifically the circumnavigation by Sir Francis Drake between 1577 and 1580. Curiously it lacks any annotation, on the map itself or in the margins, to explain the Wall symbol. Within a decade other leading cartographers including Petrus Plancius, Jodocus Hondius and Willem Blaeu began to incorporate symbols for the Great Wall on their maps of the world, and by the early 17th century it had become a standard world cartographic feature (University of Utrecht Library, Netherlands).

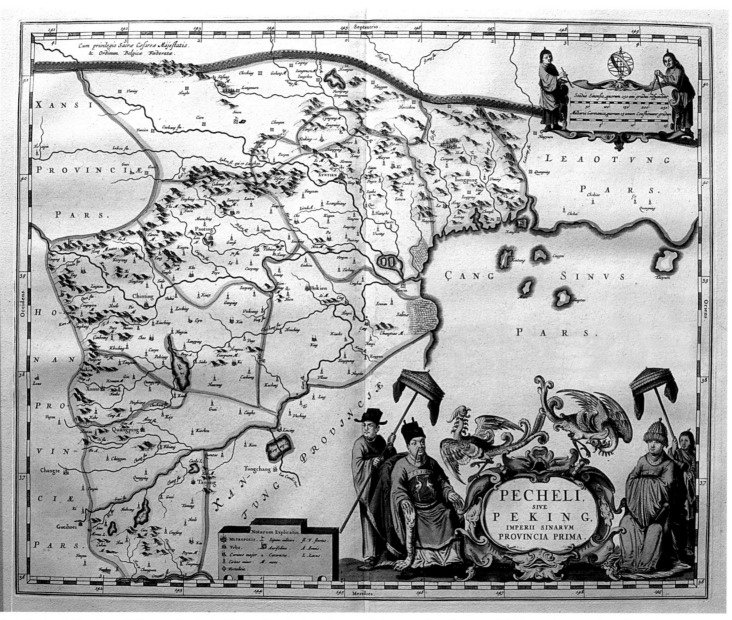

Pecheli, sive Peking Imperii Sinarum Provincia Prima, a hand coloured copperplate engraving of a map of Peking and surroundings from the *Novus Atlas Sinesis (New Atlas of China)* by Martino Martini, 49 x 39 cm, printed 1655 in Amsterdam by Johannes Blaeu (WL).

Atlas of China

The Jesuit Martino Martini (1614–61) spent 20 years in China, was allowed to travel widely, and his geographical knowledge and observations were published by Johannes Blaeu in Amsterdam in 1655 within the *Novus Atlas Sinensis, or New Atlas of China*, the first China atlas in the West, containing 17 maps. The Wall appears on six of the atlas' sheets and Martini shows it, in contrast to the segmented style used by Ortelius, as a continuous structure, three courses of masonry in height. This unbroken rendition may have reflected the construction drive of the late Ming during which existing piecemeal sections were linked up. The layered brick appearance clearly suggested the increased use of bricks during the Wanli period (1572–1620). However, it is shown along its entire length thus, indicating that Martini had no first-hand appreciation of the structure's morphology along its western and central sections, where the Wall was built predominantly of rammed earth.

As Ortelius' milestone China map influenced successive European maps of the empire for some 70 years until 1655, Martini's maps in turn were all dominant from their publication that year until the maps based on results of the first detailed triangulation survey were taken to Europe in the early 1720s.

In 1708 the Kangxi Emperor (1661–1722) commissioned a mapping survey of the north of his empire, led by three Jesuit cartographers. It is surprising that no artistic depictions, impressionist or realistic, were produced, but the decade long expedition, which utilized astronomical observation and triangulation to evaluate the latitudinal and longitudinal coordinates of 641 locations, provided a most accurate geography of China. The charts produced showed a detailed route of the Ming Great Wall, between its main terminal points, and for the first time revealed its complexity, featuring loops and spurs, and the northeastern extension.

PECHELI,
SIVE
PEKING,
IMPERII SINARVM
PROVINCIA PRIMA.

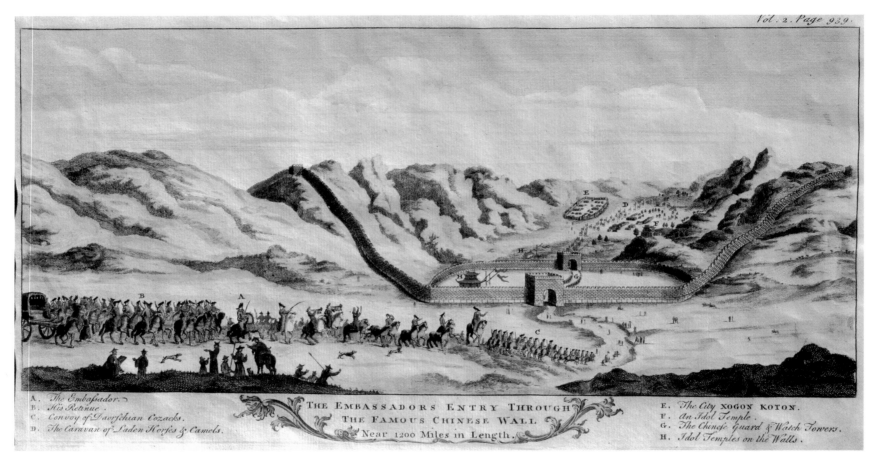

Vol. 2. Page 939.

A. *The Embassador.*
B. *His Retinue.*
C. *Convoy of Davrschian Cozacks.*
D. *The Caravan of Laden Horses & Camels.*

THE EMBASSADORS ENTRY THROUGH
THE FAMOUS CHINESE WALL.
Near 1200 Miles in Length.

E. *The City* XOGON KOTON.
F. *An Idol Temple.*
G. *The Chinese Guard & Watch Towers.*
H. *Idol Temples on the Walls.*

The Embassador's Entry Through the Famous Chinese Wall, a 17th century copperplate engraving with later handcolour, 39 x 20 cm, depicting a Russian trade delegation lead by the envoy Ismailov en route to Peking in 1720 where he was granted an audience with the Kangxi Emperor (WL).

Drawings and Engravings

Whereas the first images of the Great Wall were cartographic and largely produced from hearsay and observations collected by missionaries, engravings of the Wall produced from the mid 17th – late 19th century were by-products of trade and early tourism.

China was the largest empire in Asia and presented itself potentially as an attractive and lucrative trading partner to European powers, a number of which despatched embassies, trade missions per se, aimed at securing trading rights. The mission of the Dutch East India Company to China (1655–1657) was chronicled by draftsman Johan Nieuhoff. He drew a wall that he captioned as 'great wall', but its appearance suggests it was a city wall, probably Peking's. In the early 18th century a Russian Embassy approached the Chinese empire from the north. An engraving records its entry through the Wall, yet the view appears to be an impressionist's rendering.

The most widely distributed image of the Wall during the 19th century was based on painting made in 1793 by Captain William Parish of the British Embassy (see page 228). His '*View of the Great Wall of China, called Van-Lee-Tching, or Wall of Ten Thousand Lee, taken near the Pass of Cou-pe-koo*' achieved widespread fame and was later imitated by Thomas Allom in *Views of the Chinese Empire*. The original image has traditionally been dismissed as fanciful.

Newspapers demanded realistic images. From the mid 19th century artists were despatched to China from Europe and the United States. They headed for the Wall to the north of Peking, producing sketches that featured in lavishly illustrated publications such as the *Illustrated London News, Century Magazine* and *Harper's Weekly*.

View of the Great Wall of China, called Van Li Tching, or Wall of Ten Thousand Lee, taken near the Pass of Cou-pe-koo, 47 x 34 cm, copperplate engraving by William Alexander based on a painting by William Parish, published 1798 in Sir George Staunton's account of the British Embassy to China (WL).

The Great Wall of China at Nankow Pass, a copperplate engraving 33.5 x 23.5 cm, from the *Illustrated London News*, 1873 (WL).

Foreign visitors making their way through Nankow Pass leading to the Great Wall: a copperplate engraving, 30 x 21 cm, from the *Illustrated London News*, 1873 (WL).

Dawn of Modern Photography

In 1829 two Frenchmen, Joseph Niepce and Loius-Jacques-Mande Daguerre, formed a research partnership aimed at improving the eight-hour-long process Niepce had pioneered in 1826–27 to take the first permanent 'photograph' using a camera obscura (pinhole camera without a lens). At an assembly of the French Academy of Sciences on 19 August 1839, Daguerre demonstrated his achievement in reducing the exposure time necessary to capture an image to less than 30 minutes, and prevent the image from disappearing (fixing). The method, known as daguerreotype, was a direct-positive process creating an image on a silver-compound coated copper plate, and it ushered in the era of modern photography. Daguerre was hailed as the inventor of the first practical process of 'photography', a term literally meaning 'writing with light', first coined by scientist Sir John Herschel during the same year.

Within a decade the wealthy of the world's Western cities were captivated by daguerreotype portraiture, and in 1850 the city of New York boasted more than 70 studios engaged in the business.

Early Great Wall Photography

In the mid-19th century, when the British and French empires were at their zeniths, and much of the world fell under their colonial rule, the middle classes of Europe and the United States grew eager to see distant lands, especially their peoples, remarkable views and monuments, brought to them courtesy of improved photographic technology. John Thomson from Scotland was one of the first photo adventurers who made the long voyage out to the Far East, photographing Indo-China, China and eventually the Great Wall in 1871 (see page 166).

Badaling as it was in 1895 preserved on an albumen print, 26 x 19.5 cm, by the Japanese photographer S. Yamamoto (WL).

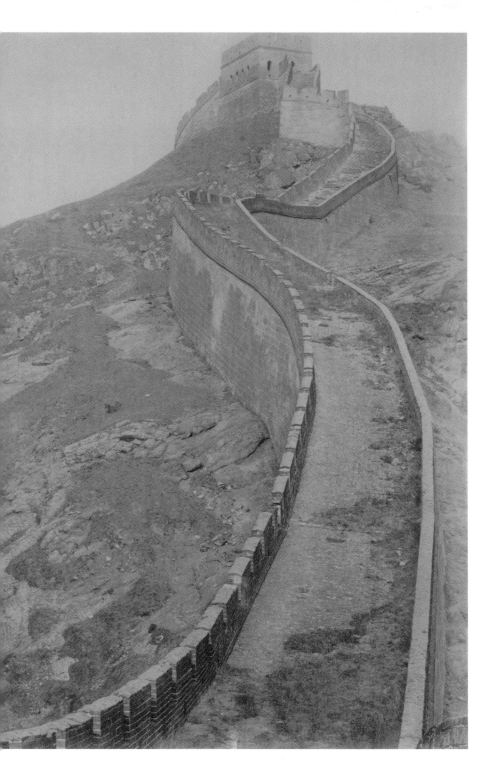

Focus on Nankow Pass

From the 1880s several resident photographers in Peking focused their cameras on the Wall. Thomas Child was a British gas engineer by trade, but a keen and competent cameraman. He frequented the Great Wall at 'Nankow Pass' (Juyong Pass) and his images, preserved as albumen prints, show several different views of the main fortifications at the very northern end of the pass, now known as Badaling, as well as other installations seen en route. He also made a photographic foray to Gubeikou, further out and to the capital's northeast, the location made famous by the engraving based on Parish's 1793 painting.

S. Yamamoto from Japan was the first professional to set up a studio in Peking to cater to the growing demand for souvenir photographs of China's great buildings and monuments (see pages 194, 206), working there for more than 20 years at the turn of the 19th century.

Heyday of Wall Exploration

In the early 1900s exploration along the whole length of the Wall, or focusing on regional parts, provided a much broader view of its remains to the world.

Aurel Stein investigated part of the Han Wall in early 1907, taking the accolade as the Wall's first archaeological explorer (see page 62). The following year, William Geil became the first full length explorer of the Wall, photographing the structure extensively on his journey from Shanhaiguan to Jiayuguan (see page 86).

Journeys by Robert Clark and Arthur de Carle Sowerby (1908-09) produced rare images of the Wall in Shaanxi (see page 118), while geologist Frederick Clapp made a journey in 1914 across east and central China lasting several months, photographing a number of remote Wall locations including Shaanxi and Gubeikou (see pages 120, 240).

Four coloured magic lantern glass slides, all 10 x 8 cm, depicting Great Wall scenes at Badaling: (left to right) three hand tinted slides depicting an American family's visit; classic view marketed by H.C. White (all early 1930s) (WL).

Four magic lantern glass slides depicting the Great Wall at Shanhaiguan in 1907, all 10 x 8 cm, exposed by Herbert Ponting: marketed by Underwood & Underwood in the United States (WL).

Hand tinted silver gelatine print measuring 26.5 x 22 cm, sold by Hartung's Photo Shop in Peking during the early 1930s (WL).

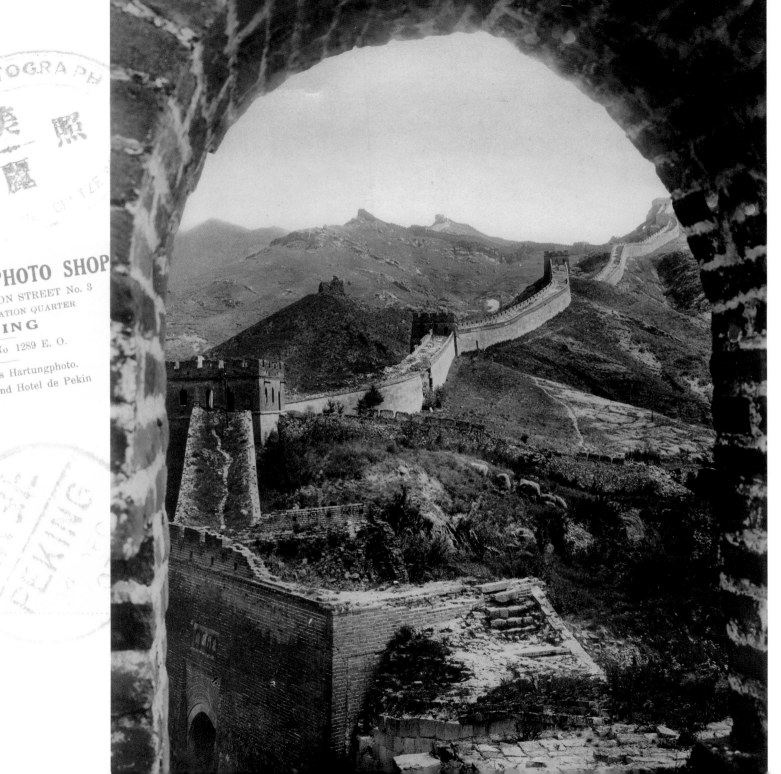

HARTUNG'S PHOTO SHOP
EAST OF LEGATION STREET No. 3
INSIDE THE LEGATION QUARTER
PEKING

Telephone No 1289 E. O.

Radio address Hartungphoto.
Branch at Grand Hotel de Pekin

北京 阿東照相館

在東交民巷東口內路北二百八十九號

美一圖照相

Early Tourism

The photography produced during the brief heyday of Great Wall exploration, lasting from 1907 to 1914, saw the publication of several books and papers, as well delivery of public lectures. All were instrumental in putting Peking on the map as an essential destination for the more adventurous and antiquarians planning grand tours of the Far East. Access to Nankow Pass was made swifter by completion of the Peking-Kalgan (Zhangjiakou) railway line in 1909. In 1923 the Great Wall for the first time became the focus of a major magazine travel story, written by Juliet Bredon, who used the pseudonym 'Adam Warwick' in the *National Geographic Magazine* (see pages 174, 186, 266).

Catering to growing tourism, several photo studios opened in the city. One of the most successful businesses was Hartung's Photo Shop operated by a German who had a studio at No. 3, East of Legation Street, and a branch studio at the Grand Hotel de Pekin, managed by professional photographer Hedda Hammer (1908–1991). Meanwhile, local shops competed for the same business, among them the Meili Studio on Nan Che Tzi (Nanchizi). All offered postcards, large-format photographs for framing with the option of customized hand tinting, and albums. Stereoviews were sold by companies such as Keystone and Underwood & Underwood.

Technology advanced enormously from 1889 with the introduction of celluloid film by Eastman Kodak, and this paved the way for easier personal photography without the use of heavy glass plates nor the need for on the spot processing. In the 1920s, the 35mm format was introduced which used rolls of celluloid film; medium format cameras soon followed using sheet film. Some of the more savvy travellers carried the latest technology with them to snap scenes experienced on their own Great Wall sorties. On their return to Europe or the United States some had their images made into magic lantern slides that were suitable for projecting onto a screen for viewing at family gatherings or by larger audiences.

War and Revolution

The outbreak of hostilities between the Communists and Nationalists in 1927, and the annexing of Manchuria by the Japanese from 1925, heralded the beginning of protracted conflicts that eventually made North China, and the Great Wall, a dangerous field for adventurers, explorers and travellers from the 1930s. The Anti-Japanese War (1931–1945) saw the production of a limited quantity of Great Wall photographs from both sides, those taken by Chinese to patriotically inspire a victorious fight against the aggressors, and those taken by the Japanese in their attempts to convince the world that they had conquered China.

It is fitting therefore that the last of the early Great Wall photographers is the first Chinese, Sha Fei. He photographed his comrades in action up on the Wall in Laiyuan County, Hebei Province in 1937–38 (see page 136).

The war years proved to be only the first of three cataclysmic events to inflict enormous negative impact on the Great Wall during the 20th century. Soon after the establishment of the People's Republic of China in 1949, the nation's heritage would receive its most destructive battering with two campaigns launched by Mao Zedong (1893–1976): the Great Leap Forward (1958–9) and the culture of destruction propelled by the dictum of 'letting the past serve the present', and the directive to 'smash the four olds' of the Cultural Revolution (1966–76). In this context early photography of the Great Wall – pre-war – had preserved on film a Great Wall that in places was no longer.

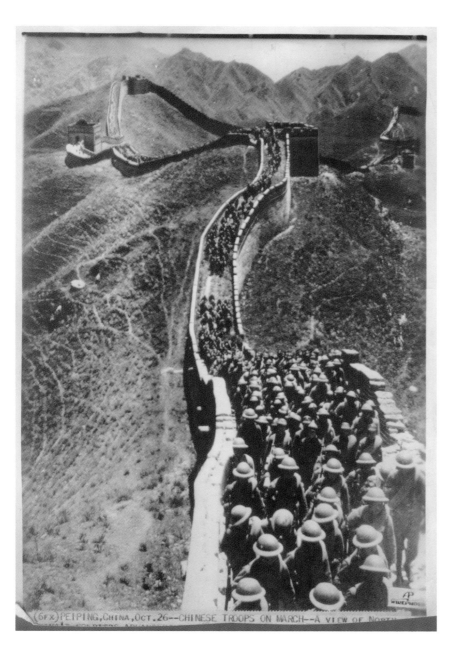

Associated Press Wirephoto datelined Peiping (Beiping) 26 October (probably 1937), 26 x 20 cm, showing Chinese Nationalist troops marching on the Great Wall southeast of Badaling (WL).

CHAPTER 3 REPHOTOGRAPHY AND THE GREAT WALL

Rephotography, although a self-explanatory term, is fairly new and has yet to appear in most dictionaries. When it does, a definition is likely to be 'the act of repeat photography at the same place with a time lag in between'. The technique has been described more evocatively as 'going back to do the same to find out what's different'.

One fact is certain, rephotography is a rapidly developing genre, and an extension of our never ending fascination with photographs. The most memorable photographs are created by what Henri Cartier-Bresson called the cameraman's perception of 'the decisive moment'. To seize it the photographer anticipates when the scene's various moving elements are at their most expressive. Then he clicks, capturing a picture that talks. The result may appear in a newspaper or a news magazine, chosen by the picture editor because it records a worthwhile yet brief moment. The subject has long since gone, the action over, the event history.

Soaring interest in photography after the popularity of daguerreotypes, post 1850s, was sustained by the eagerness of Europe and North America's middle classes to see the natural and built wonders of the world that they could not reach themselves. Photographers answering this call took their time, fixing tripods, framing up, waiting for the light. But as they focused on some of the world's most extraordinary monuments could they ever have realized that their photographs too may also preserve moments in time? Did the photographer who exposed the image of the Sister Towers at Gubeikou circa 1930 (see page 236) imagine that they may one day be gone, become history, due to some action – human or natural? Did he possess this anticipation?

Most pioneer photographers at the Wall surely considered their pictures not so much as capturing an instant, but an era, perhaps of timelessness. Viewed back home, the first photographs to provide real views of the Great Wall of China must have been perceived as surreal, arousing a level of amazement equal to our generation's viewing of the first images beamed back from Mars or Venus. Not only was the subject awe-inspiring, the technology used was revolutionary, and the distance travelled by the image more than most would cover in a lifetime.

These photographs spoke powerfully, telling a story of China's antiquity. What other building pronounced so boldly the permanence of Chinese civilization as much as it's audaciously-built Wall? It represented the most time- and material-consuming and labour-intensive construction project in human history, something that was much more than a building, but part of the geography of China and the world.

We naturally assume the small to be vulnerable, the monolithic unshakable. Although the Great Wall is vast, it can only be viewed, and preserved, as a myriad of component parts. In 1991 I had discovered one change, the disappearance of a single watchtower, illustrated by then and now photographs produced by coincidence (see page 246). Initially I wondered whether the fall of 'Geil's Tower' was a rare event. Over the ensuing years I learned it was a representative incident repeated in many places. It became clear to me that many local tragedies added up to inflict overall impact.

In 1982 I'd purchased a globe from the National Geographic Society in Washington D.C. and was thrilled to identify the Great Wall of China

as the only individual building marked thereupon. As we have learned it became a standard feature on world maps and globes from 1590. I adopted this fact as my own sound-byte to describe the unparalleled wonder of the Wall, promoting it as a plausible alternative to the oft-quoted and spurious accolade that it is the only man-made object visible from space. But returning to the Society in 2004 and buying a new globe to keep up with political changes, I was saddened to note the Wall's disappearance. It had gone.

From 1900 to 2000 more of mankind's cultural heritage was lost worldwide than at any other time in history. Populations mushroomed, urban areas sprawled, wars raged and explosives, even in peacetime, provided the means for urban renewals, sometimes destroying in an instant what had taken decades to build, and what had been preserved for centuries. People of today have thus been increasingly distanced from their pasts – not only in China – but throughout the world.

Rephotography is one way of reuniting people with the works of their ancestors, of closing the gap between our past and present. It is also a powerful advocacy tool. By providing a summary of successes and failures it can influence future conservation choices. This is the impetus behind the recent emergence of rephotography, and one of the reasons why *The Great Wall Revisited* was launched.

Another reason is certainly technical ability. We have embraced the world of the internet and digital imaging since the mid–1990s. Faded old photographs are less likely to languish untouched in drawers, or unseen in museum archives: they can now be brought out and made accessible online, be acquired through purchase or scanned reproduction, and utilized as resources for rephotography. While the basic idea for *The Great Wall Revisited* was formulated by an emotional experience as early as 1991, the project was only made technically feasible via the internet and through digitalization.

A third factor boosting rephotography in general and the impulse behind the imminent launch of *The Great Wall Revisited* in particular, was the Millennium. They had come and gone before, but the dawn of the 21st century was different. Never before were so many educated people, perhaps tens of millions, focused on one moment, because that moment presented itself as a bridge between two eras, from which we could take in two perspectives, one back into the past, and one forward into the future. For a brief moment the present was relegated from every deep-thinking person's thoughts.

On the eve of 2000 I walked up to the Wall just before midnight. I'd never headed up there before in the depth of night. I'd been up scores of times in darkness before daybreak, as Beijing slept, in readiness to photograph sunrise. This night, and time of night, was different. I saw a line of watchtowers on the ridge ahead of me: they were backlit, silhouetted by the light pollution from the capital to the south, eerily viewing my approach. I contemplated how their lookout windows – *yan* as the Chinese call them, or eyes – had witnessed the arrival of 1500, 1600, 1700, 1800 and 1900. Only by counting up through the centuries instead of just saying 'five hundred years' did I really appreciate the march of time, and the aging of the Wall. I pondered how it largely survived intact until the early 20th century, only to suffer immensely later on. What, I wondered, would the 21st century have in store?

Rephotographers, myself included, aware that the last century was one of loss, hope our craft can help make the 21st century an era of repair. The technique we use is a powerful catalyst because it is popular and accessible, and universally understood. There are no language barriers, no age constraints. It invites participation: the viewer looks back and forth, travelling in time between two images, and like children love to do, spots the differences. Perhaps the irresistibility of rephotography is rooted in the reason we have for building up family photo albums – to record how much we change. This is a kind of 'casual rephotography'.

Rephotography for conservation goals needs to be much more precise. While snap-shot portraits of people can be produced anywhere, as they are linked by the presence of a common element – the subject – albeit amidst different surroundings, rephotography of buildings or landscapes is different. The rephotographer must go there.

And only when the rephotographer arrives does he or she discover whether some basic assumptions are true or false. We tend to see ourselves as human beings living in a world in which our cities might change, but we expect the works of nature, and great marvels of mankind, to be more permanent. Arrival reveals whether, and to what extent, a wonder really is immovable in relation to its surroundings. Can it move? Yes, it can, it can disappear completely. Is it permanent? No, not necessarily. In this way the sense that a building is 'immovable' and permanent, and that even landscapes are unchanging, transpires to be just an illusion. Rephotography is the way and means of unmasking the illusion of permanence, emphasizing that the

At Badaling, autumn 2004.

moment that always seems with us, which we call 'now', whether in the past, present or future, is temporary.

In human history an unknown number of buildings have been constructed and most have integrity in their own right, from humble home to grand monument. The most extraordinary of the latter have from ancient times been singled out for recognition. The Greek historian Herodotus laid the foundations for the Seven Wonders of the World in his *Histories*, written in the fifth century B.C. All seven were limited to his known world of the eastern Mediterranean and Asia Minor. The modern and global vision of the same awe-inspired concept is the inscription of UNESCO World Heritages,

sites of universal importance, recognized as unique and listed for protection, an event that places an obligation on the host government and country's people to make outstanding efforts to be good caretakers.

I embarked on a journey to rephotograph the Great Wall because the results promised to deliver a useful message about the current condition of the largest of all UNESCO World Heritages. It transpired to be the first comprehensive rephotography project to focus on an individual building, rather than a city's collection of buildings, and the first project of its kind to focus on a UNESCO World Heritage.

<p style="text-align:center">* * *</p>

Before rephotography there must be photography. Sourcing vintage photographs is a prerequisite, and the first challenge. Although an enormous site, we have learned in the previous chapter that only a few people with cameras ever explored the Wall prior to the 1940s, and only a relatively small number of hardy travellers followed as tourists. Those that did tended to flock to the same location, Nankow Pass, touted as the best place to see the structure. Wall photographs are fairly scarce, while photographs of outlying sections of the Wall are the scarcest of them all.

Once acquired, locations had to be identified. The scale of the Great Wall presents a formidable challenge to its rephotographer. I was hunting for a few places on the face of the longest building in the world, one so immense that, during its operational period, guards manning watchtowers at its eastern end (Old Dragon's Head) would have witnessed sunrise 80 minutes before their counterparts at its western end (Jiayuguan). That's why it's called the Great Wall of China.

In my meagre attempt to intimately know the Wall, over 20 years I had accrued 1,200 days of experience, but I remained a relative novice, brought into perspective by the difficulty I had placing many of the locations. For identification work I was assisted greatly by the vaster experiences of Cheng Dalin and Luo Zhewen. In the wake of a successful identity parade I could then head out into the field to see if the image matched the reality. I knew in many cases that I wasn't going find the same Wall, so I was on the lookout for something of continuity, common ground that is desirable for effective rephotography.

In the era before GPS, which can now accurately record latitudinal-longitudinal co-ordinates to within a couple of paces, the commonest way to record a location in a caption was to include the name of the place. But what name and what place? Early foreigner travellers used the Wade Giles method of Romanization, and it has little resemblance to today's *pinyin*. This created a correlation problem. Moreover, while some sections of the Wall have historical names, the photographer may not have been aware of that name, and instead may have used the name of the nearest village, a local popular name, or invented one. William Geil was particularly fond of the latter: he offered names such as 'Mule Horse Pass' or 'Copper Green Pass'. Without an approximate idea of location, I could not even travel into the precincts; but once within a radius of a few kilometres, or in the nearest village, there was at least the promise of further pointers.

If I found the location the skills of photo work began. I used 35mm format for two reasons: it is very portable, and I had to climb many mountains, whack through thick bushes, and cross lots of sand dunes, to reach my locations. Also, I am familiar with the format, having used it successfully since 1981.

Most of my predecessors used larger format cameras, with different frame dimensions. And I learned that because of the weight of it, they were limited to how far they could carry their equipment up to and along the Wall. As I followed them I thought logistically, considering what may have been possible, ruling out the unlikely. I did my homework, working like a detective, delving into the photographer's written records for clues, piecing together a route that may have been walked, and working out which vantage points may have been chosen en route.

Next came the framing up, as best that could be achieved. A zoom lens proved suitable for this job. While my results far exceed the level of 'casual rephotography', which is only approximate, and pays little attention to framing, lens coverage, time of day or season, it only occasionally approaches the class of 'precise' 100 percent identical rephotography. This is for two reasons: first, with the difference in format between the original cameras and 35mm, it was impossible in most cases to achieve perfect replication; and second, while it would have been nice to achieve, it wasn't absolutely necessary. I have been using rephotography as a conservation tool to generate an image almost the same as the original, rather than exhibit my technical photo skills. A comparative pair of photographs was my goal. As you will see, getting a 95 percent plus likeness provides a sound basis for comparison,

and the time, effort and expense – as well as the weightlifting – required to achieve that extra 5 percent was just not worth it, even pedantic. To sum up, I did the best I could do, and I got as close as I could get.

At several locations the small percentage shortfall wasn't due entirely to differences in equipment. Occasionally it wasn't possible or safe to stand on exactly the same spot that the original photographer had done. Sometimes the land had been excavated, making it lower; sometimes earth had been dumped there making it higher; once the ground was deeply flooded and on several occasions it was inaccessible because of new buildings. At Beimenkou (see page 242), I was just four metres from the precise spot, which happened to be within the confines of a rather ramshackle electricity station, and I didn't want to be electrocuted.

In a few places I departed from my usual goal of trying to achieve as identical a match as possible, in order to give viewers a better appreciation of change. I believed that had I stuck to the rules, the result would have misled the viewer, because something of importance lay just out of frame. A good example of one of my 'wider angle views' is the case of the G 312 expressway in Gansu (see page 112). Another deviation was at Shuiguan, with a photo taken by John Thomson (see page 178). If I had exactly replicated his original, we'd have seen the top of the Wall while the rest of the frame would have been filled by trees. I asked myself: 'Would Thomson be intrigued by this new image, or would he agree with me, supporting my decision to exercise discretion and produce a more revealing view?' I thought that he would have agreed with my decision. So I stood back to show that bigger picture, which incorporated an expressway, heavy traffic and a toll booth,

things that Thomson would surely have found equally as fascinating as the rebuilt Wall.

Holding Thomson's albumen print, faded but preserving a view of 135 years earlier, convinced me that I should strive to achieve similar longevity for the photos that I produced. To this end I decided to use old fashioned film, simply because by doing so one creates a tangible, primary resource, a transparency that can be stored, and used as a template to print off many copies. Primary digital capture has a less proven storage life record. Who really knows how images saved on photo CDs and or computer hard drives will stand the test of time? I also decided to print my new images in colour, in contrast to the old, which were almost always monochrome. The whole purpose of rephotography as a technique is comparison: I consider the vivid contrast provided by colour to be an enhancement.

Following in the footsteps of great photographers, the first explorers of the Wall, was a privilege. Their vantage points became my advantage points, from where I could see the old and new, side by side. I carried back their old photos, and made them into bigger pictures. They had captured scenes long ago that they thought were static, unchanging, and timeless. I gave these pictures a part two, made them worth a second look. In this way their 'decisive moments' had been left suspended indefinitely by the vicissitude of time.

The final seizure, however, was not achieved with the pressing of my camera's shutter. It was completed back in the city, by the placing of the new print beside the old. Let us now set off on our journey along the Great Wall, in the past and present.

At Yumenguan (Jade Gate Pass), Gansu Province in October 2006.

CHAPTER **4** REVISITED SITES

YUMENGUAN

JIAYUGUAN

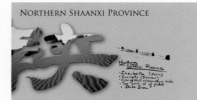

NORTHERN SHAANXI PROVINCE

HEBEI

BEIJING

GUBEIKOU

SHANHAIGUAN

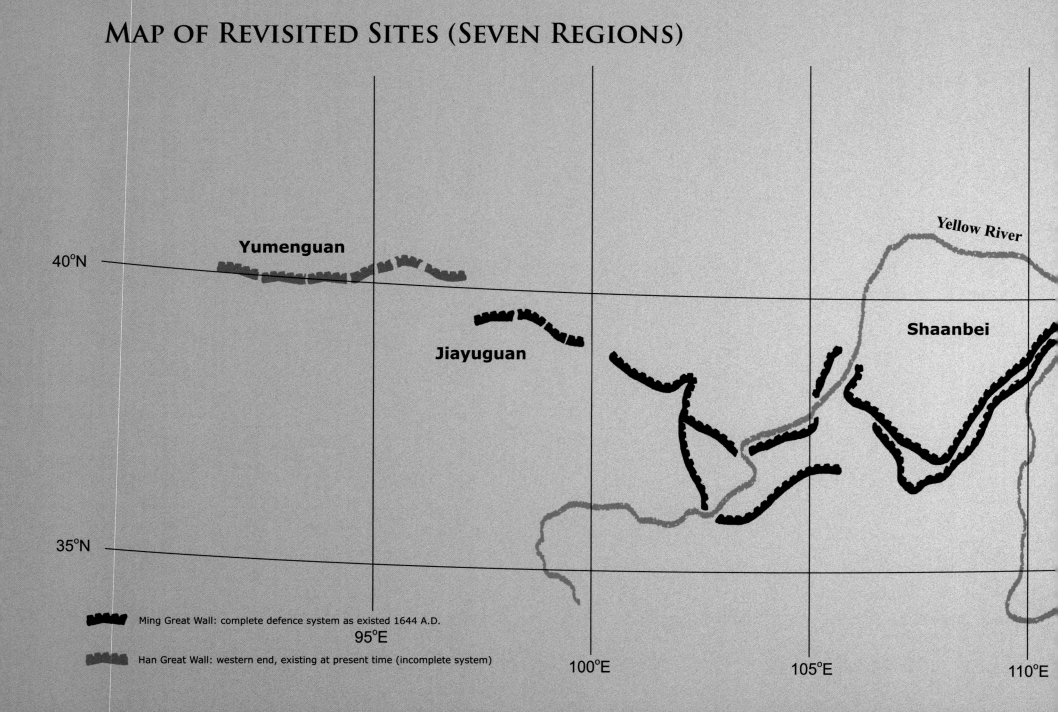

Map of Revisited Sites (Seven Regions)

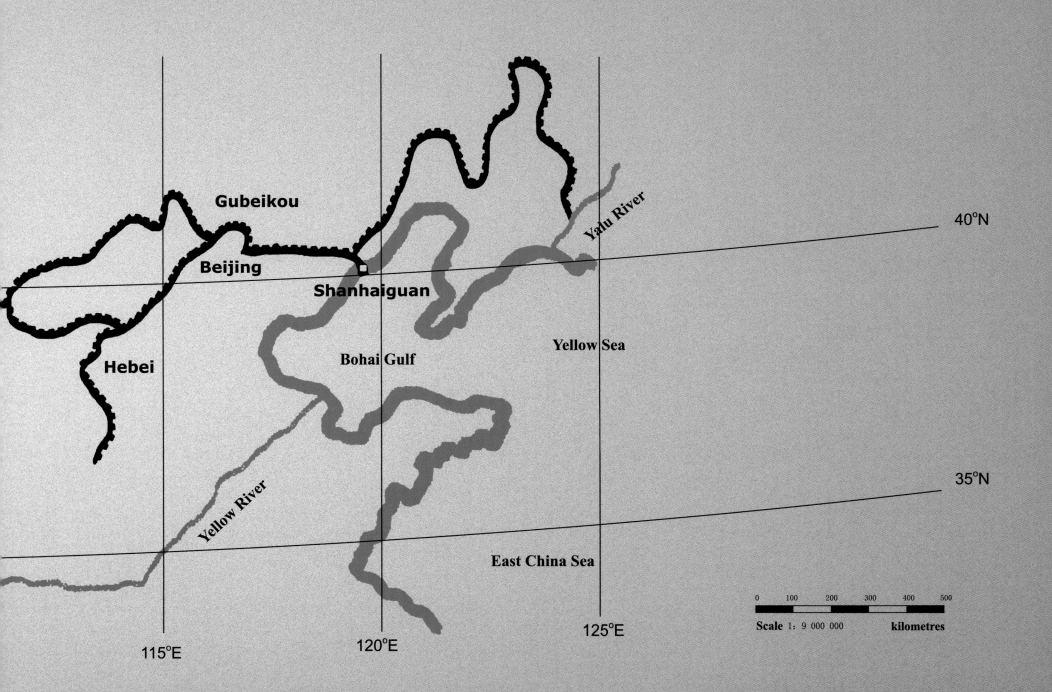

Gubeikou

Beijing

Shanhaiguan

Hebei

Bohai Gulf

Yellow River

Yalu River

Yellow Sea

East China Sea

40°N

35°N

115°E

120°E

125°E

Scale 1: 9 000 000

0 100 200 300 400 500

kilometres

YUMENGUAN

Jade Gate Pass

- Tower IX
- East of Tower XIII (east)
- East of Tower XIII (west)
- Fascines Stacked for Use
- Jade Gate (north)
- Jade Gate (west)
- Hecang Granary

Han Dynasty Great Wall containing layers of reed, constructed c. 110 B.C. and preserved to a height of 3.75 metres, at Maquanwan, west of Yumenguan.

Fortifications in the vicinity of Yumenguan, the Jade Gate Pass, mark the most westerly incorporated in this rephotographic study. The sites are all of early Han Dynasty age, c. 100 B.C., and once constituted the very western components of a lengthy defence system constructed during the period (206 B.C – 220 A.D.), as the empire expanded its territory westward from the central plains to incorporate the Hexi corridor (Gansu), and the 'Western Regions' (Xinjiang), in the wake of military successes led by commander Huo Qubing against the Xiongnu Huns.

Following the establishment of a string of military prefectures at Wuwei, Jiuquan, Zhangye and Dunhuang in 111 B.C., frontier defences were constructed throughout the Hexi corridor. Peasants were resettled to farm and build water-conservancy projects, and a west to east movement of precious goods developed.

Merchants travelled from oasis to oasis in the lee of permanently-manned defences, forging a network of tracks that much later, in 1877, would be described as *Seidenstrasse*, or the Silk Road, by the German geographer Baron Ferdinand von Richtofen. Jade from Hetian, south of the Taklamakan Desert in Xinjiang, was transported east to China's heartland, passing by a small fortress west of Dunhuang, which became known as the Jade Gate.

The Han Wall evolved to be one of the longest Great Walls in history, stretching from Lop Nur (west of Yumenguan) in the west, to the Yalu River (present-day border between China and North Korea) in the east, a tortuous distance of more than 7,200 km.

Despite its eventual length, after 2,100 years well-preserved remains of this Han Wall are rare, in both height and continuity, along a line that once stretched virtually unbroken through the regions of Gansu, Inner Mongolia, Hebei and Liaoning. Today, the best preserved remnants are to be found close to the Gansu–Xinjiang provincial boundary, probably for two main reasons. First, the morphology of the ramparts constructed here was unique; and second, the host landscape of gobi desert has consistently proved hostile to human activity, and impenetrable to all except the most determined explorers and travellers.

During the Wall building process, construction materials were sourced locally whenever possible. The most plentiful raw materials of the gobi are sand, small stones and clay, all of which were indeed used in quantity within the Han defences. Builders were also innovative by using materials that had not previously been considered. One was *luwei* reeds which grow on salt marshes in the vicinity of Yumenguan around the seasonal Shule River. Another was *hongliu* (Chinese tamarisk), which grows on the open gobi. Wood was harder to find, but could be obtained from the *huyang* (Euphrates or diversiform-leaved poplar), which prospers in groves where groundwater is available. *Huyang* timber would have been transported over considerable distances to the building site given its necessary use in tower construction, usually known as *fengsui* in this area.

Desiccated *huyang* wood from a watchtower.

ANCIENT EXTENSION OF
THE GREAT WALL
IN NORTHWESTERN KANSU
Scale same as main map
Based on Sir Aurel Stein's Map of
Chinese Turkistan and Kansu 1:253,440

The diversiform–leaved poplar in glorious autumn leaf.

It is the thick layers of dried reed stalks that give some Han ramparts around Yumenguan a unique thatched-strata appearance. Alternating layers of sand-gravel and *luwei* reeds were cleverly meshed together using alkaline water from the nearby marshes. After this saturation materials dried with a cemented quality.

Apart from resilient construction, the lack of sustained human activity over the centuries has undoubtedly been a positive factor in preservation. The British explorer Aurel Stein was the first outsider in pre-modern times to penetrate the area, and thought its frontier walls worthy of investigation. All the sites revisited around Yumenguan were in his company, while his detailed notes provided a rich source of eyewitness material.

Aurel Stein: Explorer of the 'Tun-huang Limes'

In spring 1907, one year before William Geil embarked on his exploration of the Ming Great Wall, the archaeologist-explorer Aurel Stein (1862–1943) investigated fortifications of a much older Wall in the northwest of China.

Marc Aurel Stein was born in Budapest, Hungary, and in his youth had two heroes: Alexander the Great (356–323 B.C.) and Xuanzang (early 7th century), a Chinese monk who travelled along the Silk Road. The odysseys of these contrasting historical figures, Alexander's conquests and Xuanzang's pilgrimage, defined the foci of Stein's life, lived out to the age of 81 years, exploring Asia Minor, the Fertile Crescent, the Karakorum, Chinese Turkestan (Xinjiang) and the Silk Road.

As a student Stein studied various Asian languages and arts – Sanskrit, Indology and Persian – in the cities of Budapest, Leipzig and Tubüngen. From 1885–86 he trained in the Hungarian army, learning topographical surveying, and after brief spells of curatorial work at the British Museum, London and Oriental Institute in Woking, he went to India in 1887. There he experienced the thrill of archaeology for the first time, under the auspices of American Fred Andrews, who also taught him the science and art of photography.

Stein was now in possession of a repertoire of languages, knowledge, skills and field experience for his future career as an adventurous archaeologist, the likes of which Asia had never seen. Yet all along he held a variety of official posts – educational, bureaucratic and finally cultural – within organs of provincial Indian government that were open to occupation by non-British subjects. From these positions he secured the support of government, and

Aurel Stein portrait, c. 1900 aged 35 (WL).

the establishment, as well as funding, for his adventures. He made three expeditions totalling 40,000 km across Chinese Turkestan between 1900 and 1915, travelling without any European companions, and always with one dog, or another, always called Dash. En route he carried out topographical surveys, took detailed and voluminous notes, made hundreds of discoveries and collected in excess of 100,000 artefacts and antiquities. He documented his experiences in China with four major publications: *Sand Buried Ruins of Ancient Khotan* (London, 1903), *Ruins of Desert Cathay* (London, 1912) and *Serindia* (Oxford, 1921) and *Innermost Asia* (Oxford, 1928).

Accolades and Accusations

In Great Britain Stein's work brought him acceptance, and accolades galore. He became a British subject in 1904, was knighted in 1912, awarded the coveted Founder's Gold Medal by the Royal Geographical Society, as well as honorary degrees from Oxford and Cambridge universities. But in 1931 his fourth Chinese expedition proved to be his final one in the empire now turned republic. It was foiled by the authorities: Stein was banned from further digging at Khotan (Hetian), and his finds from other sites were confiscated at Kashgar. He was branded an imperial thief who on earlier expeditions had robbed China of countless and irreplaceable antiquities, particularly manuscripts from Dunhuang. Time alone has failed to heal the wounds. China's repeated requests to the British Museum to return the 'Stein Collection' have been refused.

Stein's remarkable yet controversial career was poignantly described by two contemporaries. Owen Lattimore (1900–1989), the British historian and traveller dubbed him 'the most prodigious combination of scholar, archaeologist, explorer and geographer of his generation'. Sir Leonard Woolley (1880–1960), the British archaeologist who excavated royal tombs at Ur in ancient Mesopotamia (today's Iraq), summarized his activities as 'the most daring and adventurous raids that any archaeologist has attempted'.

While Stein undoubtedly 'raided' the Caves of The Thousand Buddhas at Dunhuang, removing huge quantities of early paper and silk manuscripts from the 'library cave', his contribution to Great Wall Studies is much less contentious: he was the first to locate, identify, excavate, survey and photograph fortifications comprising the western end of the Han Wall.

Stein's investigation of the 'Tun–huang limes', as he termed the frontier fortifications, took place in spring 1907 and 1914. Like many of his discoveries, this was entirely accidental, and like so many of his achievements, it was enormous, because he was the first scholar on the scene.

It was in late February of that year as Stein was travelling between Miran (Milan), a half-buried ancient city on the southern Silk Road, eastward across the gobi to the oasis and Buddhist sanctuary of Dunhuang, that he stumbled across the 'ancient frontier'. He made a precursory investigation before pushing on for the oasis to re-supply with provisions, rest and purchase fresh animals, and hire extra labourers to carry out excavations. The caretaker of the caves, Abbot Wang, was making a tour away from Dunhuang to collect donations; hence Stein's initial stay in the town was brief. He returned swiftly to the Han Wall.

From early March to early May 1907, by which time conditions out in the gobi had become intolerably hot, Stein surveyed 100 kilometres of the fortifications. He located and identified the Jade Gate and Hecang Granary, excavated dozens of watchtowers, finding hundreds of daily-use articles and painted wooden slips, and photographed many of the fortifications from various angles. In 1914 he made second investigation of the fortifications. American archaeologist and Harvard professor Langdon Warner (1881–1955) described Stein's effort as 'one of the most dramatic discoveries of our time, and one that has had the most far-reaching effect on elucidating the early history of China and Central Asia'.

Stein's field map showing fortifications in the vicinity of the Jade Gate Pass, drawn 18 April 1907 (Bodleian Library, Oxford). The locations of the seven attached photographs were successfully located and rephotographed.

Bare detritus

Black ridge of rock (?)

Gravel Sai

Scrub

Scrub

dead tamarisks

XV

XVI

Sai

Scrub

Salt crusted marsh

Scrub

XV.a

Scrub

XIV

Kumush

Scrub

XIII

Ferule

Sai

Sai with scanty scrub

Sai

Springs

The British Consulate General, known as Chini–Bagh (China Garden), in Kashgar, photographed by Lady Catherine, wife of Consul George Macartney. Stein was a house guest of the Macartneys on numerous occasions from 1900, though he always camped in their garden, where he developed his photographs. Chini-Bagh is now a hotel and the old consulate remains at the back of the compound (WL).

Investigation of the Han Wall was perhaps one of the highlights of Stein's exploring life. 'I feel at times as I ride along this wall to inspect new towers as if I were going to inspect posts still held by the living', he wrote excitedly to an English friend, 'Two thousand years seems so brief a time when the sweepings from soldiers' huts still lie practically on the surface in front of the door'.

Utilizing seven of Stein's photographs, rephotography with a time lag of exactly one century in between has provided a fascinating insight into recent changes on and around the Han Wall. This evidence is complemented with extracts from Stein's *Ruins of Desert Cathay*.

Tower T. IX / 20 *Li Da Dun*

Stein first saw the tower he designated T. IX on his way from Miran to Dunhuang. Returning to it he was surprised to find the footprints he had left a month before looking 'absolutely fresh'. He describes the tower's preservation and structure:

'It is clear in spite of all the force of the winds, erosion, the greatest foe of ancient remains in practically rainless regions, could not exert its destructive power on the flat surface of such ground and on what was buried beneath it.

I thus ceased to wonder at the remarkable state of preservation which the first two towers on this section of wall line presented. Up to thirty feet or so they still rose, built solid on a base of over twenty feet square and tapering towards their top. They had once borne a conning room or platform protected by a parapet, but the brickwork of the parapet had fallen, and the heavy timber of Toghrak[1] which had been inserted to strengthen the top now lay bare. It was impossible to climb up, for these towers appear to have had no stairs, and the ladders and ropes which had once given access, had of course, disappeared. On the east face of one of the towers I could still make out the holes in the brickwork which probably served as footholds. There were no remains of quarters or refuse indicating occupation near either of them. In order probably to command the ground better these towers had been built on the very edge of tongues of the gravel-covered plateau, and little ravines had formed around them'.

With directions provided by archaeologist Yue Banghu, of the Gansu Provincial Archaeological Research Institute in Lanzhou who surveyed the Yumenguan area in the early 1980s, it was possible to drive by Jeep directly to this tower, known locally as '20 *li da dun*', or the 20 *li* large platform, which indeed lies about 20 *li* (10 km) west of Yumenguan and within the boundary of the Xilu Nature Preservation Area. Access is restricted, and it is estimated that fewer than 200 persons per year, mainly ecologists and archaeologists, might be permitted to approach this tower, one factor explaining its fine state of preservation.

Stein would have been amazed to revisit this tower in autumn of 2006, some 100 years on. Of all the locations rephotographed in the course of this study, no part of the Wall showed fewer changes than this tower, a fact made even more remarkable given its age: approximately 2,116 years. Close up inspection found it to be constructed from large sun-baked bricks. The exterior was covered with a thick layer of mud. Part of this coating is still visible, mainly on the left face of the structure.

[1] Stein uses the Uighur name, learned from his native helpers hired in Xinjiang, for *huyang*, the hardwood from the diversiform-leaved poplar (see page 60).

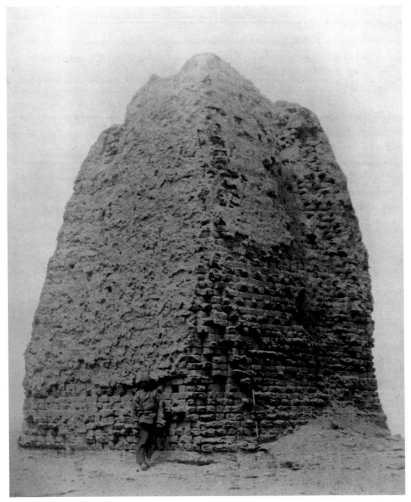

Tower T. IX: Stein, 1907 (WL).

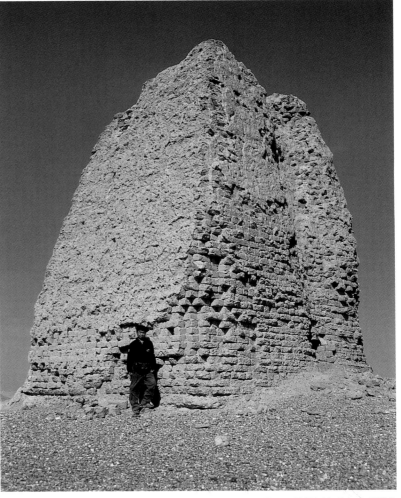

Tower T. IX, Lindesay, 2006.

'Ancient Border Wall East of Tower T. XIII' (two views)

'I decided to follow the line of wall and towers as far as I could to the east. The remnants of the wall cropped out higher and higher as we descended over steep gravel slopes. For over a mile here the extant portion of the wall was continuous, and showed a height of five to six feet above ground. Its base seemed to be buried for several feet more under drift sand which the winds had heaped up against it.

The peculiar method of construction could be examined with ease, and not even scraping was needed. Except for the horizontal fascine revetting which wind erosion had removed in most places, the alternate layers of stamped earth and reed bundles were here in perfect preservation. The former, about seven inches in thickness, showed much cohesion in spite of the coarse material full of gravel and small stones. The reed bundles, about the same thickness, were strongly tied, and with their neatly cut stacks and careful rows resembled rows of fascines. The average thickness of the wall was between eight and nine feet'.

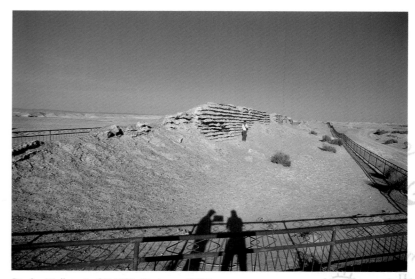

Border Wall east of T. XIII: Lindesay, 2006.

The two originals provide views of the same section of the Wall at Maquanwan from opposite directions. The horizons of *luwei*, or reed stalks, give the Wall here its unique thatched horizon appearance, and they are more than 10 courses in height at its best preserved parts. The view looking west also contains an adjoining watchtower, designated T. XIII by Stein. The same man is present in both pictures. Wearing a turban, it can be seen he is of Indian origin, the Ghurkha Ram Singh, from the Survey of India, who assisted Stein with cartography.

As with all the revisited sites around Yumenguan, changes identified by rephotography are minimal. In the view looking east, part of the Wall to the left of Singh – from ground level upwards to about the sixth horizon of *luwei* – is damaged a little more. In the photograph looking west (which includes the watchtower) , the top layer of *luwei* reed stalks directly above Singh's head appears a little more damaged after a century's aging in the new photograph. As a splendidly preserved section of 2,100 year-old Han Dynasty Great Wall, the section is fenced off for continued protection.

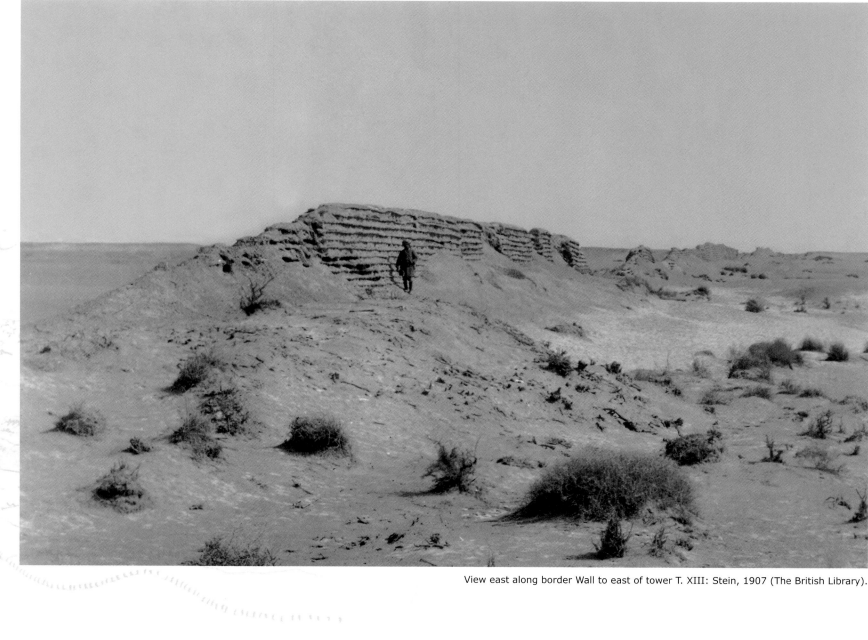

View east along border Wall to east of tower T. XIII: Stein, 1907 (The British Library).

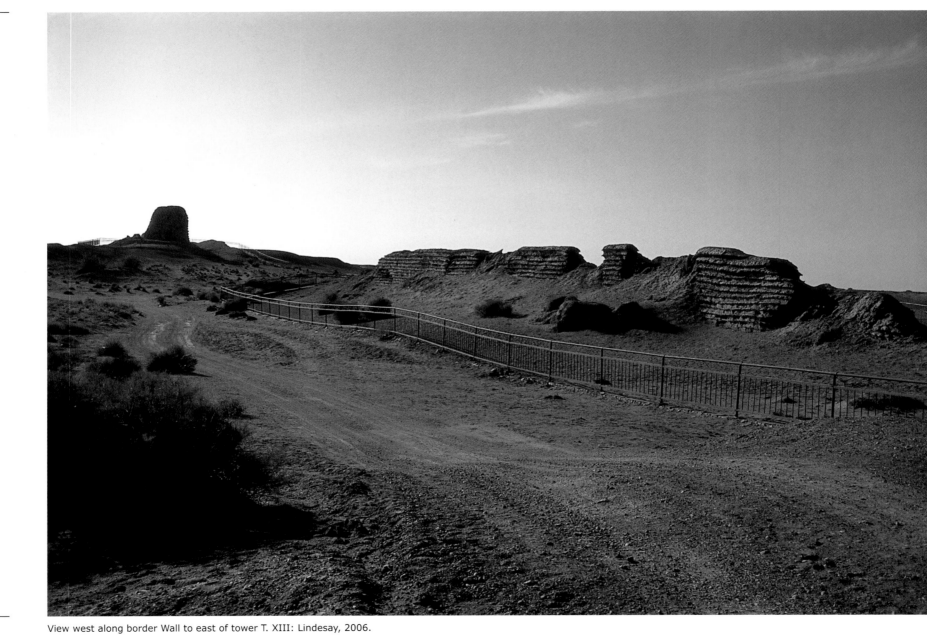

View west along border Wall to east of tower T. XIII: Lindesay, 2006.

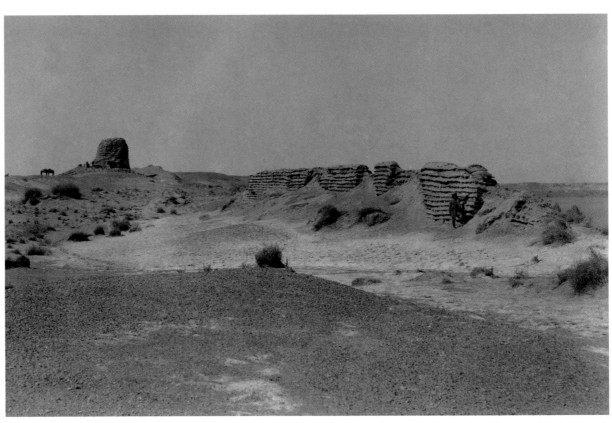

View west along border Wall to east of tower T. XIII: Stein, 1907 (The British Library).

'Fascines Stacked for Use'

'At a number of watch stations examined on my first reconnaissance I had noticed a series of queer little mounds…closer examination revealed that these small structures, each about seven or eight feet square and up to seven feet in height, were built up entirely of reed fascines, laid crosswise in alternate layers. Intermixed with them was a light sprinkling of coarse sand and gravel, but whether this was done on purpose, or merely the result of the layers having caught and retained the sand and small pebbles driven against them by exceptional gales, it was difficult to determine.

I then remembered that the dimensions of the neatly laid bundles, whether of reeds or branches, corresponded exactly to those of the fascines used in building the wall, and it dawned on me that these queer little mounds were nothing but stacks of identical fascines kept ready at the posts for any urgent repairs in the wall. Thus breaches made in it could be quickly closed without having to carry the required materials over a considerable distance. But it still remained to explain why some of the stacks at different posts were found reduced by fire to calcined fragments. The most plausible explanation did not suggest itself until M. Chauvannes' translations[1] showed me how frequent are the references to fire signals in the records from watch stations. No doubt such signals would ordinarily be lit on the top of the tower. But when time was pressing, or perhaps when a big fire was needed to penetrate a murky night, it would be simpler to set a whole stack on fire'.

[1]Although a fine linguist, Stein could not understand Chinese. Translations of painted inscriptions on wooden slips were produced for him by Monsieur Edouard Chauvannes in London.

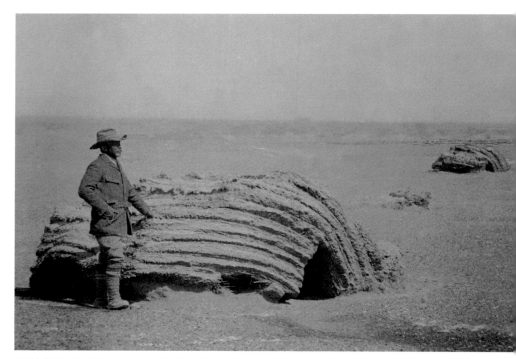

Aurel Stein standing beside a fascine of *luwei* prepared for signalling: Stein, 1907 (The British Library).

According to archaeologist Yue Banghu, the fascines of *luwei* were stacked for use only as bonfire signals, and not to repair breaches in the nearby Wall. Any sand and gravel within the structure was wind blown.

Revisiting found the fascines just 150 metres south of the Wall. A total of five remain at this site, and all are now fenced off.

William Lindesay standing beside a fascine of *luwei* prepared for signalling: Lindesay, 2006.

T. XIV: The Jade Gate (two views)

'At the end of close on ten miles we came upon a small ruined fort of massive appearance. Its walls, built of remarkably hard and well laid strata of tamped clay, each about three inches thick, rose in very fair proportion to a height of nearly thirty feet. Fully fifteen feet thick at the base, they formed a solid square about ninety feet on each side. What splendid shelter they might give, not against human attack alone, but also against those cutting east winds, the very home of which we now seem to approach. There was no trace of early quarters inside, and only scanty refuse from recent occupation by wayfarers. And yet, as I climbed to the top of a rough staircase spared from the massive walls in a corner, and looked around over all this desolation, I felt sure that I stood on a structure which had braved man and nature for many centuries past.

The view enjoyed from the top was wide and impressive. To the northeast four towers lit up by the sun behind us could be made out echeloned in the distance, silent guardians of a wall line which I could recognize here and there in faint streaks of brown shown up by my glasses. What a fine position, I thought, this height of the fort wall must have been for a commandant to survey his line of watch stations, and look out for the signals they might send along it! But how long ago was that? Those sombre, barren hills of the Kuruk-tagh[1], now standing out clearly on the northern horizon, had seen the wall and towers first rise, and would see their ruins finally disappear before the blasts of the ages'.

[1] Stein uses the Uighur name of Kuruk-tagh, learned from his native helpers hired in Xinjiang, for the Hei Shan, or Black Mountains.

When Stein returned to T. XIV, several weeks after his initial visit described above, he set about mounting a systematic search of the area in his usual methodical way. At the foot of a hillock, about 90 metres north of the fort, his diggers unearthed grey pottery shards and *hanjian*, or painted wooden slips, which proved to date from 48–45 B.C. Stein wrote:

'The documents seemed to have been addressed to some superior officer. The presumption was that we had struck the site of some sectional headquarters for this part of the Limes. It received support when I learned that at least one of the records certainly emanated from the general officer commanding at Tun-huang, while several others contained reports or orders to superior officers holding charge of "The barrier of Yu-men" '.

Stein had located the Jade Gate.

Revisiting was straightforward: the site is located 90 km west of Dunhuang. The two views rephotographed show the north and west faces of the gate, also known as *xiao fang pan*, or 'little square tray fortress'.

The original north face perspective was taken early in the morning: Stein indicated in *Ruins of Desert Cathay* that he set up camp nearby, but not within the gate's large enclosure as it was infested with troublesome insects. The northern entrance is seen bricked up, probably by herders who used the enclosure for penning their goats, the droppings of which attracted the insects. As usual for Stein, he once again included people to add scale to his photographs. The east (left) face shows a pillar of rammed earth standing at the far corner. According to Yue Banghu, the Lanzhou-based archaeologist, this had collapsed when he surveyed the gate in 1982.

Revisiting shows reconstruction of the eastern half of the gate, to the

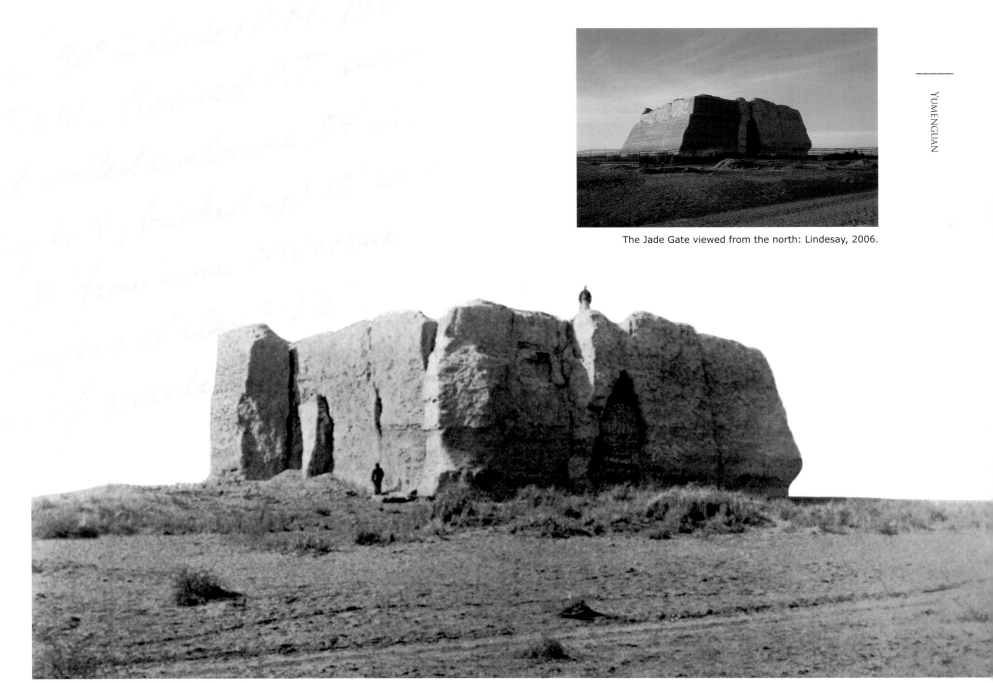

The Jade Gate viewed from the north: Lindesay, 2006.

The Jade Gate viewed from the north: Stein, 1907 (WL).

immediate left of the now-open entrance.

The original west and south face perspective shows four of Stein's men with their horses at the entrance of the fortress. It is likely that the horses were tethered inside overnight. The tiny object at the right-hand corner is Dash the Great, a fox terrier in the long and famous series of seven dogs that accompanied Stein on his explorations. Acquired as a puppy in 1904, Dash's fame widened after publication of a news column on the 'Explorer Dog' in the *Daily Mail* praising him as Stein's best friend who had trekked 10,000 miles around the Taklamakan. The reporter noted however that 'taking into account his canine habits of progression' Dash the Great may have clocked up 20,000 miles, and only resorted to riding pony back for short distances at times of 'great heat'. The dog lived to the ripe old age of 14 before being run down by a bus in Oxford in 1918 where Stein stayed for some months while liaising with Clarendon, his publisher for *Serindia*, the book in which this image (west face) was eventually published.

Revisiting shows little or no apparent change. The traveller looking over the fence in this new photo had come from Beijing. He took interest in the old photograph, acknowledged Stein's positive contribution of leaving photos worthy of study, and noted everyone had long since gone.

The entire structure is now enclosed by a high metal fence.

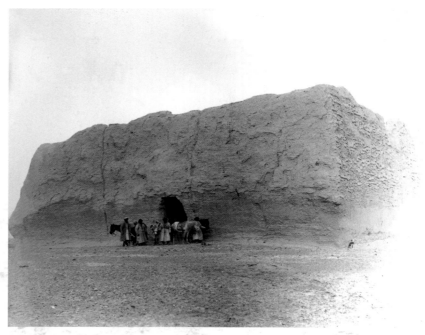

The Jade Gate viewed from the west: Stein, 1907 (The British Library).

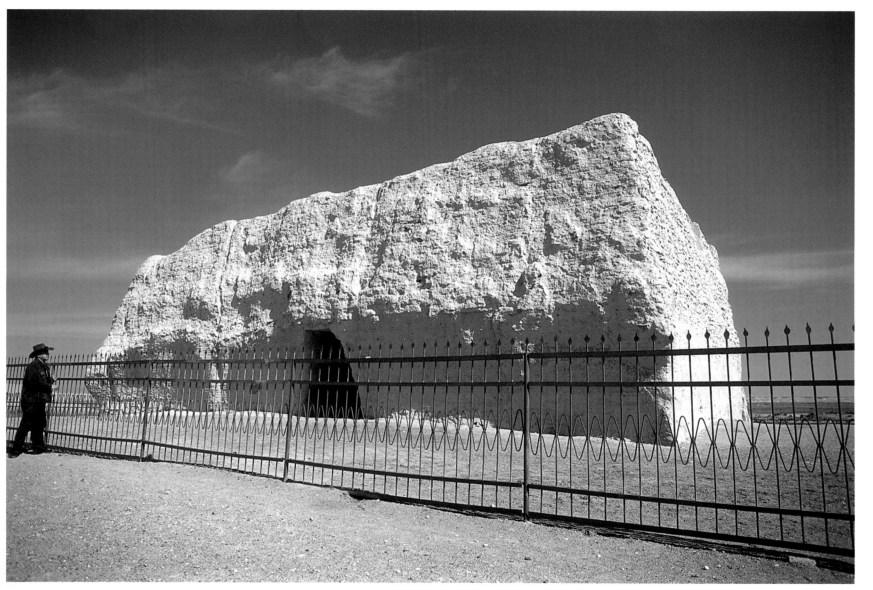

The Jade Gate viewed from the west: Lindesay, 2006.

'A Ruin of Palace-Like Dimensions' (Hecang Granary)

'On the following morning[1] I moved camp to a large ruin, some five miles eastward, which when we had first passed on our journey to Tun-huang, had struck me with its palace-like dimensions. But the familiarity I had gained with its general plan and arrangement of the Limes nor the close survey I now made of the imposing ruin could at first give me any clue to its true character and purpose.

The building with its enclosing walls presented the imposing length of over 550 feet, at first sight suggested a barrack or Ya-men, yet the very proportions were enough to dispel such a notion. It consisted of mainly three big halls, each 139 feet long and 48.5 feet wide, which adjoined lengthways and formed a continuous block facing due south'.

[1] 26 April 1907.

On further investigation Stein found that the large halls lacked windows, a characteristic that further puzzled him. Once again, as they had done at the Jade Gate, painted wooden slips provided clues as to the mysterious building's purpose. This time two references to a granary were found, as well as dates corresponding to 52 B.C. Stein theorized:

'… this strange big building may have been erected for the purpose of serving as a supply-store to the troops stationed or moving along the wall. The structural peculiarities above noted; the small opening for ventilation, the size of the halls quite unsuitable for habitation; the choice of the building site conveniently accessible yet well raised above the adjoining ground (lake and salt marsh to the immediate north); the arrangements for guarding the building, not against hostile attack, but against theft, all found thus their simple explanation'.

The Hecang Granary, also known as *da fang pan*, or the 'large square tray fortress', lies close to the line of Great Wall fortifications on the south side of the seasonal Shule River to the east of Yumenguan. As Stein worked it out, the building functioned as a storehouse for grain to sustain both the army as well as merchants passing along the trading route of the Silk Road, which ran in the lee of the fortifications.

The main structure is approximately 132 metres in length, 17 metres width at its maximum and best preserved to a height of almost seven metres. Good ventilation to prevent the rotting of stored grain was achieved by building the granary in an elevated position and south of the river and adjoining salt marshes, a location that benefits from breezes. Large openings were made in the walls of the three halls to facilitate ventilation.

Archaeologists working at the site in 1943 discovered a tablet bearing the date of the 11th year of the Western Jin Period, suggesting that the granary was still in use c. 370 years after its construction. Barley and millet were also found.

Revisiting found the granary to be virtually unchanged over the last century. The site is now fenced off.

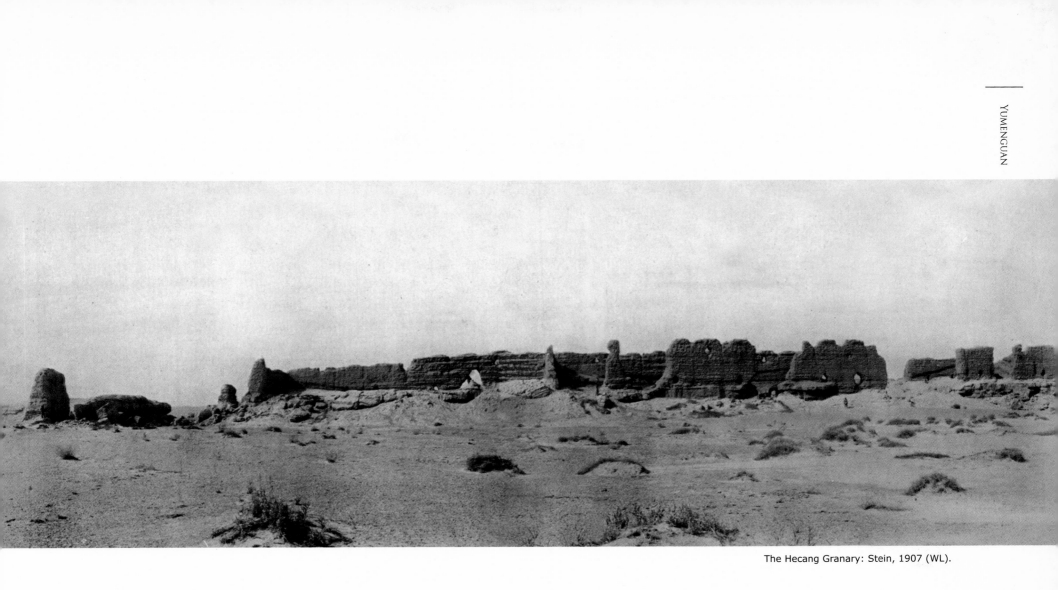

The Hecang Granary: Stein, 1907 (WL).

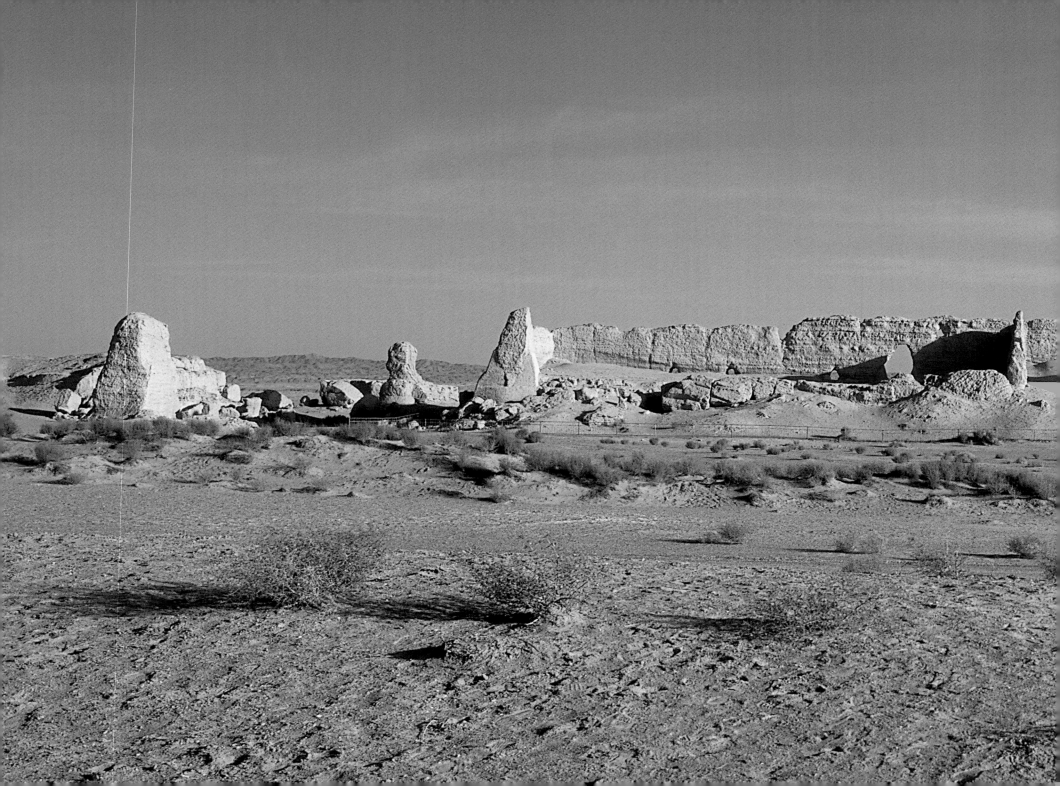

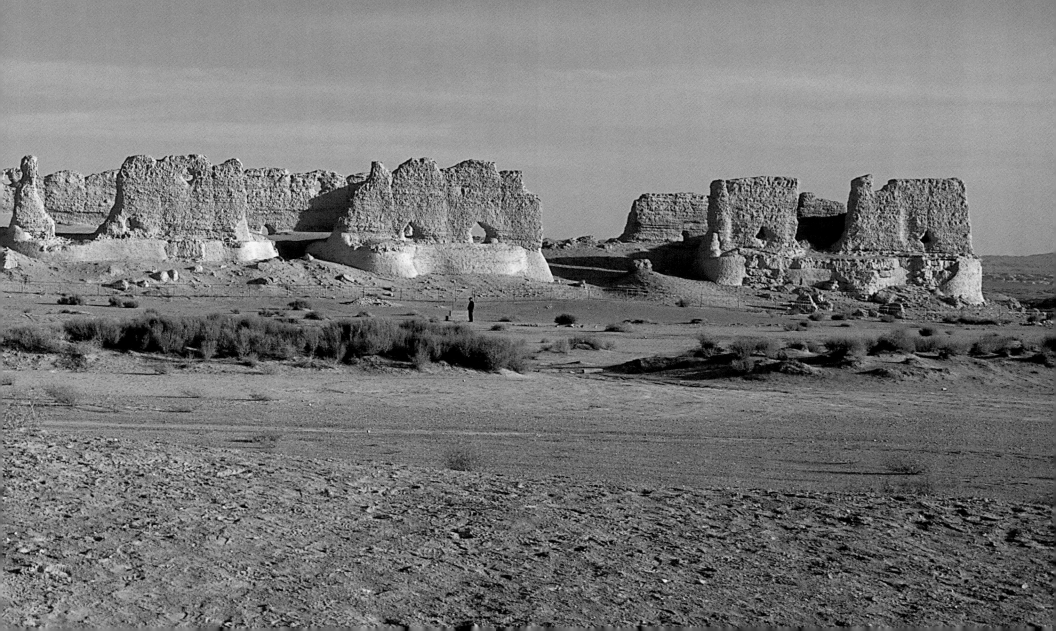

The Hecang Granary: Lindesay, 2006.

JIAYUGUAN

Jiayuguan

- Taolai River
- Di Yi Dun
- Open Wall
- Wall & Fortress
- Rouyuan Tower
- Martial Barrier Stele
- East Dam Gate (inside)
- East Dam Gate (outside)
- Shandan Changchengkou

Aerial view of Jiayuguan showing the 'Open Wall' crossing the desert between the fortress and Qilian Mountains (Wang Jin).

Fortifications revisited at Jiayuguan in northwestern Gansu Province mark the undisputed position of the western terminus of the Ming Dynasty (1368–1644) Great Wall.

The Ming Wall, the most recent of China's Great Wall defence systems, evolved to be approximately 6,700 km in length, and featured along its vast swathe from desert to sea a number of locations that in topographical terms presented themselves as favourable invasion routes for large cavalry armies. To counter threats at these highly vulnerable points, known as *guankou*, or strategic passes, priority was given to the construction of impregnable fortifications (see also Juyongguan, Gubeikou and Shanhaiguan on pages 168, 224, 250 respectively).

Jiayuguan was chosen for the placement of defences as it presents one of the narrowest places in the 1000-kilometre-long Hexi corridor. Just 15 km in width from north to south at this point, the terrain describes a bottleneck, providing natural assistance to any man-made fortifications. Essentially, the layout presented any would-be attacker with just two choices: to face formidably-designed and well-manned defences, or seek a way around them, across terrain that was virtually impossible to advance across.

To the north are the Hei Shan, or Black Mountains, part of the Mazhong range, and to the south are foothills which rise rapidly to become the snow-covered peaks of Qilian Shan. Also contained in this narrow strip of gobi desert are two other relief features playing key roles in the defence system: one, an elevated area chosen for construction of the fortress, and two, a deep canyon, the Qilian Gorge, bounded by cliffs on both sides, running parallel to the foot of the southern hills, selected as the end point of the Wall.

The fortress, with an external perimeter of one thousand metres, stands on the crown of the plateau, with the so-called 'Hidden Wall' to its north and 'Open Wall' (visible) to its south. Its pedestalled position, high crenellated walls and three tall gate towers announced to all those approaching from afar that the magnificent empire of China lay ahead – or would soon be behind them.

In the 1920s, English missionary Mildred Cable (1878–1952) neared the fortress from the east, recording the drama of her approach thus:

'The cart bumped mercilessly over the loose stones of the dismal plain, and each slow mile brought the outline of the fort into clear relief. It was an impressive structure. To the north of the central arch was a turreted watchtower, and from it the long line of the Wall dipped into a valley, climbed a hill and vanished over the summit.

The massive monument now towered overhead, and impressive though it was in its own dignity, it made a yet further appeal to the imagination, for this was Kiayukuan, the Barrier to the Pleasant Valley, the barrier which marks the western end of that amazing and absurd structure known as the Great Wall of China ….The length of the Wall, which outlined the crest of the hill to the north, would continue irrespective of difficulties caused by mountains or valleys, rivers and deserts, until it reached the sea 1,400 miles away'.

'The Gobi Desert' (London, 1942)

Aurel Stein was probably the first person to photograph Jiayuguan. In 1907 he spent two days inspecting the fortifications and three of the photographs he produced were rephotographed. However, the majority of old pictures of Jiayuguan rephotographed came from the portfolio of William Geil, taken in 1908 as the American concluded his five-month long investigation of the Wall.

Images from these earliest explorers of the Great Wall show not only the changes that have taken place at Jiayuguan, but also highlight some of the Great Wall's varied architectural components: the finest example of a fortress, high gate towers, watchtowers and very rare views of rammed-earth Wall.

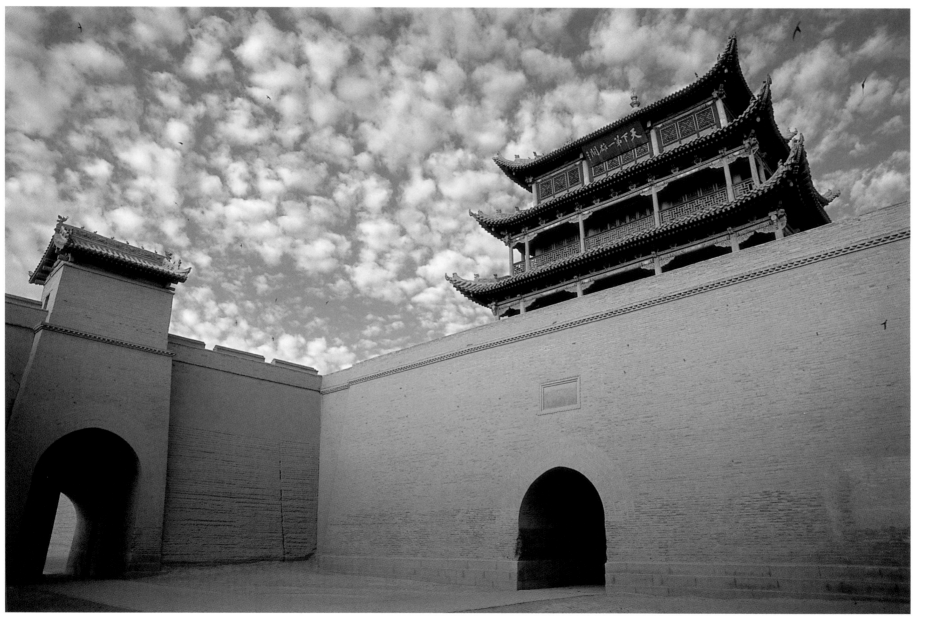

The Guanghua Tower, the easternmost gate tower of the Jiayuguan Fortress, viewed from the *wengcheng* enclosure.

William Edgar Geil: The First Wall Explorer

During the opening years of the 20th century the world could see from maps that the Great Wall crossed a vast swathe of northern China, for more than 21 degrees of longitude, but curiously they had only been shown photographs of the structure in the mountains just a stone's throw north of the capital, Peking.

The first man attempting to find out what the Great Wall looked like beyond Peking, to both west and east, was the American missionary explorer William Edgar Geil (1865–1925). With a curiosity apparently aroused by the presence of the Great Wall on maps, Geil summed up the lack of knowledge about the structure – and the impetus behind his five month long journey – with a poignant and humorous opening to his book *The Great Wall of China* (New York, 1909):

'There is a Great Wall of China. So much the geographies tell everybody; but they do not make it clear whether it is built of china, or why it is, or how long it is, or how long it has been'.

Geil hailed from Doylestown in Buck's County, Pennsylvania, and travelled to China early in 1908 to explore the Great Wall. Over a period of approximately five months between May and September he followed fortifications of mainly Ming Dynasty age between Shanhaiguan on the Yellow Sea coast westward to Jiayuguan in the gobi desert.

Portrait of William Edgar Geil, signed on reverse, c. 1910, aged 45 years (WL).

Magic lantern slide of William Geil's, bequeathed to Luther Newton Hayes in 1925: thought to have been coloured by an artist in Shanghai (Hayes Family Estate).

Calligraphy of stele from Jiayuguan.

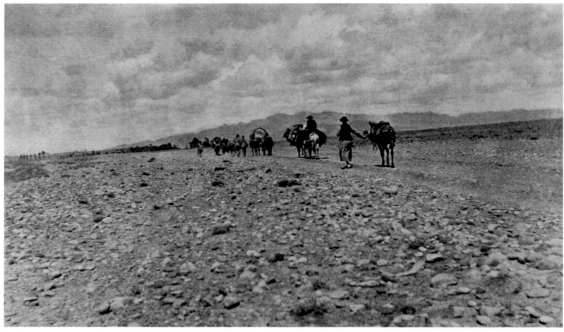

Geil's caravan crossing gobi desert in the Hexi corridor of Gansu Province (WL).

Taking a steamer across the Pacific from San Francisco, Geil, though a seasoned traveller, could not conceal his sense of excitement at the prospect that lay ahead:

'A journey along the Great Wall! We had longed to make it, and now almost feverishly eager, we had arrived at the City of the Golden Gate …. Whether the ship cut the brine in mid-ocean or rested in the peaceful bosom of fair Hawaii … it made no difference, there was the 1,200 miles of Wall, instinct with life, always present in our brain. We could not rid ourselves of it. Thoughts of self, of the presidential election, the Balkan volcano muttering and smoking, or even the peaceful meadow brooks of Doylestown, Pennsylvania, were sternly debarred. We ate with the Wall, slept with the Wall, thought Wall ….'

Prior to 1908 Geil had voyaged down the Yangzi River by steamer, and after his Wall journey he returned to China to visit all 18 of its ancient imperial capitals, as well as the five sacred Buddhist mountains. Yet his greatest fame was secured for becoming the first explorer of the Great Wall. He not only completed a full-

In the Taihang Mountains, Hebei (WL).

Calligraphy of stele from Shanhaiguan.

length traverse of its principal remains, but produced the first book dedicated to the subject, published in New York and London in 1909. This milestone work revealed for the first time in words, and more dramatically through its many quality photographs, the varied architectural elements which comprise the Great Wall, its different morphologies as well as the diversity of its host landscapes. Many of the photographs he published have been rephotographed as part of this project to revisit the Great Wall, and it was the kind presentation of his book that prompted my realization that rephotography could be used as a powerful conservation-awareness tool (see pages 246, 278).

In the wake of his success Geil embarked on a transatlantic lecture tour, showing viewers large-as-life images of the Great Wall by use of a magic lantern slide projector. The tall, handsome man filled auditoriums with his eloquent storytelling and first-hand historical knowledge, delivered with the volume expected from a preacher, and a welcome smattering of humour to boot.

Despite his achievements and popularity, Geil was soon forgotten after his death in 1925, in dramatic contrast for example to Aurel Stein. Perhaps the reason was that Stein, a fanatical collector, filled museums with the spoils of his explorations, while Geil was quite the opposite. Not a collector, but a disseminator of his Christian belief, Geil took nothing from the Great Wall except photographs and rubbings of inscribed tablets. Museums in the United States are devoid of reference to his exploration, and institutions in Doylestown, his birthplace and residential home until his death in 1925, have little or no knowledge of him, let alone commemorate his place in history as the greatest early pioneer of the Great Wall of China.

Details concerning Geil's journey – his itinerary, daily progress, arrival dates – were not included in his book, while primary sources of information, such as diaries, manuscripts, rubbings, negatives, prints and glass slides, that one expects would have been carefully preserved, either by relatives or close friends, remain elusive.

One can deduce that he made numerous detours during his traverse of the Wall to visit missionary residents. He certainly cultivated a friendship with W.A.P. Martin, the missionary and historian living in Peking's Western Hills. And it can be derived that he was accompanied for several weeks during the early part of his journey along the Wall by Luther Newton Hayes (1883–1978), the son of American missionaries (see page 218).

Concerning his photography, Geil makes no mention of the subject in his book, which contains many professionally composed, exposed and reproduced images. His biographer, Phillip Whitwell Wilson, who in 1927 published *An Explorer of Changing Horizons*, uses understatement masterfully by telling us that 'seldom are Dr. Geil's prints out of focus'. Elsewhere we learn that Geil married Constance Emerson relatively late in life, and the couple made their home at 'The Barrens', a large house in Doylestown.

Wilson described their home, with William's study crowded with books and curios from his travels. Outside, we are told, there stood two large bas reliefs bearing two columns of Chinese characters, bold and challenging. They were facsimile copies of the two steles standing at the eastern and western ends of the Wall, from Jiayuguan and Shanhaiguan respectively, and recorded by rubbings made on the spot by Geil. The original steles are still there, far away from one another, one facing the sand-laden winds blowing across the northwestern gobi, the other facing the sea spray off the Yellow Sea.

Embarking on his Great Wall odyssey Geil had written:

'Our unshaken determination was to do the work thoroughly…so complete that the future historian of the Wall would find little to write about unless he pirated our notes'.

Through the fine focus of his lenses, Geil certainly provided the world with a privileged view of the Great Wall across the whole of China. A century after his efforts, the same photographs preserve a more precious view, at a time when the Great Wall crossed more of China.

The Jiayuguan Fortress, August 1908 by Geil, preserved as a magic lantern glass slide (Hayes Family Estate).

Taolai River in Qilian Gorge

The very western terminus of the Ming Wall is marked by a watchtower known as *Di Yi Dun* (The First Platform), seen as an earthen mound at top left on the skyline in both photographs. It is perched on the edge of a precipice, 82 metres below which flows the Taolai River, fed by melt-waters from the snow-capped Qilian Shan. On the floor of the canyon, the torrent continues to cut its course, with the full force of its flow at this curve undermining the cliff immediately below the beacon platform.

Photographed originally in August 1908 by William Geil, revisiting shows engineering efforts made in 1999 to protect the tower by the construction of a breakwater to halt the river's undercutting of the cliff.

In 1998, Guo Yingming, a visiting Hong Kong resident feared that if he was to return in the future he might discover the beacon tower to have slumped away due to the continual river erosion at the cliff base. He donated RMB 500,000 yuan (US$ 62,500) to help fund the construction of a breakwater, a sum supplemented by RMB 200,000 yuan (US$ 25,000) in local government investment.

The first platform (top left) viewed from the gorge: Geil, 1908 (WL).

"The river, once an ally, eventually threatened to undercut the cliff and topple the tower," said Li Xiaofeng, the official in charge of the site.

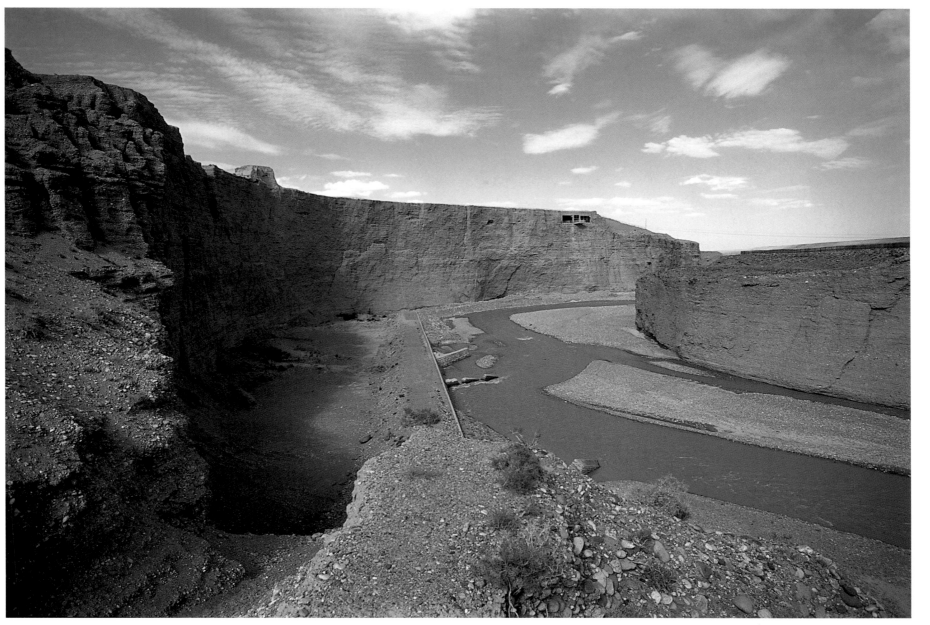

The first platform viewed from the gorge: Lindesay, 2005.

Di Yi Dun (The First Platform): 'The Real End of the Wall'

William Geil, present in the original August 1908 photograph, described the last few miles of his long journey along the Wall thus:

'We took mules and visited the real end of the Great Wall, which is not Kiayukwan itself, but a point fifteen li[1] southwest of it. During the journey thither no human crossed our path, and there was not a house in sight the whole way. Five antelopes were the principal sign of life. There was nothing to attract the eye beyond whirling spirals of sand and tufts of brown sage bush. The monotony would have been without relief but for the presence on the scene of the ruin whose end we were seeking – the ruin of the most stupendous achievement in Asia.

When at last we reached the actual termination of the Wall, a surprise lay in store for us. The construction does not abut the southern mountains, but stops short on a precipice sheer down two hundred feet, as perpendicular as if cut by engineers with a plumb line. Mr. Clark dropped a stone and his heart beat eight times before we heard it splash into the water below'.

[1] The li is a Chinese unit of distance and approximates to half a kilometre.

The first – or the final – outpost of the Wall provides commanding views in all directions: south across the gorge of the Taolai River into the Qilian range, across the gobi plain to the west, and along remnants of the Wall toward the Jiayuguan Fortress, seven kilometres north. It was built in 1539 under supervision of commander Li Han.

Revisiting shows the overall shape of the platform to be slightly more

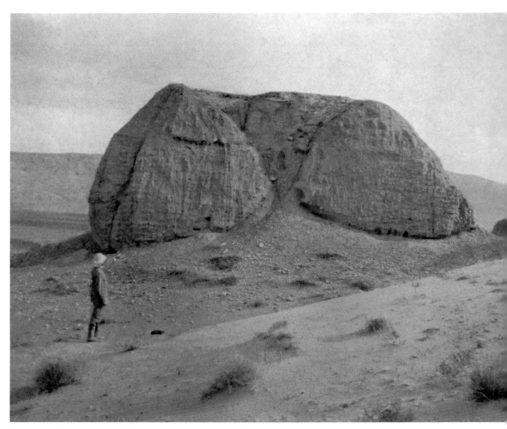

The First Platform viewed from the north: Geil, 1908 (WL).

weathered, while the important fortification has now been fenced off, for its own preservation, and to protect the increasing numbers of tourists from the 82-metre precipice.

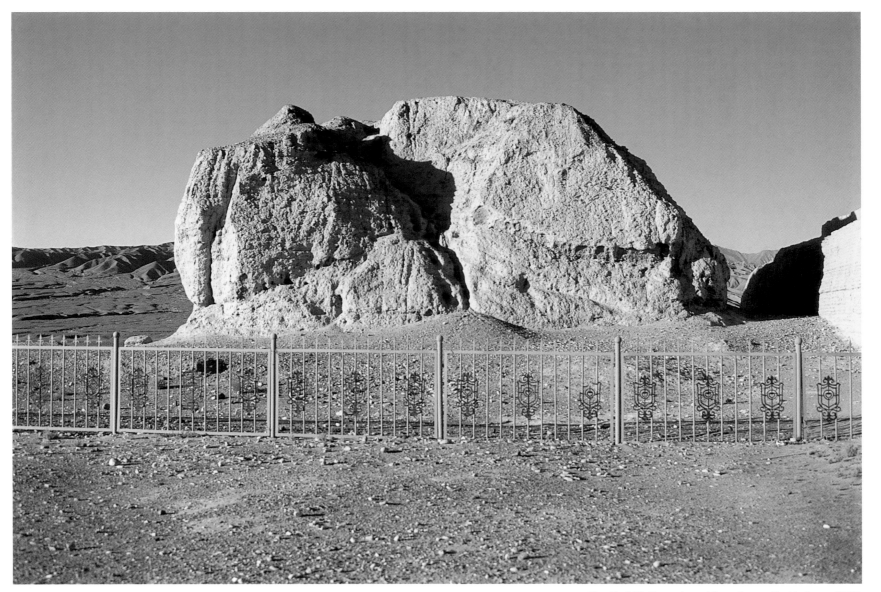

The First Platform viewed from the north: Lindesay, 2005.

Jiayuguan Fortress and the Wall

The original 1908 photograph by William Geil is the earliest preserved complete view of the fortress with adjoining 'Open Wall'. While the image contains little else apart from the Wall, fortress, horse and rider, Geil had recorded in words what he had seen beyond one of the gates.

'Alone we passed through the West gate of Kiayukwan, and alone we stood in desolation. As we looked west we saw no human habitation to modify the unhappy landscape. Boundless and bare, the lone and level sands stretched far away. My eyes beheld only sand and pebbles and gaunt poles, standing up like petrified principles, holding aloft a line of wire to carry to distant regions messages of peace and perhaps war'.

Revisiting shows a proliferation of what Geil called 'gaunt poles'. The fortress of today stands amidst a forest of industrial steles sending power to booming industries in the city of Jiayuguan.

Despite the Great Wall's UNESCO inscription in 1987 as a World Heritage, it is seen as a cultural heritage, not a cultural–natural heritage, and therefore its setting gains no theoretical protection from the listing. Apart from the intrinsic value of protecting the Wall in its natural setting, there are archaeological reasons: the land beside the Wall is where its builders sourced materials for its construction.

Jiayuguan Fortress: Geil, 1908 (WL).

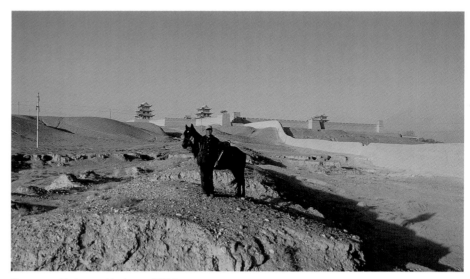

Jiayuguan Fortress: Lindesay, 2004.

The 'Open Wall', Jiayuguan

As Aurel Stein approached Jiayuguan from the west in July 1907 he had been struck by the clarity of 'a faint white line lit up by the setting sun, the long expected Great Wall', even though he was still 32 km and half a day's ride away.

The next day he neared the fortifications 'on a long and weary march', enduring 'a sun beating down, no wind stirring, heat and glare', yet the Wall remained largely hidden due to relief of the land, only re-emerging during the final furlong:

'From a distance of about two miles the many storied gate tower built in wood first became visible, then, as we got nearer, the clay wall which stretches away on either side of the square fort guarding the great gate. On the south it was visible for some seven miles to the foot of the protecting buttress of the Nan-Shan'.

The original photograph by Stein preserves those 'seven miles' (actually seven *kilometres* precisely), showing the Wall running unbroken, apart from its brief disappearance in a dip towards the foothills on the horizon.

Today, this 'tail-end of the Dragon' is a fractured milieu. Revisiting found it was found to be crossed above by 17 power lines, breached by one abandoned road and one major current road, as well as two minor roads, eight dirt tracks and two railway lines. Sand and gravel extraction, destroying the fragile gobi ecology, took place just metres away from the structure.

Indications of increased concern for the protection of the Wall and its environs were also evident. The West to East gas pipeline, stretching from the Tarim Basin in Xinjiang to Shanghai, was routed under the Wall in 2004, while the new G 312 expressway also passes under the structure.

Recording GPS data while waiting for good light.

The 'Open Wall' at Jiayuguan: Stein 1907 (The British Library).

The 'Open Wall' at Jiayuguan: Lindesay, 2006.

Jiayuguan Fortress and Rouyuan Gate Tower

The original photographs, taken in July 1907 by Aurel Stein, show a distant and view of the fortress' impressive gate towers and a close up of the middle one, the Rouyuan Tower, taken from the second storey of the Jiayuguan Tower (to its immediate left.)

Soon after taking the distant view photograph on 19 July, Stein was met by 'a picturesque band of soldiers and officers whom the commandant of the Chia-yu-kuan garrison had sent out'. They escorted his caravan through a short cut in the 'Open Wall' to 'a delightfully green expanse of tree-bordered meadows' lying to the southeast of the fortress. As was Stein's custom, he set about selecting a place to set up camp, but before he had the chance to pitch his tent he was approached by Shuang Ta-jen, 'Keeper of the Gate… an extremely pleasant old gentleman' whose Ya-men residence lay within the fortress itself.

The two men discussed the defences at Jiayuguan, by which time Stein wrote he had forgotten his 'longing for a tub and change'. He was then 'carried off without much further ado to the Ya-men of the cheery old major':

'The short walk through the gates and streets of Chia-yu-kuan was a treat for the eyes. The high walls of reddish clay kept in fair repair, with their loopholed battlements, took one straight back to the middle ages. No less than three big vaulted gates had we to pass through before we reached the little castrum that hides behind these circumvallations. The little town within the innermost wall looked sadly decayed…but the Ya-men of the commandant was still a comfortable abode'.

Prior to being served a 'neatly served repast' Stein was pleasantly surprised to be provided with a wash basin, hot water, towels and soap. Summing up the day he wrote: 'I could not have found a more cheering welcome at the Western Gate of the Middle Kingdom'.

Next morning Stein returned to the fortress interior. He took his photograph of the Rouyuan Tower at this time (see page 102).

'The sun had already risen before I was free to ascend the great tower[1] built over the west gate, whence a distant view could be gained. From the height of the second storey it was easy to follow the line of the much-decayed rampart and adjoining clay towers which stretched away across the vast plain'.

[1] The Jiayuguan Tower.

I revisited the second storey of the Jiayuguan Tower in 2004 with Wang Jin, who explained that in 1971, as 'literature served the revolution' he was assigned to teach the writing of poems, in the strangest of places: within the Jiayuguan Fortress. He lived on the site of the low buildings to the left centre of the 1907 photograph. Seeing the fortress from within every day changed his life. From this time he yearned to see the whole length of the Great Wall.

Eleven years later in 1982 he packed a few essentials into the basket of his bicycle and set out to ride from Shanhaiguan to Jiayuguan. Ever since, he's been documenting the Great Wall throughout the northwest with his camera, publishing many albums of fine art photographs and earning himself the nickname *Xibei Wang*, or 'Wang of the Northwest'. One of his images adorns

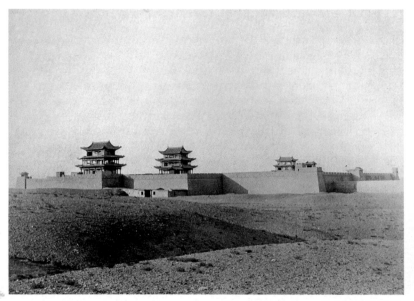

Jiayuguan Fortress: Stein, 1907 (WL).

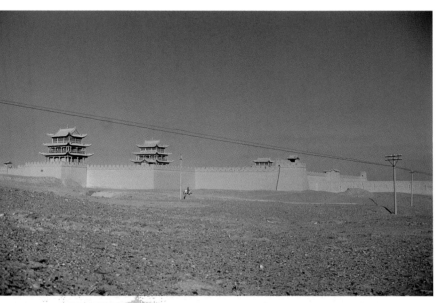

Jiayuguan Fortress: Lindesay, 2004.

the Gansu provincial meeting room in Beijing's Great Hall of the People.

Holding the old photograph, Wang said that the Jiayuguan Tower – where Stein stood in 1907 to take his photograph – was burned down in the 1930s by Muslim rebels. Looking out towards the encroaching city, he noted that smokestacks had changed the view, and hoped the nearest of them, at the cement works, might disappear if the scene was to be rephotographed in the next few years.

Wang Jin recalling old times in the Jiayuguan Fortress.

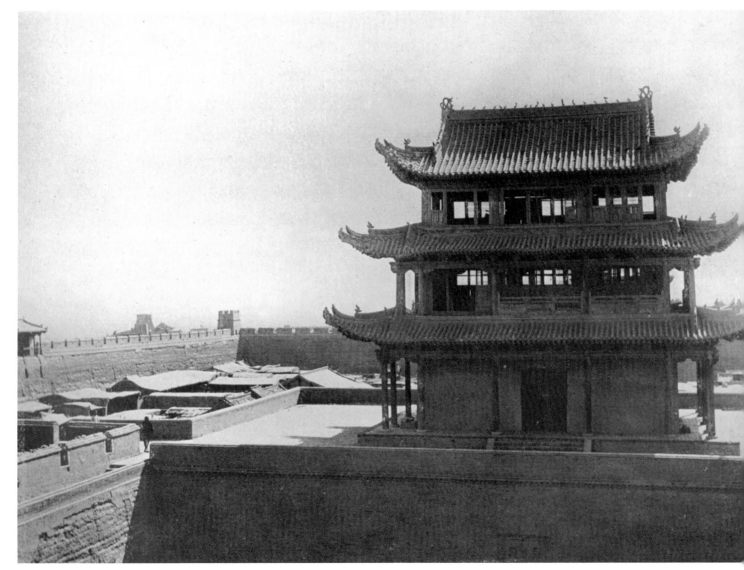

Rouyuan Tower: Stein, 1907 (WL).

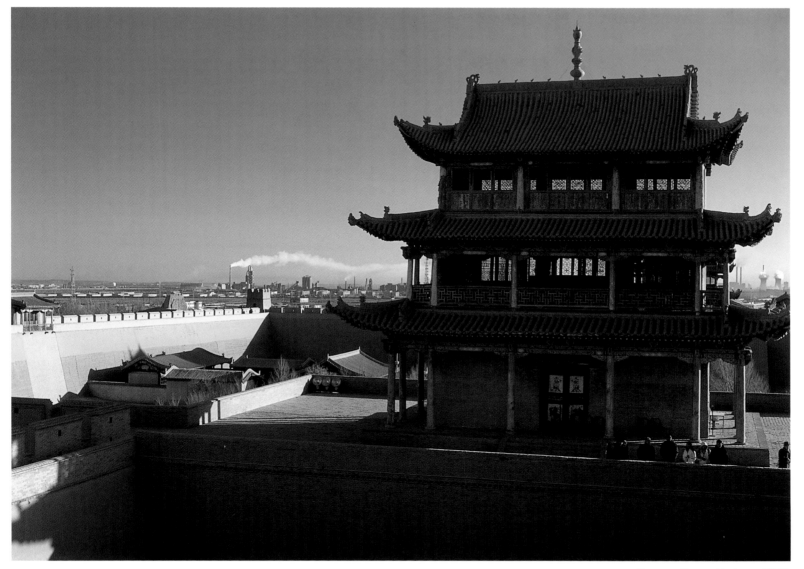

Rouyuan Tower: Lindesay, 2004.

Jiayuguan Gate Tower and the Martial Barrier Stele

William Geil walked through the archway beneath the Jiayuguan Gate Tower to take his photograph of the three-storied structure which 'looked very beautiful to a wearied traveller who, for weeks past, had wandered over the desert'.

The tower was burned down in the 1930s and its tablet bearing the characters 'Jia Yu Guan' was lost. Revisiting shows the reconstruction that took place in 1984 after an official visit to Jiayuguan by then-paramount Chinese leader Deng Xiaoping (1904–1997) who had just called for patriots to rebuild the Great Wall (see page 216).

Geil was then attracted by a brick-encased tablet (see page 106) about 100 metres away from the gate tower, standing on the gobi beside the post road. 'We at once fell to copying and deciphering these inscriptions while a dust storm obscures the surrounding desolation'.

The stele bears the characters *Tianxia Xiongguan* (The Martial Barrier of All Under Heaven), as well as other scratchings made by wayfarers, merchants, pilgrims and vagrants. One of the inscriptions (visible perhaps to the left or right of the second character from the top in Geil's old photograph) was copied by Geil and translated thus:

'*This barrier is the ancient boundary between flowers and thorns. Spring wind and autumn zephyrs desire to reach the western barbarians. After I have gone through and arranged peace, let the Tai Mountains close up this pass*'.

Revisiting found that the stele had been moved to a position inside the fortress for safety from modern, perhaps less eloquent, graffiti. A replica now stands outside the gate on the gobi.

"How old is this photo?"

Jiayuguan Tower: Geil, 1908 (WL).

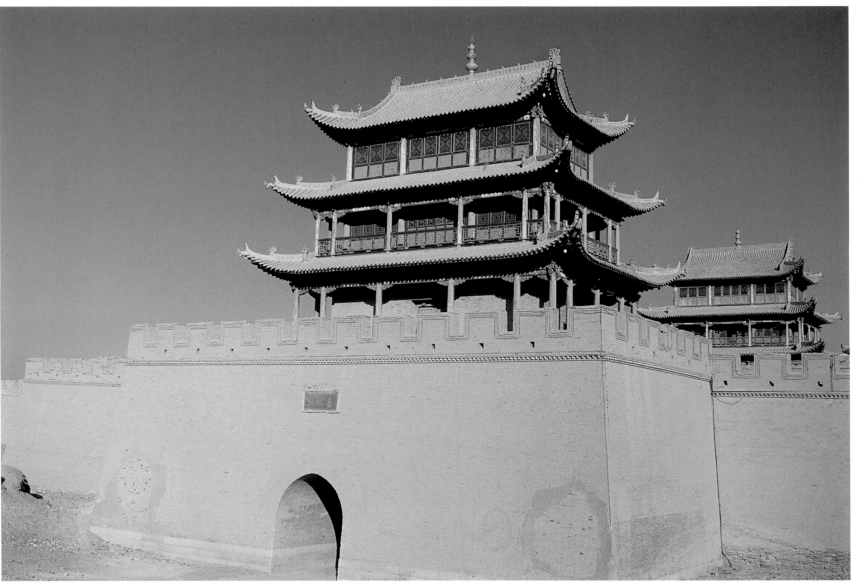

Jiayuguan Tower: Lindesay, 2004.

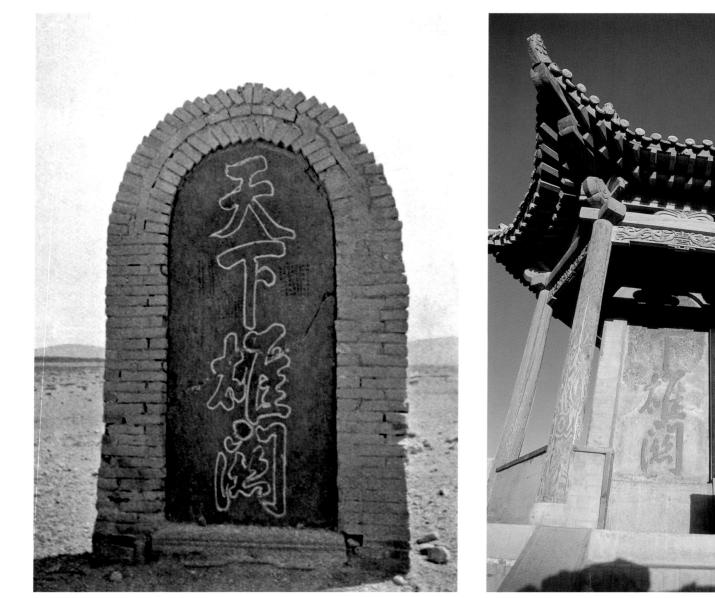

The Martial Barrier stele: Geil, 1908 (WL).

The relocated Martial Barrier stele: Lindesay, 2004.

Replica stele beside the old post road outside the western gate of the Jiayuguan Fortress.

Eastern Dam Gate (exterior and interior)

These exterior and interior views of the Eastern Dam Gate were taken in 1908 by William Geil. The gate is located within the eastern face of the outer wall of the Jiayuguan Fortress. In ancient times it functioned as the first gate for those proceeding westward through the precincts of the fortress, and was the only way through the defences.

Due to the presence of a large building it was impossible to stand on the correct spot required for more precise rephotography. Nevertheless, revisiting shows that the large screen once positioned directly in front of the entrance, traditionally to block the path of evil spirits, which the Chinese believed could only travel in straight lines, has been lost. A small plinth is present nearby, commemorating the inscription of the Wall as a UNESCO World Heritage. Elsewhere, five small square ovens, additional facilities for signalling, directly at the foot of the tall rammed-earth tower, are no longer present. The Wall to the right of the tower is the start of the so-called hidden Wall, not part of the fortress wall.

Regarding the interior view, revisiting shows the general clearance of pre-modern, but not ancient, utility buildings. On the cold early morning of the rephotograph, a small corps of People's Liberation Army soldiers was making a visit to the fortress. The gate and causeway now function as the main entrance for all today's visitors.

Eastern Dam Gate exterior view: Geil, 1908 (WL).

Eastern Dam Gate exterior view: Lindesay, 2004.

Eastern Dam Gate interior view: Geil 1908 (WL).

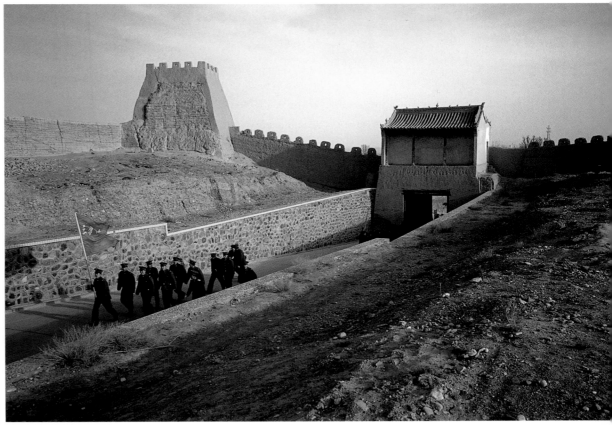

Eastern Dam Gate interior view: Lindesay, 2004.

Rammed-Earth Wall, southeast of Shandan Cement Works

The original photograph, taken by myself in April 1987 shows a section of rammed-earth Wall crossing the gobi desert between Shandan cement works and Changcheng Kou, or Great Wall Gap, where the fortifications are pierced by a road.

Shandan County, at the centre of the Hexi corridor, hosts one of the best preserved sections of Ming Dynasty Great Wall of rammed-earth style. Some 80 km of the county's original 90 km of Great Wall still remain, most impressively as a near-continuous landscape feature between the county seat of Shandan and Laojun township. Here the ramparts stand an average of four metres above the flat surroundings, while some towers maintain a height of seven or eight metres.

Revisiting found that farmers were cultivating wheat in newly-made fields immediately beside the Wall, on terrain that was formerly inhospitable and desolate. Superficially, one tends to think that farming here would be beneficial, not only for the local community, but indirectly by protecting the ramparts from further erosive forces, such as sand-laden winds and drifting.

Investigation revealed that cultivation was first made possible by importing topsoil to provide a fertile basis for crop growth, and sustainable by procurement of a plentiful source of water for irrigation. Wells have been drilled and pumps used to bring groundwater to the wheat.

By midsummer the wheat fields are waterlogged, with some pools present. Water from fields on both sides of the ramparts soaks the ground, permeating not only beneath the fortifications but also into their lower stratum, rendering long blocks of the Wall completely unstable.

Long sections of rammed earth Wall in Shandan County now stand on waterlogged ground after the recent start-up of wheat cultivation. This is a serious situation which threatens the stability of the Wall.

This new cultivation has changed the ecology of the area, attracting small rodents to inhabit the Wall and thrive on the plentiful food supply. These creatures have burrowed nests and warrens and created 'runs' in the friable Wall face, action that further undermines its stability.

Han Jiancheng, keeper of the Great Wall Exhibition Room where the G 312 expressway breaches the Wall at Changcheng Kou, expressed frustration when faced with the issue of protecting the Wall while trying to offer opportunities for farmers to escape poverty. "If the Wall soaks for another few years so much of it will fall down," he said.

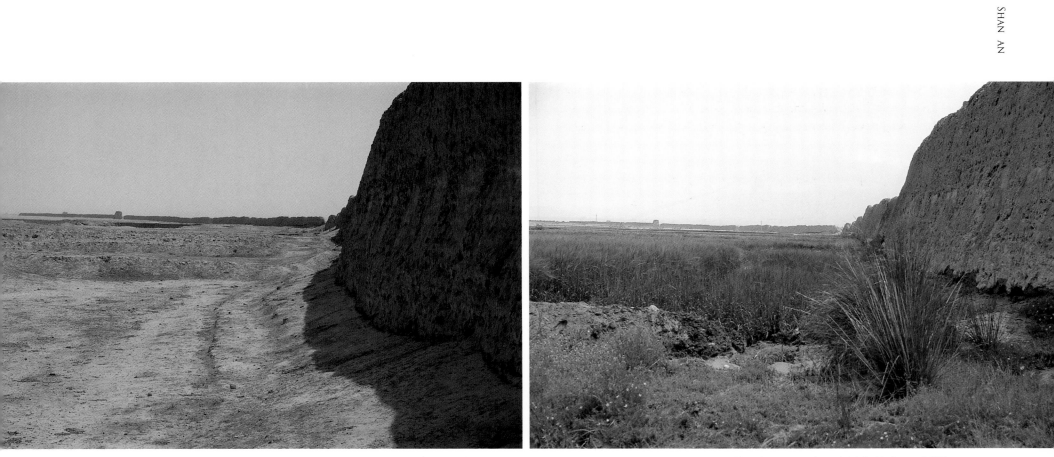

Shandan rammed-earth Wall: Lindesay, 1987.

Shandan rammed-earth Wall: Lindesay, 2005.

G 312–Great Wall crossing at Shandan

Rephotography at Changcheng Kou, or Great Wall Gap, 20 km southeast of Shandan in Gansu Province, shows that the absolute age of a photograph is not necessarily an indication of its usefulness in rephotography. The earlier photograph, taken by myself in April 1987, has acquired vintage status as the changes have been so great.

Depicting the same road 18 years apart, I revisited to find a six-lane expressway, the G 312 piercing a wider gap in the rammed-earth Great Wall, as well as a cluster of restaurants catering to long-distance truck drivers whose overloaded vehicles shake the fragile Wall as they roar beside one of the section's highest towers.

Construction of this expressway, linking Lanzhou with Wulumuchi, has continued further west as part of the central government's attempt to equalize the balance of economic development between the prosperous east and the less developed western interior. However, a more recent encounter between the road and the Great Wall, at Jiayuguan, has seen it being routed under the fortifications (see page 97).

G 312 expressway–Great Wall crossing at Shandan: Lindesay, 1987.

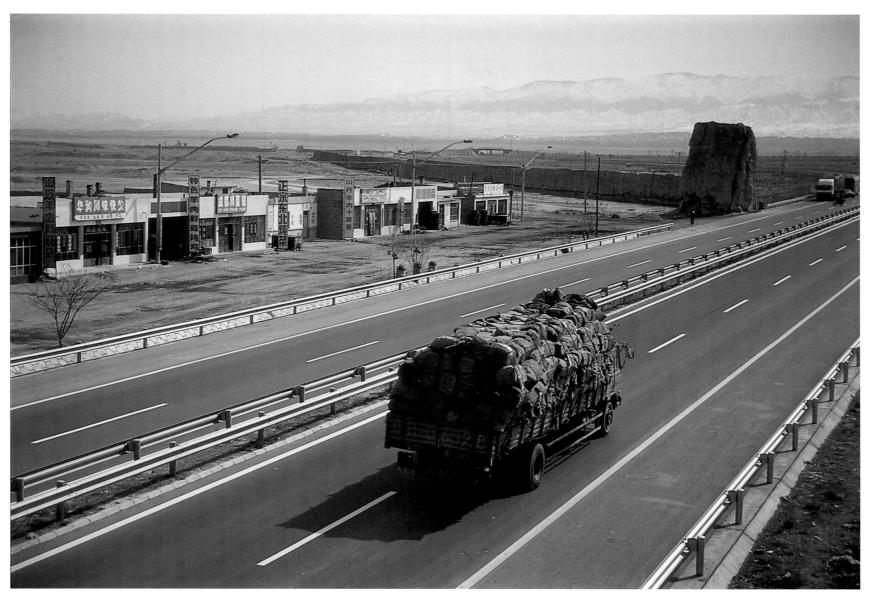

G 312 expressway–Great Wall crossing at Shandan: Lindesay, 2005.

NORTHERN SHAANXI PROVINCE

Northern Shaanxi Province

- Zhenbeitan (Yulin)
- Xuanluta (Shenmu)
- View of Wall w/ encroaching sands
- Two Towers . N. of Yulin
- Shiba Dun

Wu Li Dun, or the Five *Li* (from Anbian) Platform (Li Shaobai).

Brown Snake and Toad-headed Lizard, a watercolour by Arthur de C. Sowerby, naturalist and illustrator (WL).

Fortifications rephotographed in Shaanbei, or Northern Shaanxi Province, form the core part of a section of the Ming Great Wall which edges the southern rim of the Mu Us Shamo, or Ordos Desert, an area which lies enclosed by the big bend of the Yellow River's middle reaches.

Shaanxi is the third provincial-level region of nine that the Ming Great Wall traverses on its route eastward from desert to sea. At Shanhaiguan, on the Yellow Sea, stands the Old Dragon's Head. To Jiayuguan in the northwest, we can say, extends the 'Dragon's Tail'. Staying with this metaphor, we can regard the Wall in Shaanbei as comprising the 'Heart of the Dragon'.

The earliest Great Walls had incorporated the Yellow River's braided channels well to the south, which served not only as a psychological demarcation but also a physical one at certain times of year to hinder the advance of invaders. The Zhao State Wall, built c. 300 B.C. (see page 23), was routed well to the north of the river, and this structure was later incorporated within the Qin Dynasty Great Wall (221–206 B.C.).

Partly gobi in character, and in some areas a sea of sand dunes, the Ordos presented a problem; it was an extension of a great northern wasteland, piercing China's frontier region and unsuitable for farming, yet enclosed by the Yellow River. Effective control of the region by the Chinese required forward garrisoning and resettlement beyond the natural boundary between arable farming and herding. Successive governments had constantly encouraged its colonization, but the region was shunned by peasants. It was not only difficult to farm, but would be on the front line in the event of invasion.

During the Ming Dynasty a different strategy was adopted, with border defences being routed south of the Ordos, rather than north of it. Alliances were made with selected nomadic groups, first by offering trading rights (see page 122) and later, if the relationship proved satisfactory, better land on which to resettle. Under these policies, known as 'checking barbarians with barbarians' and 'fighting barbarians with barbarians', tracts of the Ordos were conceded, which saw the desert functioning as a territorial and tribal buffer. Yet the fragility of the strategy was emphasized by the more reliable border insurance policy of Wall construction. Two lines of defence (see page 121) were built as a belt and braces security measure. Approximately 1,000 kilometres of the Great Wall, mainly of Ming age, once crossed Shaanxi Province.

Lying midway along the Wall's west to east length, the fortifications in Shaanxi also represent 'hybrid construction' in terms of their materials. While Ming Wall in the west is of rammed-earth construction, and that in the mountains of the east is made of stone and brick, the Wall in this central area is largely a combination of the two. The ramparts were made of rammed earth, while towers were encased in quarried stones and bricks.

Although William Geil crossed the Ordos, the few photographs he exposed of the region's Wall proved to be untraceable. The following year came Robert Sterling Clark and Arthur de Carle Sowerby, and then in 1914 the geologist Frederick Clapp. Both expeditions produced photographs that proved findable, and all are of significance for evidencing changes to the Wall in a hostile desert environment.

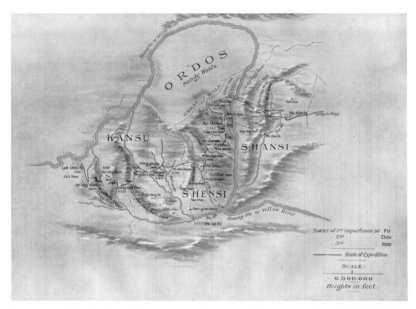

Route map of the Clark and Sowerby expedition from Taiyuan to Lanzhou, 1908–09 (WL).

The Clark and Sowerby Expedition

With a keen interest in natural history Robert Sterling Clark (1877–1956) organized an expedition to collect zoological specimens in the central part of North China from 1908–09. He invited Arthur de Carle Sowerby (1855–1954) to join him as naturalist and illustrator.

The two men at the head of the 36-man expedition, seven of whom were foreigners, came from very different backgrounds. Clark was born into a wealthy New York family, and arrived in China as a United States army officer, while Sowerby was born and bred in China, the son of missionaries working in Taiyuan, the capital of Shanxi Province.

Clark had a growing interest in China, particularly its relatively unknown wild places, yearned for personal adventure, and had family wealth to fund his ambition. Sowerby was an old China hand, with perfect professional qualifications. His family hailed from Cumbria in northwest England, and boasted a lineage of eminent scientists and artists, a background that bred in him the talent of a fine illustrator and the preciseness of a disciplined scientist.

The expedition's caravan consisting of 57 horses and mules carrying apparatus for plane-table surveying, astronomical and meteorological observations, zoological collecting and photography, as well as food supplies, tents and camp furniture, left Taiyuan on 28 September 1908, reaching Yulin, south of the Great Wall, two months later.

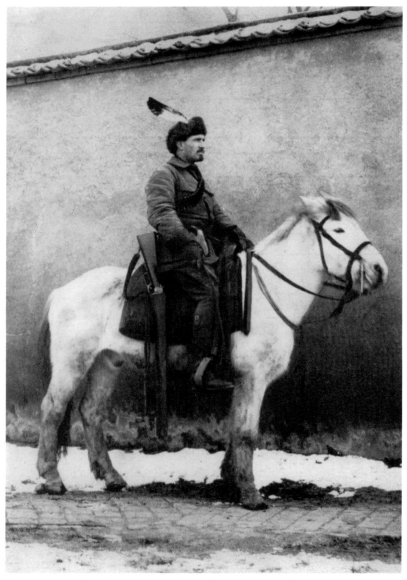

Arthur de Carle Sowerby on horseback in Taiyuan, Shanxi (WL).

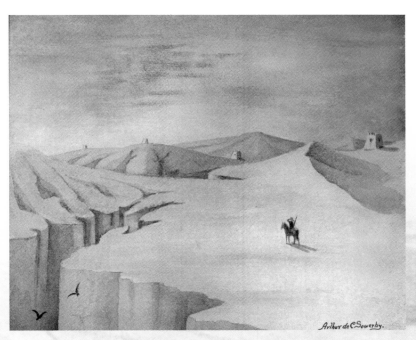

Sunset on the Ordos Border, a watercolour by Sowerby (WL).

Robert Clark wrote:

'Just within the Great Wall, and about three miles north of the city, stands a large fort originally built to guard the entrance, through which runs the main road from the Ordos. It is some ninety feet in height and surrounded by a high wall. There are three storeys: the first a solid block of masonry about thirty feet square; the second and third similar, but lessening in size.

From here a splendid birds-eye view of the desert is obtainable – countless sand dunes stretch north and south to the horizon....The Great Wall at this point, and indeed the whole boundary-line between the Ordos and Shensi[1], is little more than a low ridge of earth. Its course however is easily distinguishable by the watch towers still existing at intervals of about three hundred yards. In many cases these are in admirable states of preservation, leading to the supposition that the Wall in this part was not faced with brick or stone'.

[1] Shaanxi.

'*Through Shen-Kan, The Account of the Clark Expedition in North China*' (London, 1912).

Clark was standing on Zhenbeitai, the 'Pacifying the North Terrace', a scene captured in a watercolour painting by Sowerby, the only painting used in this rephotography project. Later, in the course of exploring the Wall extending into the desert Clark also exposed photographs, which were eventually found to Yulin's northeast after lengthy searches. Captioning one of his images in the published account of the expedition Clark drew his readers' attention to encroaching sands, a problem that also concerned Frederick Clapp, the second photographer of the Wall to pass through the region.

Frederick Clapp

Little biographical information has come to light concerning the life of Frederick Clapp (1879–1944), except that he was a professional geologist and employed by the United States Geological Survey from 1902–08. It was early 1914 when he arrived at the port of Qinhuangdao, on the Bohai Gulf, close to Shanhaiguan, and from where he set off on a journey across north China.

The main purpose of Clapp's journey was to make observations concerning the geology of north China with regard to its potential petroleum resources, rather than specifically follow the Great Wall. Nevertheless, taking his photography as an indication of the locations he reached, he saw long sections of the structure from time to time, and at very remote places, travelling as far west as Ningsiafu (Yinchuan). He also used his cartographic skills and existing map sources to produce the first specifically-published map to show the route and length of the Great Wall. This was printed as a supplement to his report *Along and Across the Great Wall of China* (see extracts below), contributed in 1920 to the *Geographical Review*, a journal published by the American Geographical Society of New York. At one-metre in length, and drawn to a scale of 1: 2,000,000, he marked the fortifications as an unbroken line while stressing it was 'not continuous, often lying in ruins or not surveyed'. He calculated 'the length of the Wall', actually the Ming Wall plus that section of the Han Dynasty structure surveyed by Stein, to be 3,930 miles (6,288 km).

From his report we learn that his exploration was in the company of two fellow Americans, Myron Fuller, also a geologist, and Kenneth McKoy, an expatriate in China, as well as two Chinese surnamed Wu and Hou.

Portrait of geologist Frederick Clapp c. 1915, aged 35 (The American Geographical Society).

The small group set off from Shanhaiguan town on a cold winter's day, 17 February 1914, and four months later reached Shaanxi.

'In Shensi Province the wall was first seen by us on June 17, after three days' traveling, near Shenmuhsien[1]. All published maps show this wall as the "Great Wall". At Shenmu, however, the natives said: "This is not the 'Great Wall', this is the 'First Frontier Wall', built only four hundred years ago, the Great Wall is farther north". And they added that the "Second Frontier Wall lies about 30 miles beyond"'.

From Shenmuhsien we followed the Frontier Wall, here an earthen wall for three days into Yulinfu, over a trail said never to have been traveled by foreigners. We journeyed much of the time across the rolling, sandy wastes, 5000 feet above the sea which comprises the desert. On the hills many temples, watchtowers and the remains of the Frontier Wall testified to the former importance of the region. One day we passed through the city of Changlopo, which is so rapidly being buried that one must climb over the walls on sand dunes in order to enter'.

[1] Shenmu County town.

Clapp concluded his report with a thought for the future.

'One foe alone has not been stopped by the Great Wall. This is the sand of the Desert of Gobi that is driven by wind and climatic conditions southward mile after mile, year after year. Is there no remedy to this situation? The writer believes there is. A new Great Wall should be constructed. Not of brick or stone or earth guarded by soldiers, but a forest barrier guarded by expert foresters. A forest one mile wide along the northern border of the country would probably suffice; in Shensi, at any rate, the project is feasible'.

The 'Green Great Wall' project that Clapp called for eventually began in the early 1980s and continues to this day, as many of the rephotographs on the following pages serve to illustrate.

Rephotography of the Shaanbei Wall proved to be the most challenging of all seven regions covered by the study because of the unstable nature of the host desert landscape and impermanence of background features in old photographs. In terms of percentage success, only five out of 15 locations could be found. A total of 12 days – travel and field work – were required to score these successes, a worthwhile investment given the importance of incorporating more desert-environment sites into the study.

Perhaps the starkest message was delivered not from the locations successfully revisited, but by those which proved impossible to find, perhaps because the Wall in these places had already disappeared.

Zhenbeitai (Pacifying the North Terrace), Yulin

The original, a watercolour painting by Arthur de C. Sowerby from November 1908, is the only known pre-modern image of Zhenbeitai, the largest watchtower on the entire Ming Great Wall.

Although linked directly to the linear Great Wall, the purpose of the terrace was quite different from the smaller watchtowers dotted along the adjoining defence, and along its whole length. Rather than functioning primarily as a relay station for the signalling of military information, Zhenbeitai was built to protect and oversee the annual 'horse-tea markets' that were promoted during the late Wanli (1572–1620) period as policies aimed at pacifying the Ordos nomads (see page 117).

Built over a three-month period in the spring of the 35th year of the Wanli Emperor (1607) on the orders of the governor of the Yansui military region, the building served as an impressive emblem of imperial China in whose shadow nomadic tribesmen traded horses with Chinese merchants in exchange for tea, textiles and medicines.

Revisiting found the terrace to have been reconstructed and functioning as a main tourist attraction of the region. According to Kang Lanying, former director of Yulin County Culture Bureau, rebuilding of the terrace took place in the late 1990s with funding donated by a local property developer. She pointed out that Sowerby's painting, though charming, was not completely accurate as the artist neglected to detail the exterior brick facing, which still remained right up to its time of reconstruction.

Zhenbeitai, the largest watchtower on the Ming Wall: Lindesay, 2005.

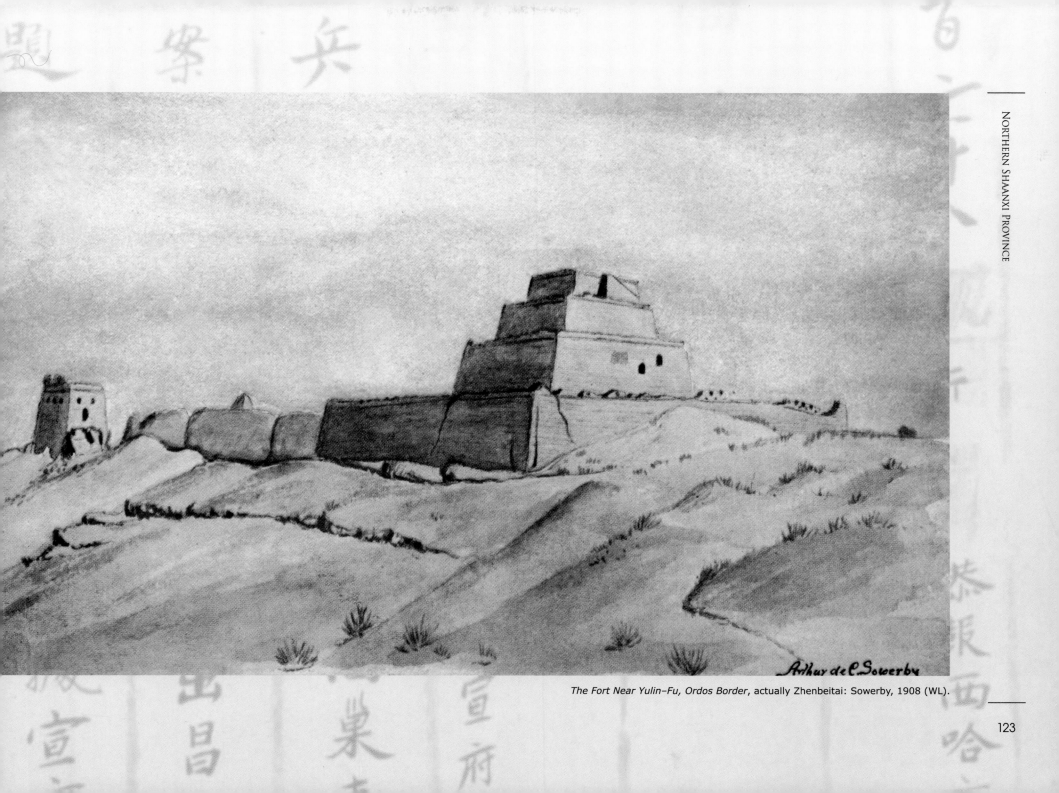

The Fort Near Yulin–Fu, Ordos Border, actually Zhenbeitai: Sowerby, 1908 (WL).

Xuanluta, nr. Gaojiapu, Shenmu County

It was, as the Chinese themselves put it, like 'looking for a needle in the ocean'. I thought I had little real chance of finding this location, but I had to make an attempt, otherwise the study would lack revisited images of the Wall lying at the heart of the Dragon.

The ocean in question was the Ordos Desert, crossed in 1914 by Frederick Clapp. As always, I started my search in a village, talking to an elder.

"You say this photograph was taken by an American?" asked a 60-year-old teacher.

"Nearly 100 years ago, you say?" he remarked. I asked him impatiently whether he knew of the location.

"Well … it's hard to say…. I don't think this part is here anymore," he said.

"But it could be close-by, it's worth you having a look now, you've come so far," he said, imparting just a glimmer of hope.

I had more than one look. I walked dusty tracks, and climbed many hills, always hoping for the trail to get hotter in the next village. One leg of the search took me across a flood-swollen river in a wobbly oxcart that almost dumped me, along with my Olympus and Leica cameras, plus half a dozen lenses, in the muddy water.

Convinced I had done my best, I prepared to concede defeat and return empty handed to Beijing. Then I was introduced to Shaanxi local Li Shengcheng, born in Anbian, a small town beside the Great Wall.

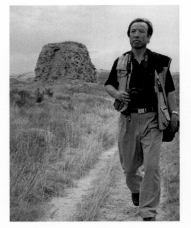

Li Shengcheng leading the way to old photo locations, July 2005.

Village elders were important sources of directional information in the search for locations.

Li told me that he had spent 108 days in 1992 following the Wall across his home province, from its entry at Yanchi in the west to its exit at Fugu in the east. He walked a 900–kilometre–route linking its remains, identified 1,115 watchtowers en route, photographed every one of them, and assigned each a number. "Let me have a look in my records," Li said. He phoned me a few days later. "I've found it, it looks like tower number 194."

Li and I met again and travelled to Xuanluta, a hamlet near Gaojiapu, but still had to exercise some final patience. We spent two days in a farmer's *yaodong*, or cave dwelling (vernacular architecture of rural Shaanxi), waiting for a window in the weather to break up the humid, murky days of midsummer.

The revisit shows that the tower from which the original photograph was taken has since collapsed. A small road crosses the foreground of the scene, but the site is clearly recognizable by the position of the two towers near the horizon.

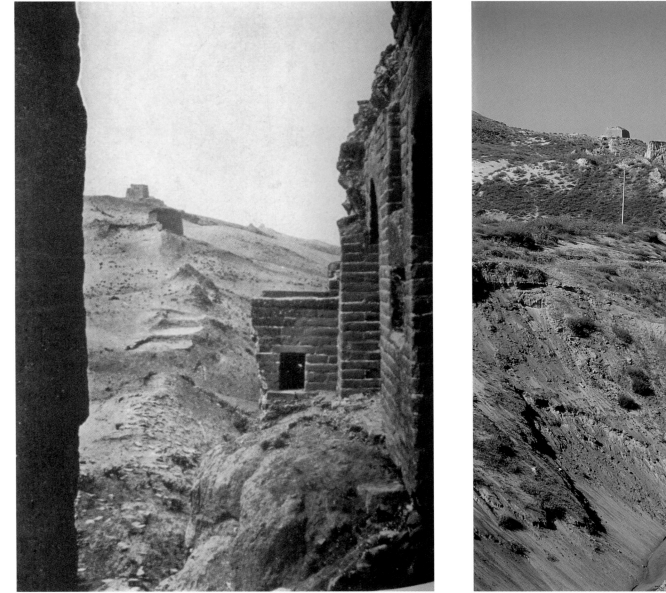

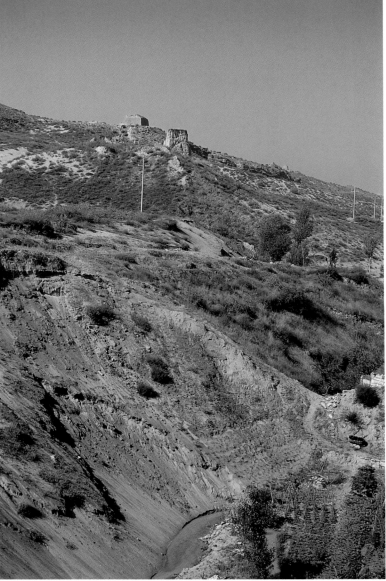

Towers on the Ordos at Xuanluta: Clapp, 1914 (WL).

Fewer towers at Xuanluta: Lindesay, 2005.

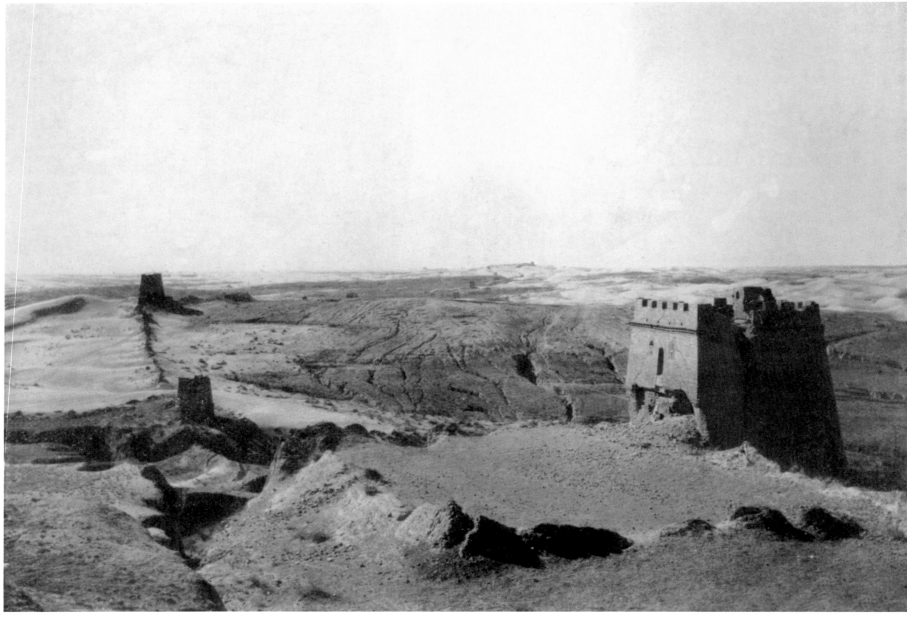

Sands encroaching on the Wall north of Yulin: Clark and Sowerby, 1908 (WL).

'View of the Great Wall, showing encroaching sands'

It matched almost perfectly. As I retook this photo (top right) I was 99 percent convinced it was the right location, almost everything correlated – the background, the line of the Wall, remnant towers, and the big tower in the foreground.

There was, however, one inexplicable element: a large chunk of detached masonry below the closest tower. I could not come up with a viable explanation, and neither could anyone in the expert group.

Two months later I received a phone call from Li Shengcheng, explorer of the Wall in Shaanxi Province. He said it was indeed the wrong place, and he knew the right location of the original 1908 photograph taken on the Clark and Sowerby expedition.

I was astounded that a 'double' location, like a human double, could exist on the Great Wall – perhaps it's a true measure of its extent, as vast and varied as the human race, and occasionally almost the same.

But was this next location (lower right) the original?

Scrutinizing the background of the 1908 image, on the left is an area of loose wind-blown sand between the second and third towers, while on the right is incised plateau. Just to the left and behind the first tower is a deep gully. To the left and in front of the first tower is a square enclosure.

These features correspond exactly with the new image. The relative positions of the towers, although dramatically changed by the disappearance of their brick exteriors, match precisely, as does the remains of a square enclosure beside the first tower. The landscape, rephotographed in October, compared to November in the original, appears more vegetated, with a dirt road crossing the landscape and power lines and posts in various places.

A remarkably similar, but incorrect location: Lindesay, 2005.

The correct location: Li, 2006.

Two Towers North of Yulin

The original photograph, taken on the Clark and Sowerby expedition in November 1908, shows two towers amid sand dunes and desert scrub. A man stands with his horse beside the first tower, which shows damage to its corner. This may have been triggered by wind erosion at the base of the tower, undermining the lowest course of foundation blocks, precipitating collapse and the gradual exfoliation of the structure's brick casing.

The search for the site found this likely candidate. Located just 40 minutes' walk from the previous one, its position fits logistically into the possible route taken by the early travellers. If it is the right location then the first tower has completely collapsed, with only its base remaining. A mound marks the route of the Wall to the second tower, whose mud interior remains. Although the second tower on the original looks narrower and taller, while the new one looks shorter and wider, this may be explained by weathering of the tower top, which changed its apparent shape. Elsewhere, the flattish area to the horseman's right, curving round in front of the camera, may correspond with the foreground of the new photograph where saplings grow. A third tower is visible as a tiny speck on the skyline towards the edge of the right hand frame. This cannot be seen in the original, its absence possibly explained by the change in the height of the land. Once concealed in the old view, it is now revealed in the new.

Two towers north of Yulin: Li, 2006.

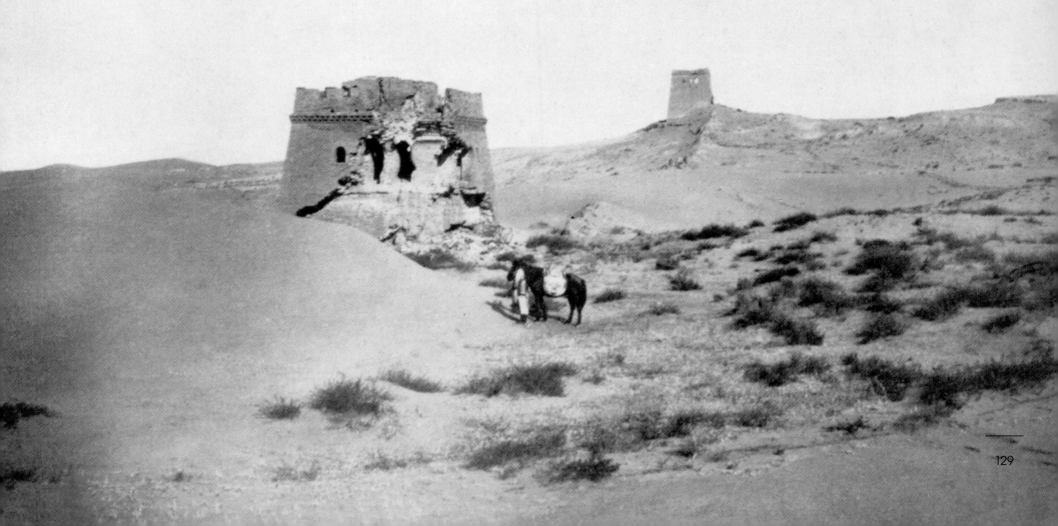

Two towers north of Yulin: Clark and Sowerby, 1908 (WL).

'Towers of the First Frontier Wall' / *Shiba Dun*

The original photograph, taken by Frederick Clapp in June 1914, was captioned by him as 'Towers of the "First Frontier Wall", constituting the boundary between Inner Mongolia and the Province of Shensi, seen from Changlopu near Yulinfu. The Wall here is being buried by the sands of the Ordos Desert'.

Scrutinizing the image one can count a string of eight towers, each approximately 100 metres apart, receding into the murk of a dull and dusty day.

The menacing presence of the sand dunes did not auger well for the discovery of this location after a further 90 years of wind, but the rare

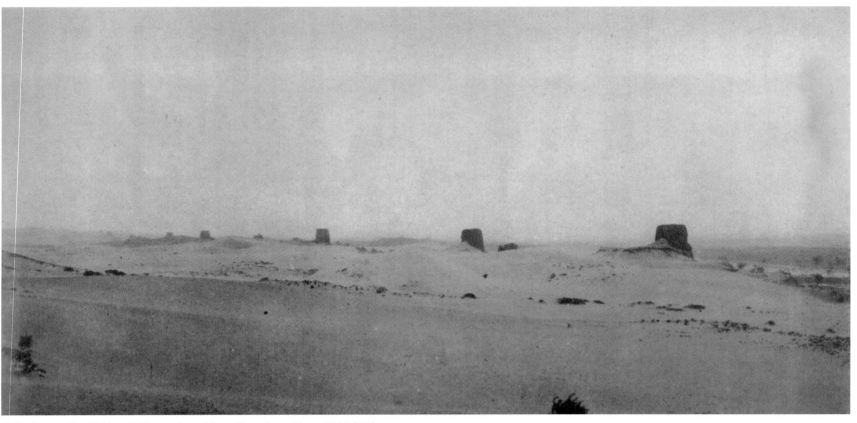

Shiba Dun, or the Eighteenth Tower, viewed from Changlopu: Clapp, 1914 (WL).

availability of a detailed caption – if accurate– promised to offer a shortcut to success. Li Shengcheng indeed believed the photograph was exposed from either atop or beside the fortified town wall of Changlopu, so we drove right there, 40 km from Yulin.

Walking to that part of the now-derelict wall enclosing today's Changlopu, we looked across a landscape that corresponded, at least in terms of relief, to the original. It had been transformed by re-vegetation, while the possible line of remains of the 'First Frontier Wall' photographed by Clapp was approximately correct, even though only two towers – the first and possibly the sixth or seventh – could still be seen. Locally, the closest tower is known as *shiba dun*, or the eighteenth tower.

Shiba Dun viewed from Changlopu: Lindesay, 2005.

Hebei

Laryuan County Hebei
- Chajianling Gate
- Chajian Ridge
- 'Three Towers'
- 'Victory Tower'
- Yangjiazhuang
- 'Picturesque Pass'
- Tangzigou (2 views)

Towers at every turn along the Wall's line, Laiyuan County (Lindesay).

Fortifications rephotographed in Laiyuan County, approximately 150 km southwest of Beijing, lie on the Inner Wall and form the southern arc of a looped structure that was built to provide a double layer of defence for Beijing (see page 163). The strategy behind the Wall's placement here, routed along the ridges of the Taihang Mountains on the Shanxi–Hebei border, was to foil attempts by invaders to access the central plains and threaten the dynastic capital from the weakly-defended, in natural landscape terms, northern part of the Shanxi plateau.

The Wall in this county lies to the immediate west of the Zijingguan strategic pass, targeted by cavalry of Genghis Khan (1162–1227) during the Mongols' campaign in North China that began in 1209 with a surprise attack on the Jin Dynasty's middle capital of Zhongdu, located on the site of present-day Beijing. The campaign was finally completed 70 years later by Kublai Khan (b.1215, r. 1271–1294), grandson of Genghis Khan, whose armies finally toppled the Southern Song Dynasty (1127–1279). Much of China during the 13th century therefore fell under Mongol occupation, while the Yuan Dynasty ruled all China from 1279–1368.

To prevent a repeat of such events during the Ming, construction work began on an Inner Great Wall after placement of the outer defences. The fortifications in Laiyuan bear characteristics of both simple and advanced fortifications. Broadly speaking the Great Wall in the county typically consists of relatively low-grade ramparts made of field- or roughly-quarried stone which was upgraded in quality by the late addition of high-quality watchtowers made largely of bricks, placed in close proximity along the line of defence. In this way, the heavily-manned Wall promised to deliver victory in the event of attack.

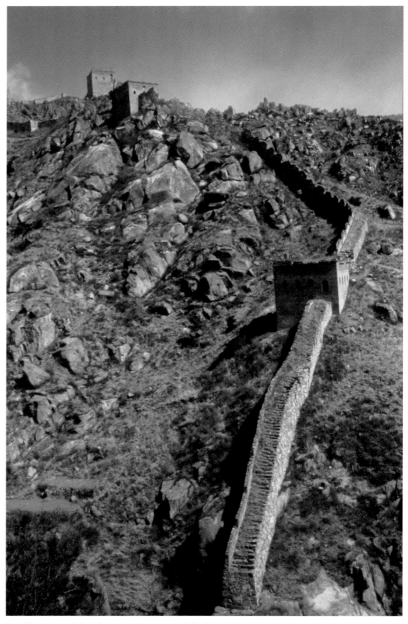

Fortifications defending a minor pass in Laiyuan County.

A phoenix roof guardian, 17 cm in height, discovered on the top storey of a watchtower in Laiyuan County.

A low-grade construction section of the Wall composed of roughly cut stones bound with mortar or dried mud.

Ironically, the biggest conflict that took place within this theatre of war was not during Ming times, but in the late 1930s. It was between the Communist-led Eighth Route Army and invading Japanese forces, who were attempting to push south from the Chinese region of Manchuria, which they had annexed earlier, hoping to capture the city of Beijing.

It was against this background that Sha Fei, a photojournalist with the Eighth Route Army, was sent to Laiyuan in late 1937. In 1908 William Geil had passed through the county, photographing many locations, only a few of which could be found. These two sources present a detailed portfolio of the Wall's supreme watchtower architecture in the mountains of Hebei Province.

The Great Wall of Sha Fei

Few Chinese know of Situ Chuan (1912–1950), yet many recognize him by his alias, Sha Fei – the photojournalist who captured enduring images of their countrymen fighting the Japanese army on the Great Wall of China at the peak of the Anti-Japanese War in 1937–38.

The short, triumphant and ultimately tragic life of Sha Fei began on 5 May 1912, just seven months after the fall of the Qing Dynasty in October 1911 which ended 2,100 years of imperial dynastic rule. The son of merchants in Guangzhou, capital of Guangdong Province in south China, Situ Chuan received tuition-free schooling, and upon graduation at just 14-years-old he joined the Northern Expedition Army. He trained and worked as a radio operator for the Nationalist-Communist alliance, which was launched to establish central government control over northern China, which was then ruled by provincial warlords.

Despite the partial success of the Northern Expedition, the political alliance which created it fractured in 1927 when Chiang Kai-shek, commander-in-chief of the Nationalists forces, cracked down against the opposition Communist party by jailing and executing its members and supporters. These actions were the opening salvos of a civil war that would rage for 22 years, only to be interrupted by the unified fight against the Japanese invasion.

Situ may have taken his earliest and happiest photographs on his honeymoon, spent in 1933 touring the idyllic water cities of Suzhou and Hangzhou, famed throughout China as heaven on earth. In October 1936, he photographed Lu Xun, the standard bearer of China's revolutionary

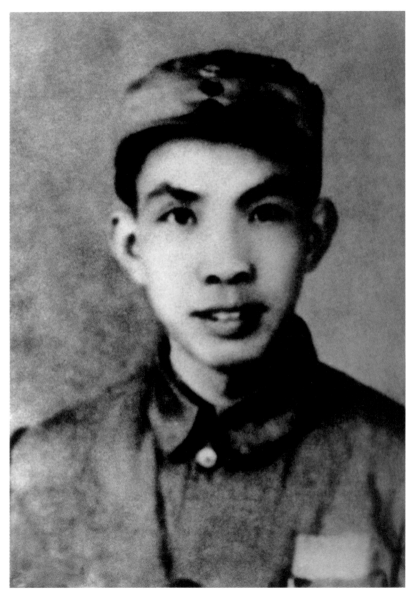

Portrait of Sha Fei , c. 1937, aged 25 (Wang Yan).

literary movement in the 1930's, with a group of left-wing artists at an exhibition of their woodcuts depicting the life of the poor and the humiliated. One picture, taken shortly before Lu Xun passed away, was to make headlines within a week of its production, and Situ's career path was now mapped out.

The following year saw Situ Chuan, now Sha Fei, once again participating in an alliance between the Nationalists and Communists – the United Front created in December 1936 by the daring capture of Chiang Kai-shek, who was forced to call a ceasefire in the civil war and pledge unity with the Communists to fight the Japanese. Chiang had earlier dismissed the invaders as 'a disease of the skin' compared to the 'disease of the heart' that the Communists posed.

Sha Fei joined the Communist-led Eighth Route Army, embarking on his new role as war photographer with General Nie Rongzhen's forces, which controlled the Taihang Mountains between Shanxi and Hebei provinces. His early work captured the horror of Japanese brutalities, including bound and naked victims shot in cold blood, smouldering villages and farmers struggling pitifully to pick up their lives among the embers of war.

These pictures imbued outrage and indignation in all who viewed them, showing the civilized world that a demon equally as depraved as Hitler's Nazi Germany had embarked on a campaign involving crimes against humanity in its bid to dominate Asia.

The following year Sha Fei was given an assignment aimed at both inspiring national pride as well as countering the Japanese propaganda machine, which from the earliest opportunity had been churning out photographs of its troops and officers atop the Great Wall of China

waving Japanese flags. In total Sha Fei produced a few dozen published photographs of Chinese troops in action in the ancient Great Wall theatre of war turned modern front line.

It was testimony to quality of the old defence that the ramparts were chosen by Chinese commanders as a place to 'dig the trenches' in a modern war. The Wall had been built five centuries earlier in compliance with the fundamental art of war stratagem of occupying high ground, and it had not lost its value. Its ridge routing provided supreme vantage points to observe an enemy's movements, whether ancient or modern barbarian. Towers also saw their ancient purposes revived, as barracks, ammunitions stores and places to deploy machine guns.

Sha Fei clearly designed his Great Wall photographs with care and variation. They cover army activities ranging from the 'action' of machine-gunning the enemy to marching, both atop the Wall and through a Wall-side village, as well as troops listening to a pep talk by their commanding officer, and revelling in the joy of victory with rifles held aloft and flag being waved from the roof of a tower.

Bronze memorial to Sha Fei, unveiled in 2004 at the Shuangfengshan Cemetery, Shijiazhuang (Wang Yan).

With a good eye for composition Sha Fei selected locations to display the Wall's most magnificent architecture, letting it speak for itself, conveying its own indomitable spirit. In this way, his locations function to depict far more than a battlefront of practical and strategic value; they were crafted to show Chinese that as a nationality they had a history of repelling invaders since time immemorial.

On 17 August 1937 the *Guangxi Daily* published an illustrated report from the front provided by Sha Fei: 'Photographing and Saving the Nation from Extinction'. Later he launched the *Jinchaji Pictorial* along with 20 or so other journalists, stressing his belief that the press could not only inform a nation, but inspire it.

When Sha Fei's photographs were published they were not captioned with place names. After the war, fate would have it that he fell ill and had little energy for such work. In 1948, suffering from tuberculosis he was admitted to hospital. There he murdered a Japanese doctor who was among a group of sympathizers who had remained in China after the war to support the Communists. Sha Fei was court-martialed and was found guilty. On the freezing cold morning of 4 March 1950 outside Shijiazhuang, the provincial capital of Hebei Province, he was honoured with a military salute. Then a piercing gun report rang out above the sweep of a howling gale, bringing Sha Fei's short life to an end.

After the Cultural Revolution (1966–76) an investigation into Sha Fei's case was carried out by the political department of the People's Liberation Army. It found that he was mentally ill at the time of the murder and therefore he deserved rehabilitation. In 1986 the Beijing Military Court retracted his sentence.

In 1997 the father and son team of Yan Xinqiang and Yan Gongming, members of the China Great Wall Society, set out to locate some of the places that featured in Sha Fei's famous, but lost, photographs. After several weeks' work the researchers managed to pinpoint the majority of the photographs in the field, which had been taken in three main areas: Futuyu and Chajianling in Laiyuan County, Hebei Province, and at Lingqiu County in neighbouring Shanxi.

On learning of this Great Wall rephotography project, Wang Yan, a surviving daughter of Sha Fei (who adopted her mother's maiden name), provided a selection of Wall photographs taken by her father, as well as introductions to the men who knew their precise locations. With this assistance, I revisited a remote section of the structure, sadly to discover its dramatic fall. Lying in ruins nevertheless, these are the parts of the Wall – the very stones, bricks and towers – which provided so much inspiration to so many. Sha Fei's photography here effectively reloaded the Great Wall for China.

His surviving works have won him the title as the first Chinese photographer of the Great Wall. After producing such artistic and propagandistic masterpieces, his country's fight against the Japanese could never be a losing battle.

Sha Fei with his camera, possibly a Leica, c. 1937 (Wang Yan).

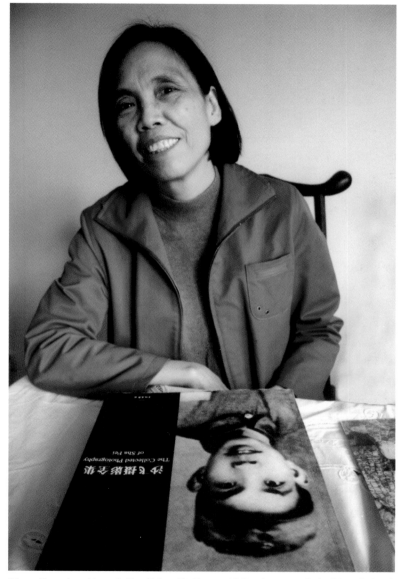

Wang Yan, daughter of Sha Fei, with the portfolio she compiled of her father's photographs.

Chajianling Gate

The original photograph was taken by Sha Fei in autumn of 1937 and captioned 'Marching forward after the victory on Chajian Ridge'. A column of soldiers is shown making its way through Chajianling, a village to the south of Laiyuan county town. Men are dressed in little more than cotton-padded jackets, are shod in plimsolls, and carry bedrolls and straw hats on their backs.

A Great Wall gate tower is the focus of the photograph, which is well preserved with its archway, internal windows and top storey battlements all prominent. The adjoining Wall, leading down from the top of the frame on the right (above the contemporary buildings), appears already badly damaged and may have been used as a handy quarry by the villagers.

Revisiting shows the tower's upper structure to have been levelled, yet its archway has survived. The building to the tower's immediate left, behind the blue shack, has an exterior wall made almost entirely of Great Wall bricks. Adjoining fortifications are little more than a mound of rubble claimed by nature.

The archway tunnel showed signs of later abuse and current re-use. Its large granite blocks bear the faded characters in red paint of a slogan wishing eternal life to Chairman Mao. On the morning of the revisit it was favoured as a sheltered location by the village butcher for selling freshly slaughtered pork.

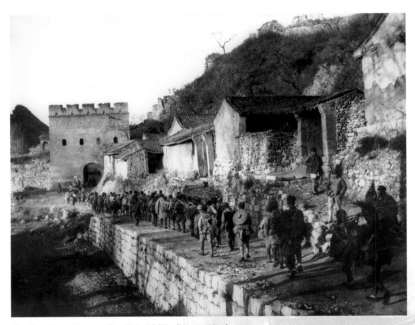

Chajianling village: Sha Fei, 1937 (Wang Yan).

Chajianling village: Lindesay, 2005.

Chajianling (Ridge)

The original photograph by Sha Fei in 1937 was captioned 'Command site of the Eighth Route Army at Chajian Ridge'. It shows six soldiers, four standing and two in the prone position, looking across a valley to a ridge of the Great Wall crowned with four watchtowers.

The largest figure, second from left, appears to be the group's commander, and holds binoculars in his left hand, while the other men have rifles and pistols at the ready.

Revisiting this site, which had coincidentally been photographed thirty years earlier by William Geil in 1908 (see page 150), shows the complete destruction of three of the towers.

Three different stories are told by local villagers. Some say that the towers were destroyed by soldiers of the Eight Route Army themselves, who used the towers for some time, but were ordered to destroy them when they vacated the area in order to prevent their possible use by advancing Japanese troops. Others say the towers were either bombed by Japanese warplanes or forcibly destroyed by villagers captured by Japanese troops.

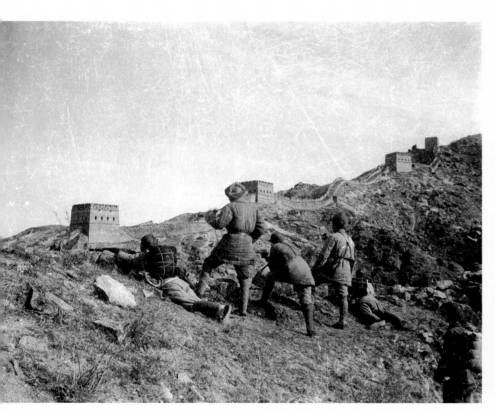

Chajianling ridge: Sha Fei, 1937 (Wang Yan).

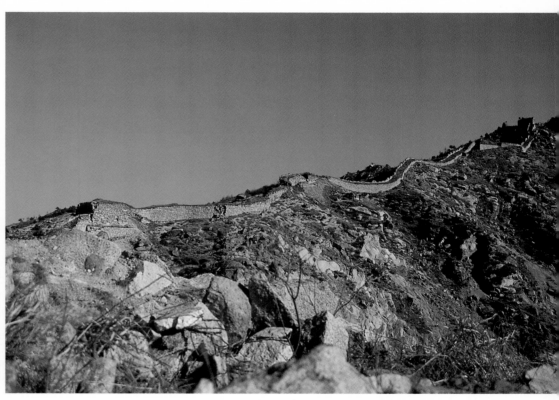

Chajianling ridge: Lindesay, 2005.

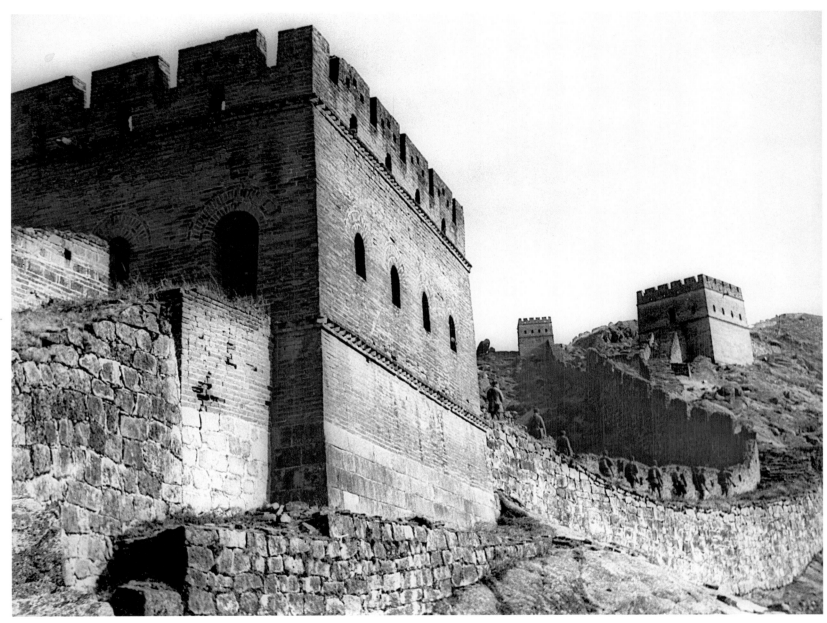

Three towers on Chajianling: Sha Fei, 1937 (Wang Yan).

Three Towers

More than any other of Sha Fei's Great Wall works, this photograph from 1937 shows the building's magnificence, and exhibits the cameraman's technical and artistic skills, including fine exposure judgement, perfect contrast control, stunning use of perspective and limited distortion. The image contains much interesting subject matter.

Standing enormously on the left is a watchtower in almost perfect condition. Exposure accuracy allows us to see the dark lichen on its foundation blocks, as well as make out its individual bricks, on both sunlit and shaded faces. At the centre of the frame the Wall curves away and up. The outside battlement is intact, and along its grassed-over pavement nine soldiers march in single file (nine is a most auspicious number in China). The viewer's eyes follow them, heading towards the two top towers, which stand out semi-silhouetted against the skyline.

Revisiting shows that only part of the top tower now remains. Without the hallmark curve of the Wall in mid frame this location would have been extremely difficult to recognize.

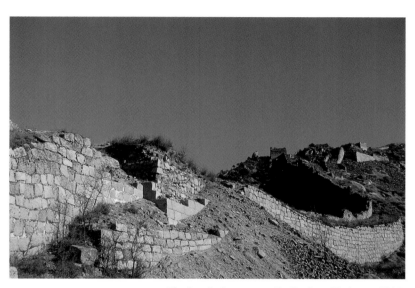

The levelled scene on Chajianling: Lindesay, 2005.

Machine gunner at Yangjiazhuang: Sha Fei, 1937 (Wang Yan).

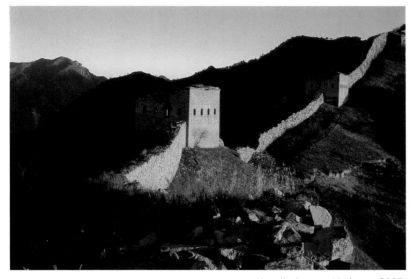

Yangjiazhuang: Lindesay, 2005.

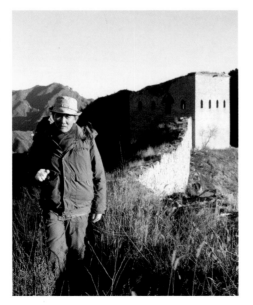

Researcher Yan Xinqiang leads the way to sites photographed by Sha Fei.

Machine Gunner at Yangjiazhuang

The original by Sha Fei was taken in the spring of 1938 on a section of the Wall to the west of Yangjiazhuang, south of Futuyu. This proved to be his most successful Great Wall action photograph. It has been used in numerous revolutionary posters, graces virtually every war exhibition hall in the country and also formed the design template for a postage stamp issued in 1995 to commemorate the 50th anniversary of China's victory in the Anti-Japanese War.

The photo shows three soldiers in crouched and prone positions firing at the enemy, using a machine gun and large pistol. In the background the Wall climbs away, its line dominated by two well preserved watchtowers. The closest one to camera has walls remaining from the small apex-roofed building that once stood on its upper storey. The ramparts in view are without any standing battlements.

Revisiting shows the body of the Wall to have changed very little. The basic structures of the lower parts of each tower remain intact, although both have suffered damage on their upper levels. In both cases this has started to impact the internal arches of the towers.

Victory Tower

The original photograph, taken in the spring of 1938 by Sha Fei, was captioned 'Celebrating the victory of Futuyu'. About 30 soldiers divided into two groups raise their rifles, while the flag of the Eighth Route Army is waved aloft.

The tower itself shows damage in the form of a major crack extending for approximately three metres, from the top of the doorway to the roof. Above the doorway is a gap where an engraved tablet would have denoted the name or number the tower. By 1938 it had already been removed.

Revisiting shows the collapse of the tower with only its lower walls remaining, as well as the partial forms of both windows and the doorway. Much of the rubble now lies in a high mound where many of the soldiers once stood. In the background stand two new towers to carry electric power.

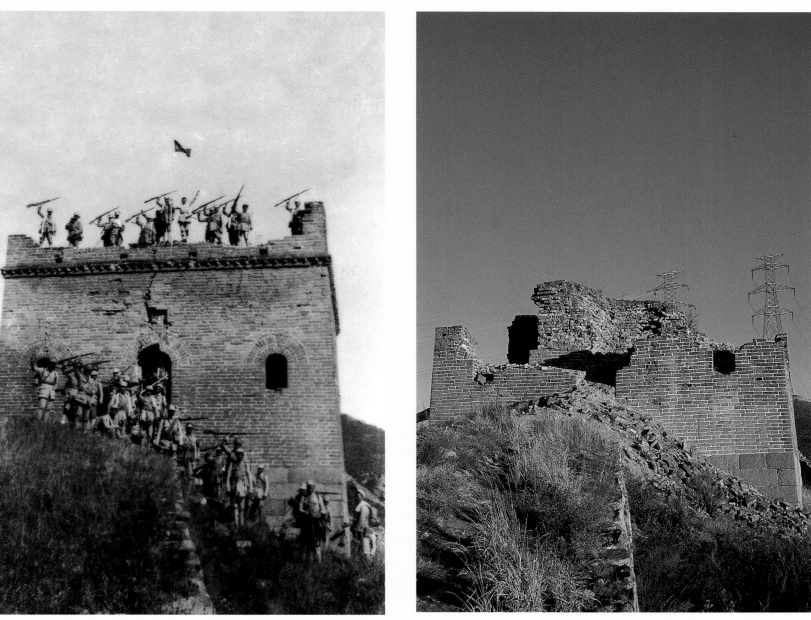

Victory tower: Sha Fei, 1937 (Wang Yan).

The tower fights a losing battle to survive: Lindesay, 2005.

149

'Picturesque Pass'

The original photograph was taken in 1908 by William Geil as he travelled west from Peking via Laiyuan toward Wutai Shan, one of the five sacred Buddhist mountains of China, which lies in the northeastern part of Shanxi Province.

'A superb view of the Great Wall erected by Emperor Wan Li' was how William Geil described this view. He admired the vista so much that his American publisher, Sturgis & Walton of New York City, reproduced it as an embossed image on the cover of limited editions for his personal use, which he inscribed and presented to friends. In the book he wrote that this one image – and his own words – failed to capture the true beauty of what he dubbed the 'Picturesque Pass':

'It is not the still picture, but the fleeting shadows of clouds, the changing light, which enriches the vision. From the sun comes a gleam that picks out the chain of Wall with its jewels of towers. Words fail to tell the splendours of this view. Had only we been able to photograph this wondrous landscape in all its glorious changes for one brief hour'.

Less glorious changes occurred in years to come, as captured by the new photograph. The crown's base remains, but the jewels have long since gone. Incidentally, thirty years after Geil, Sha Fei would take a photograph from the same position (see page 142), showing the towers still standing proudly.

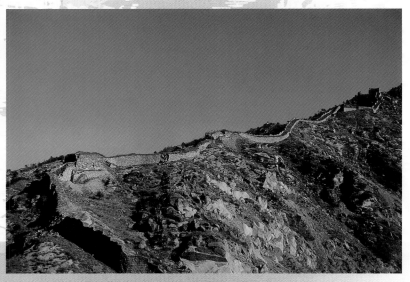

'The Picturesque Pass' without towers: Lindesay, 2005.

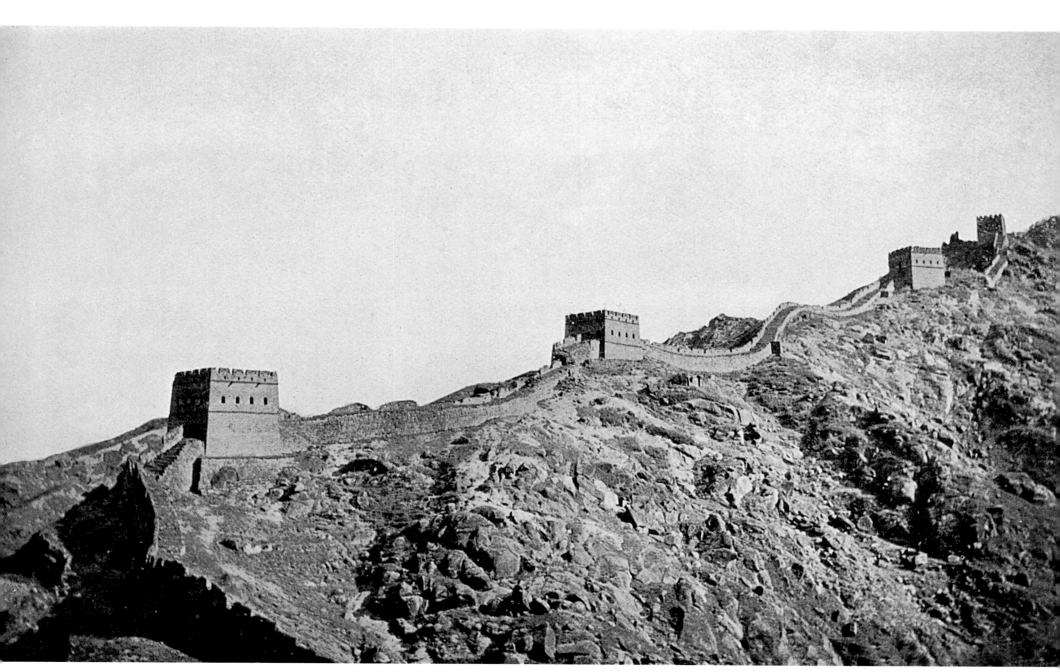

'The Picturesque Pass': Geil, 1908 (WL).

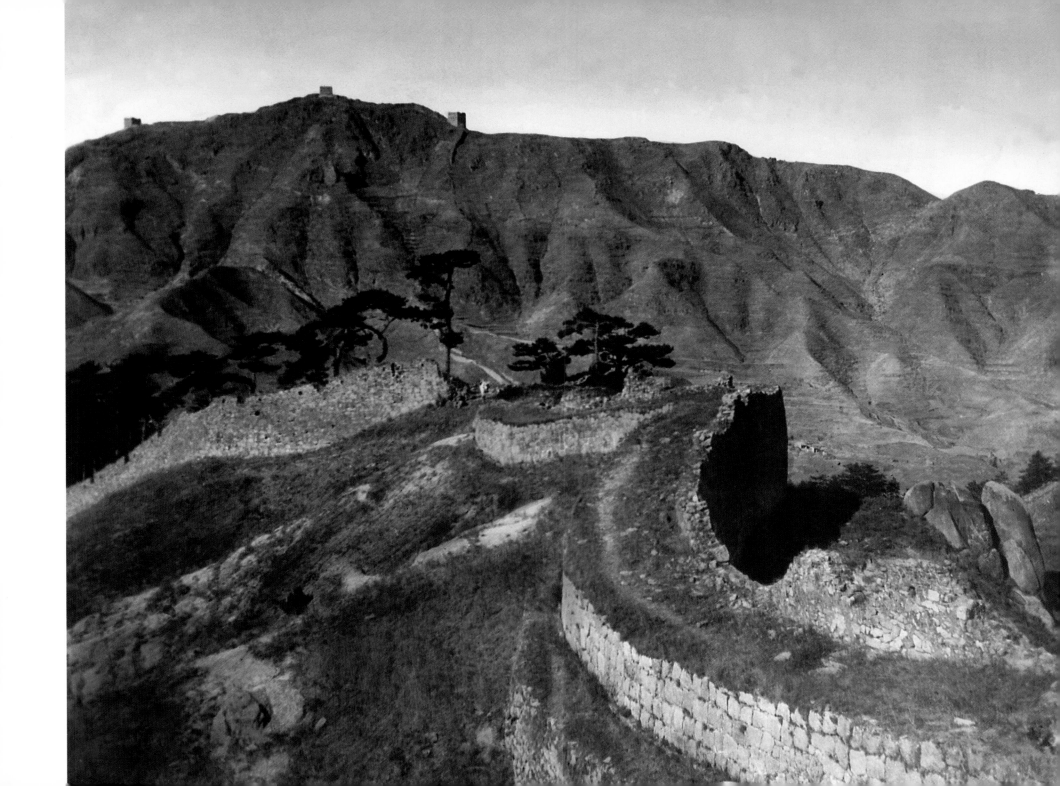

Pine Trees on Chajian Ridge

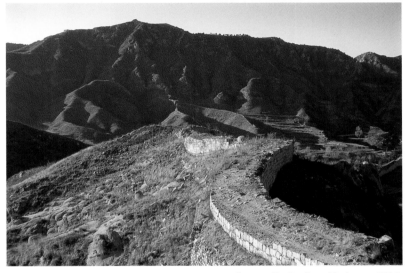

Wall near Chajianling: Lindesay, 2005.

The original was taken by William Geil in 1908, just 40 metres away from another of his exposures (see previous pages). This hand coloured copy, obtained from a magic lantern glass slide, came to be owned by Luther Newton Hayes (see page 218). It is a rare close up photograph of low-grade Ming ramparts built of roughly-quarried stone.

Battlements, also of quarried stone, are present for short distances, mainly on the section which plunges downhill to the left. In the background, through and to the right of the pine trees, is the walled village of Chajianling. On the mountain across the valley the form of three towers stand out prominently on the skyline.

Revisiting shows the collapse of the battlements from the foreground rampart, and the disappearance of the downhill section. The pine trees have been felled. On the skyline across the valley the towers have been levelled.

Left: Wall near Chajianling: a glass slide by Geil (1908), bequeathed to Newton Hayes in 1925 (Hayes Family Estate).

Geil's Caravan at Tangzigou

The original photograph was taken by William Geil in 1908 and shows four mules, presumably from his own caravan, taking a rest beside a stream near Tangzigou. The village lies nestled in a gorge beside the Wall, about 20 km off the old road between Peking and Wutai Shan. Three fine towers greet the caravan's return to the Wall's shadow.

Revisiting shows that all towers have withstood the passage of the last century virtually unscathed save for the collapse of their upper storey battlements. A new gravel road lies on the opposite side of the stream which is spanned by a single arch bridge.

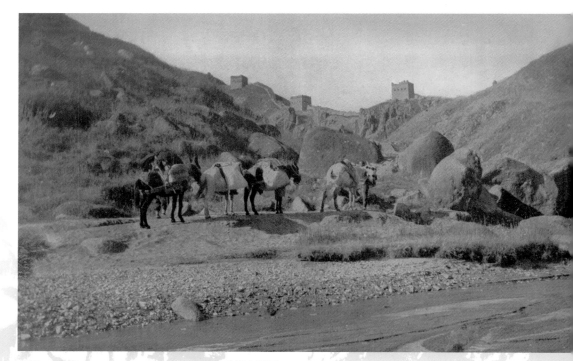

William Geil's caravan near Tangzigou: Geil, 1908 (WL).

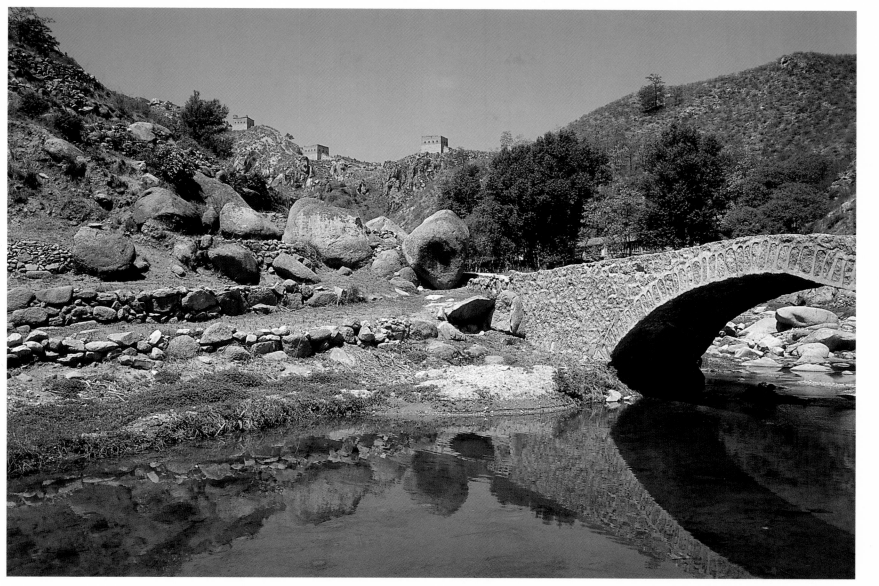

The approach to Tangzigou: Lindesay, 2006.

A carved keystone entrance to a watchtower above Tangzigou: Lindesay, 2004.

The entrance without the carved keystone: Lindesay, 2005.

Monster Face Keystone, Tangzigou

Both old and new photographs, only separated in time by 12 months, were taken by chance as I was making preliminary investigations in the vicinity of Futuyu searching for sites originally photographed by Sha Fei.

The earlier photograph dates from 2004. It shows the entrance to a watchtower, which bears a large carved granite keystone depicting a monster's face. Its placement denotes a tower of importance, possibly one used by the sectional commander of the defences. Such iconography was incorporated to ward off evil spirits.

I passed by the tower within a year of taking the earlier photograph, and was shocked to see that the keystone had been gouged out. A stone used by the thief to stand on was still there in the portal on the right, while freshly-broken bricks lay on the ground.

Niangziguan

The original photograph depicting Niangziguan, or The Woman General's Pass, is located approximately 70 km southwest of Laiyuan County on a section of the Great Wall well to the south of Beijing, and one which has a north-south trend. It was taken in 1980 by the Great Wall expert, author and photographer, Cheng Dalin (see page 177).

As a photojournalist in China's Xinhua News Agency, from late 1978 Cheng was assigned the special task of photographing the Great Wall.

In 1980, after completing a photographic mission in Henan Province, Cheng travelled back to Beijing via Niangziguan, a pass which from the 7th century had been of strategic importance, at that time commanded by a princess in charge of an entirely female contingent of soldiers.

The location was incorporated into the elaborate Ming Great Wall defence system in a section of the Wall constructed during the 20^{th} year of the Jiajing Emperor (1552).

The 1980 photograph shows the south gate of the pass well preserved and faced with quarried stone. Atop the archway there is a single storey gate tower on which is hung a horizontal board painted with four large Chinese characters reading: 'For Protection of the Imperial Capital'. Cheng took photographs of the gate along with ramparts of the adjoining Great Wall in the vicinity using his large format Linhof camera.

In 1995 Cheng returned to Niangziguan, this time to photograph activities being held to commemorate the 50th anniversary of China's victory against Japan. He was shocked to find that the single-storey watchtower above the gate had been demolished and replaced with a multi-storey edifice

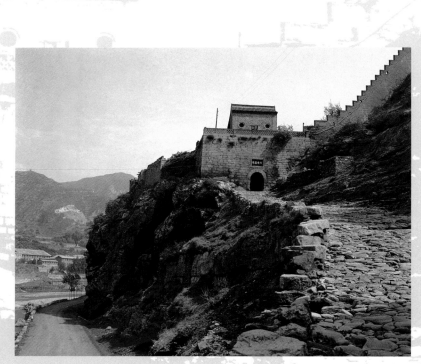

Niangziguan: Cheng, 1980.

with flying eaves. The wall, which originally had an outer facing of bricks had been rebuilt with stone.

Cheng lost no time in using rephotography to expose a folly that is diametrically opposed to the principle of rebuilding ancient structures, requiring preservation of original style, shape and architectural characteristics. He believes that the tragedy which took place at Niangziguan is a shocking example of how ancient structures can be lost by so-called 'repair' or 'rebuilding'.

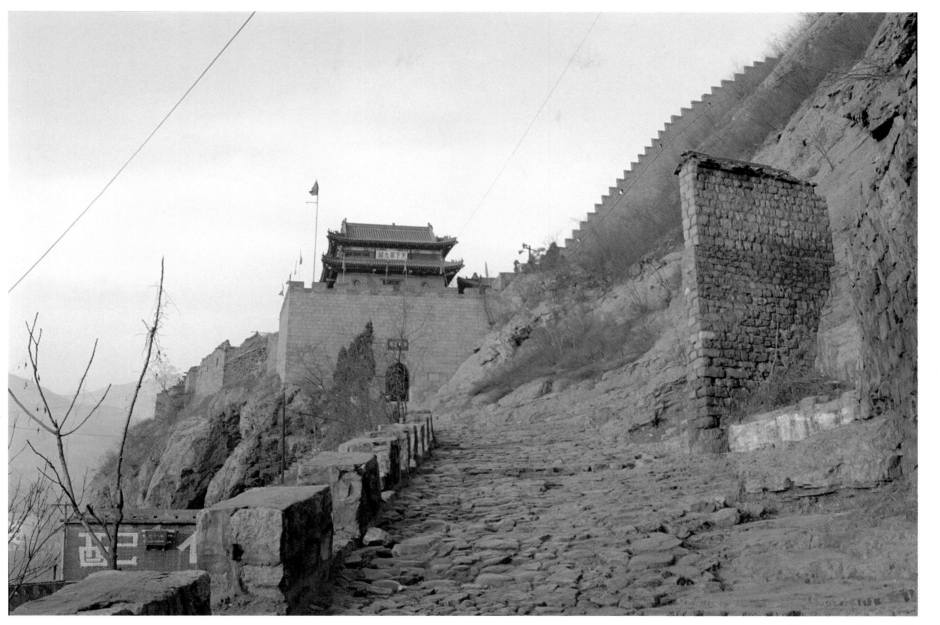

Niangziguan: Cheng, 1995.

Beijing

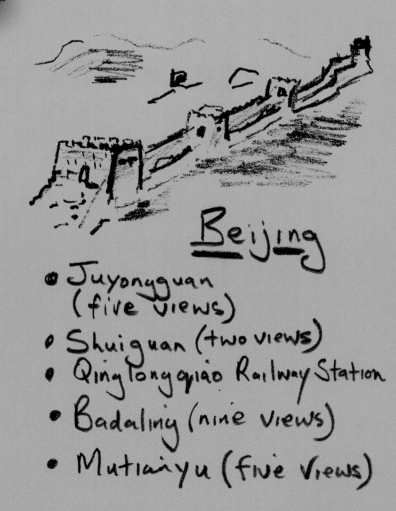

Beijing

- Juyongguan (five views)
- Shuiguan (two views)
- Qinglongqiao Railway Station
- Badaling (nine views)
- Mutianyu (five views)

Well preserved section of the Wall with complete battlements and capstones, Huairou County (Lindesay).

Sites rephotographed in the Beijing region make up the largest group by far of the seven areas covered by this study. This was the part of the Wall that made an indelible impression on all those who saw it, or even read about it.

Early photographs and descriptions captured the essence of an extraordinary wonder, one to rival the much closer and very familiar classical antiquities in Europe and the Middle East, whose great monuments had challenged writers and poets from time immemorial. It dwarfed all of mankind's other building efforts, and even before the first manned flight, it was predicted that the only vantage point from which the Great Wall's full extent and grandeur could be surveyed was one out of this world – in space, from the moon, or even further.

'Of all the works of man's creation the Great Wall is the only one that would be visible to the human eye from Mars', Luther Newton Hayes told an audience gathered in Shanghai on a November evening in 1927.

'We unanimously declared it the most impressive landmark we had ever seen', wrote Frederick Clapp in the American Geographical Review of New York in 1920.

Adam Warwick told *National Geographic Magazine* readers in 1923 that 'No description can convey an adequate idea of the immensity or grandeur of the Great Wall of China'.

William Martin suggested that 'To study the history of China there is no point as favourable as the summit of the Great Wall'.

Whether they had ridden along it on horseback for months, walked in its lee for weeks, spent a whole day there, stood on it for a brief hour, or stared at a photograph of it for a few minutes, the experience was awesome and everlasting.

The above-mentioned visitors certainly all stood on the Wall at Nankow Pass, the narrow defile en route from the north to the south, a route from steppe to plain, from cold to warmth, a division between herding and farming, between the nomadic and settled and between barbarian and civilized. Walking on the ramparts climbing out of the valley the Wall could be followed by eye much further, snaking its way along ridges, over peaks and plunging down into gullies, always continuing. It seemed to defy all difficulties in its way, it seemed flexible, yet was made of granite.

Beijing, capital during most of the Ming Dynasty, came to be shielded by the heavily-garrisoned Great Wall on its western and northern flanks after an epoch of relentless construction that probably continued in one place or another along the northern border, and especially in the capital region, from the year of the dynasty's founding in 1368 until its collapse in 1644. It was this effort, the longest, greatest and final chapter of almost 20 centuries of Wall-building by various dynasties that changed so impressively the geography of north China, especially that of Shuntian, the capital region. The Wall was a defence, but environmental art. It provoked imagination, admiration and misunderstanding. Yet the basic fact was its purpose: to prevent history from repeating itself. Each of the defence's blocks was hewn and every brick was baked to stop the Mongol hordes from conquering China once again.

Shuntian lay just south of Nankow Pass, the main gate to China. The ancient metropolitan area corresponds to part of today's Beijing Municipality, one of nine provincial-level administrative areas traversed by the Ming Wall, and it contains approximately 629 kilometres of extant border defences. On a per square kilometre basis, this is the highest concentration of Wall in the country, packed into an area equivalent in size to Wales of the United Kingdom, or the State of New Jersey in the United States.

The layout of the fortifications (not just a single line of Wall through the mountains, but with one major division which initiates the start of a major loop, scores of minor divisions created by the construction of tail spurs, and

even independent accessory walls and watchtowers) reflects the limitless effort invested by the military in its aim of providing comprehensive protection to the imperial seat of power.

In simplified geographical terms, a single main line of Wall from the east enters the Beijing region along its northeastern border of Pingu County with Hebei Province at Jiangjunguan, proceeding through Simatai and Jinshanling. To the west of Gubeikou it takes a southwestern route to the north of the Miyun reservoir, entering Huairou County at Hefangkou. West of Mutianyu at Beijing *Jie*, or 'the Knot', it divides into the northern and southern lines (also known as the Outer and Inner Walls). The Outer makes a northwestern route into Yanqing County and out into northern Hebei; the Inner proceeds west via Huanghuacheng, north of the Ming Tombs, into Juyongguan and towards Hengling and Zhenbiancheng on Beijing's western border with southwestern Hebei. These two walls eventually rejoin to the east of Pianguan and the Yellow River in Shanxi Province.

All of Beijing's Great Wall is constructed with rock, or a combination of quarried stone and brick. Wall made entirely of roughly cut rock is usually found in fairly high, inaccessible areas, which were unlikely to be targeted by large forces of nomads. The rocks here are usually natural 'field stones', gathered from the ground and perhaps chiselled minimally to create a flat surface for placing in the Wall face. Initially, these sections were built as dry walls without mortar, often to be upgraded at a later date by its application. At the opposite end of the quality spectrum were those sections defending the strategic passes, major or minor. The most critical in the Beijing area, and on the entire Wall, was Badaling, dubbed the key to the capital and empire, and widely considered to show the highest standard of construction.

Fortifications within the Juyong Pass were four layers in depth, with the two most important elements being Badaling at the top of the valley, and the Juyong Fortress to its south.

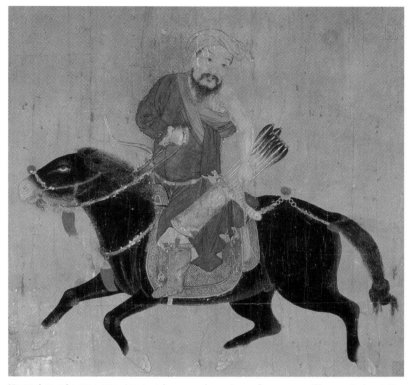

Mongol cavalryman carrying two bows and a quiver of arrows, a Ming period painting on silk (Courtesy of Victoria & Albert Museum, London).

The Wall at Badaling is built on extremely large and long rectangular quarried blocks of light pink granite, some more than two metres in length and one metric ton in weight, topped with brick-laid pavements and battlements. Towers are separated on average by little more than 100 metres, standing out prominently as hill forts, their dark eyes peering out as if still on duty, giving the Wall its character, for they are its spine, where the troops were garrisoned.

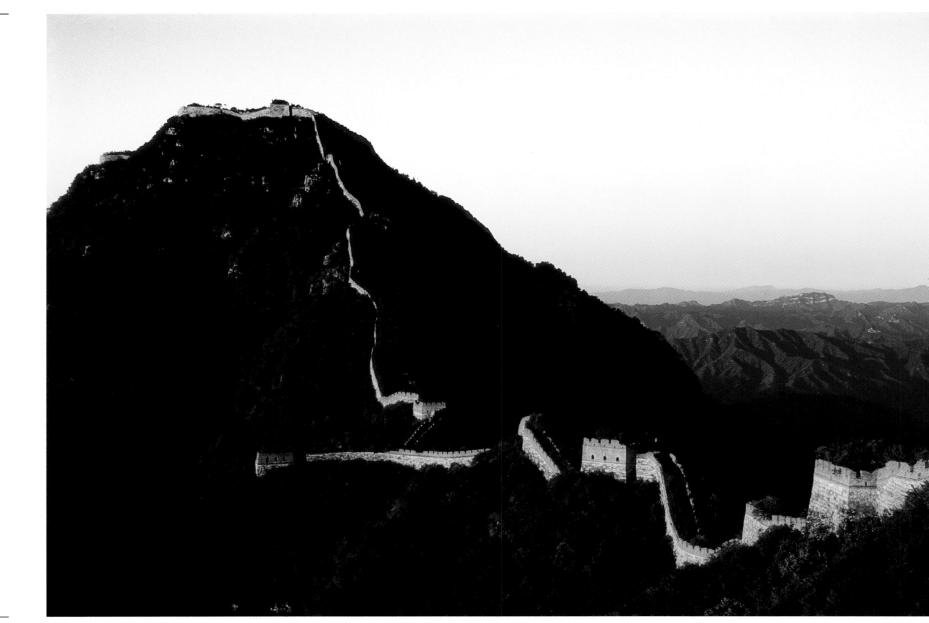

The main eastern division, known as Beijing *Jie*, or the Y, viewed from the north, Huairou County.

Fortifications, however impressive, merely constituted the hardware. The software – military command, men and motivations levels – using the Wall as their shield and platform of defence and counter-attack would ultimately dictate the outcome of any conflict. South of Badaling is the Juyong Fortress, actually an enclosing wall, 6.5 km in circumference, which functioned as the military headquarters of the valley, the base for the top brass, with their offices, barracks of reinforcements, arsenals of the most technologically advanced weapons in the world, and a temple to the God of War. At times its population was 10,000 strong.

Badaling was photographed extensively by the Wall's early travellers. Perhaps 98 percent of vintage Great Wall photographs in collections or appearing on the market today depict the fortifications there, yet relatively few are quality images in terms of their composition, exposure, size or state of print preservation. Some 'repeat' shots prove to be 'casual' or 'coincidental' rephotographs, and they are useful for monitoring changes to the Wall between the late 1860s and 1940s, itself a span of 70 years that brought changes by nature or wrought by war.

Apart from Badaling and the Juyong Fortress, there are precious few other views of the Wall blockading side valleys in between, such as Shuiguan and Qinglongqiao. Elsewhere in the Beijing region coverage becomes even scarcer. Only William Geil ventured extensively into the mountains, exposing the only known early images of Mutianyu, Lianhuachi and Huanghuacheng.

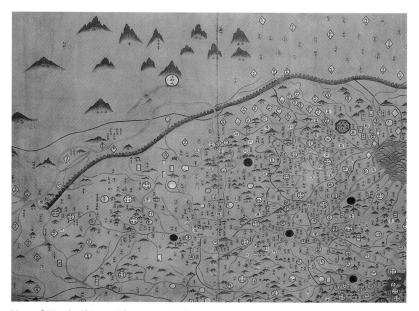

Map of North China with postscript by Yan Yiqi, copied from the original, which is now lost. Beijing is clearly marked (yellow octagon), with the vulnerability of the capital close to the border region all apparent (Beijing Library).

John Thomson: Master Photographer at Nankow Pass

One fine autumn afternoon in 2004 I travelled out from my home in Beijing to the Shuiguan section of the Great Wall in the Juyong Pass, approximately 70 km northwest of the city.

I was carrying a copy of a beautifully-toned albumen print said to have been produced c. 1871 and attributed to John Thomson (1837–1921), a Scot and pioneer of the genre of travel and social documentary photography. Thomson had studied under David Hill and Robert Adamson in Edinburgh, researchers who had improved upon Henry Fox Talbot's (a contemporary of Daguerre) work of reducing exposure times to a matter of seconds and using a negative method.

Although I was revisiting the Shuiguan Great Wall with Thomson's photograph in hand to rephotograph the fortifications and record the changes there, it was the change in both accessibility and photographic technology that were uppermost in my mind that afternoon.

John Thomson, whose photographs were published in *Illustrations of China and Its People* (London, 1873), described the means of his journey out to the Wall in a brief caption for a photograph of what he called a 'Pekingese Mule Litter':

'This is the usual conveyance adopted by the Chinese, if they wish for ease and comfort when they visit localities outside the Great Wall. Two long shafts support the litter and are harnessed at the ends to the backs of two mules. It was to this chair that I consigned myself on the occasion of my journey to the Great Wall'.

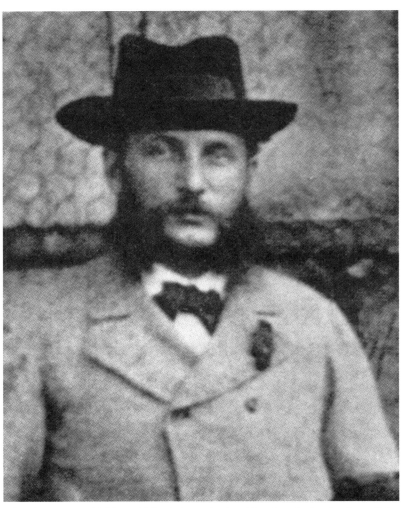

John Thomson, c. 1875 aged 38, photographed on his return to London from China (WL).

Despite the ease and comfort provided by this vehicle, it took Thomson two days to reach his destination, probably after an overnight stop at Nankow (Nankou). He was followed by a number of mules carrying his photographic equipment, normally poled by eight bearers. In addition to the arduous travel up a valley where banditry was rife, and the concern for the safety of so much breakable equipment, the actual photographic work that he was soon to engage in was quite a scientific rigmarole.

I used a digital camera for my test photos. An hour later I was back in Beijing, looking at images of the location on my computer, and pondering where was the best place to rephotograph from, and at what time of day. Thomson might have been awe-struck at my speed and our technology, but I was astounded by his tenacity, patience, science and art.

Shuiguan means 'Water Gate'. This name describes the location, a section of the Great Wall through which a stream flowed below a portcullis. In Thomson's photograph I could see a stream bed in front of the Wall. I imagined him placing his large camera on a sturdy tripod beside it, and then using the water from the stream, essential for the wet collodion plate process, of which he was a leading proponent. Meanwhile, a tent functioning as a portable darkroom lay erected at the ready, with dishes, funnels, measures and scale, bottles of chemicals and glass plates within.

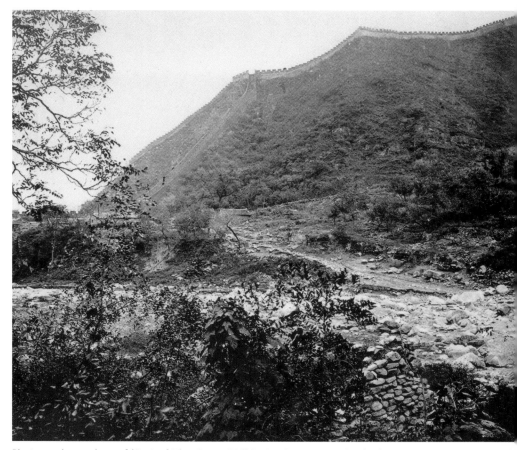

Photograph on glass of 'Part of The Great Wall in Nankow Pass, 1871'. This is actually Juyongguan. By John Thomson (The Wellcome Library, London).

The masterpiece that Thomson produced under these circumstances of early expeditionary photography, and my rephotographed version, can be seen on page 179.

Proceeding north on his journey Thomson reached the most spectacular section of Wall at Badaling. Here he concluded his photographic odyssey, and the photograph produced was chosen as the final image in his book (see pages 190). 'My readers doubtless share with me in feeling that no illustrated work on China would be worthy of its name if it did not contain a picture of the Great Wall', he wrote.

Having spent more than three years in China, from his entry at Hong Kong in 1868 to his departure from Tianjin for London in 1872, Thomson returned to London. He opened a studio on Grosvenor Street, and as a fellow of the Royal Geographical Society provided tuition in expedition photography to members before they set off to explore. Doubtless, the travel photography standards that John Thomson forged helped to inspire the first extensive explorations of more far-flung sections of the Great Wall, distant from the capital.

Five Views of Juyongguan

After passing by watchtowers overlooking the southern entrance of the Nankou valley, Juyongguan was the second group of Great Wall fortifications seen on the outward trip from Peking for those heading for Badaling, and also the first large-scale defences, though independent from the main line. All early road travellers had to pass by its ruins and through its archways, yet surprisingly few bothered with photography here.

A bird's eye view of today's Juyongguan reveals the structure as a large fortress per se, describing in shape a huge loop, approximately 6.5 km in circumference strung out across the valley. On the mountainsides the ramparts are dotted with watchtowers, while tall gate towers with archway passages guard the valley floor.

A number of photographers focused on the Yuntai, or Cloud Platform, through which the old road once passed. Bearing Buddhist bas-reliefs, six scripts were also visible within its hexagonal passageway. Originally the platform formed the base for a pagoda constructed during the Yuan Dynasty. While most buildings from the conquest-dynasty period were destroyed after the restoration of native Han rule in 1368, Yuntai was spared on account of its Buddhist relevance.

Juyongguan was reconstructed in the early 1990s. Despite its proximity to Badaling, developed as the main tourist site for the Great Wall since the 1950s, Juyongguan was rebuilt on account of not only its historical importance, but also to provide Changping County with a tourist site to rival Badaling in Yanqing and Mutianyu in Huairou.

Following this general site introduction, individual and detailed histories and discourses are written for each pair of photographs.

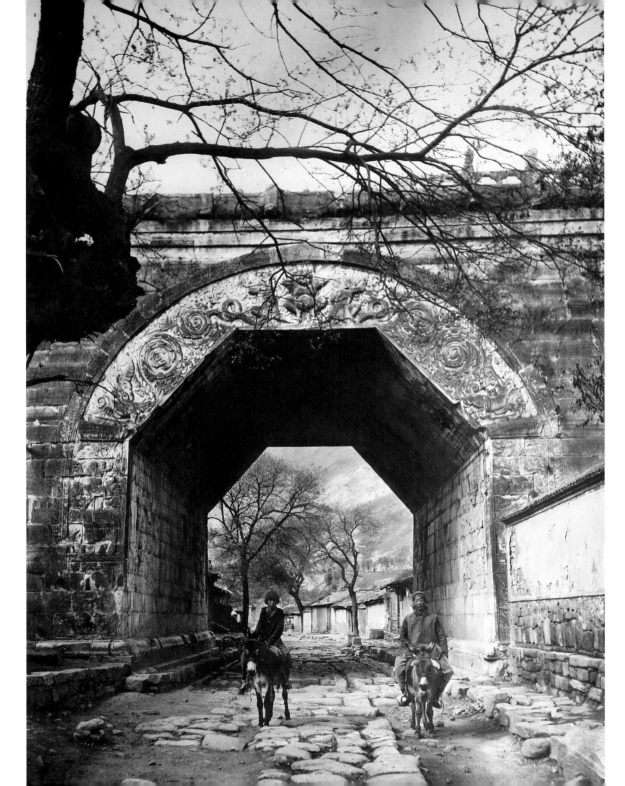

Yuntai, or the Cloud Platform, also known as the Language Archway, as it displays six scripts within its portals; hand–tinted photograph of early 1930s measuring 38 x 27.5 cm, from Meili Studio, Nanchizi (Street) Peking (WL).

169

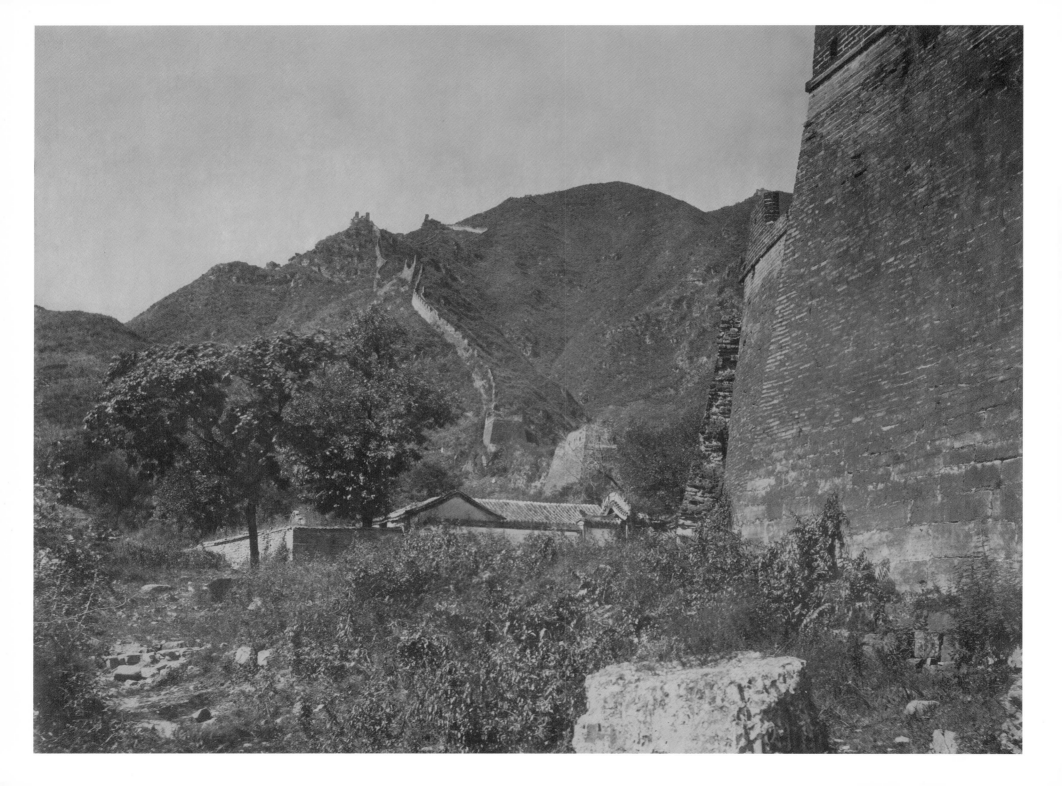

Juyongguan (southwest)

Southwest quadrant of Juyongguan: Lindesay, 2004.

The original was taken c. 1870 and shows the southwest quadrant of the Juyong Fortress Wall. It is a beautifully toned and albumen print of a quality and composition which suggest it was the work of a competent professional photographer, perhaps John Thomson.

The photographer positioned himself about 20 metres away from the old road. This framing contains the base of the massive gate tower on its right hand side, and the ascent of the ramparts up the so-called West Mountain.

Revisiting shows the line of the Wall to be clearly visible, with the newly-produced construction materials contrasting with the surrounding re-planted forests.

Left: Southwest quadrant of Juyongguan: an albumen print, 27 x 20 cm, possibly Thomson, 1871 (WL).

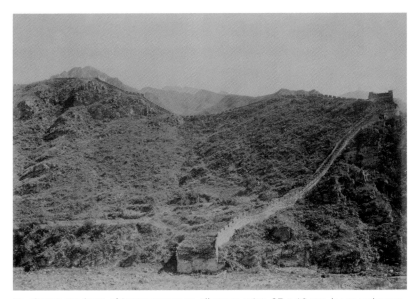 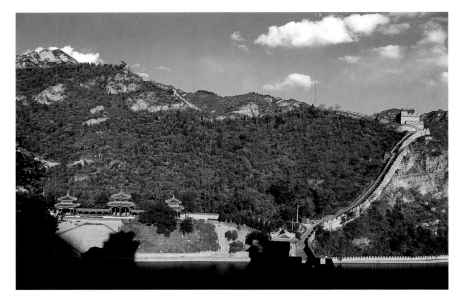

Southeast quadrant of Juyongguan: an albumen print, 27 x 19 cm, by an unknown photographer, c. 1880s (WL).

Southeast quadrant of Juyongguan: Lindesay, 2005.

Juyongguan (southeast)

The original, by an anonymous photographer, was taken c.1880 and shows the southeast quadrant of the Juyong Fortress Wall.

It appears as though the photographer was positioned quite close to the road for the exposure, pointing his camera across a gully to capture a distant view of the ramparts ascending the so-called East Mountain from the dry river bed running across the foot of the frame. During the Wall's operational period there would have been a water-gate facility across this river.

The ramparts appear to have been fairly-well preserved at this time: in several places crenulated battlements are standing intact on the outside face of the Wall, while those on the inside face are lower in height and lack the embrasures and loopholes, a design characteristic of the defences in the entire valley.

Revisiting shows the reconstruction, as well as the appearance of a platform with three pavilions linked by balustrades, just above the river, which is now a small lake.

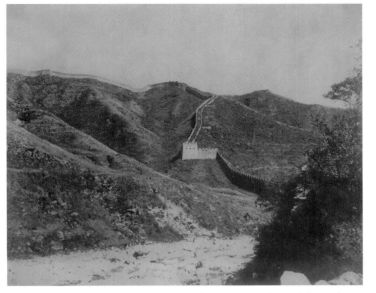

Northeast quadrant of Juyongguan: an albumen print, 24 x 19.5 cm, by an unknown photographer, c. 1880s (WL).

Northeast quadrant of Juyongguan: Lindesay, 2005.

Juyongguan (northeast)

The original, by an anonymous photographer, was taken c. 1880 and shows the northeast quadrant of the Juyong Fortress Wall. Ramparts ascend the East Mountain from the dry river bed in the foreground.

Revisiting shows reconstruction. At the lower right corner of the composition a tower is included, remains of which in the older image were hidden by trees. The rephotograph shows that there is a bifurcation at the top of the ridge: a rampart turns to the right to link up with the rest of the encircling fortress Wall, while the rampart running along the left ridge is a tail offshoot.

Juyongguan (northwest)

The original was taken by Adam Warwick (see pages 46, 186, 266), commissioned by the National Geographic Society in Washington D.C. to write a feature story on the Great Wall. Published in the February 1923 edition of the society's magazine, the image was likely exposed the previous year.

To take this photograph, Adam Warwick was positioned somewhere on the northern side of the East Mountain, about 200 metres east of the road and 30 metres above the valley floor. This position is very close to the railway line of today and yesteryear. It is quite feasible the picture was taken from the train window, perhaps as it made a brief stop on its journey up the pass toward the destination of Qinglongqiao (see page 186).

Warwick's photograph is an interesting and varied composition. At the base of the frame are small cultivated plots tended by farmers whose homesteads were clustered within the ancient walls of Juyongguan. Above this cultivation is a triangular piece of steep land bounded at each apex by remnants of three towers of differing scales. On the valley floor, at bottom left and right, can be seen the platform bases of what were once multi-storied gate towers. From each of these structures, two separate ramparts were built up the steep mountainside, brought to convergence at a two-eyed (windowed) tower. From here a single line of rampart ascended to the peak, from where it turned south (left) to join fortifications of the southwest quadrant.

Rephotography from Warwick's vantage point captures the routing of the Badaling Expressway at the base of the frame, which passes along the valley floor and the centre of the fortress. The lower left apex of the triangle has been rebuilt as a gate tower. The old road no longer passes through its archway beneath – a new minor road has been built along a line about 30 metres higher up.

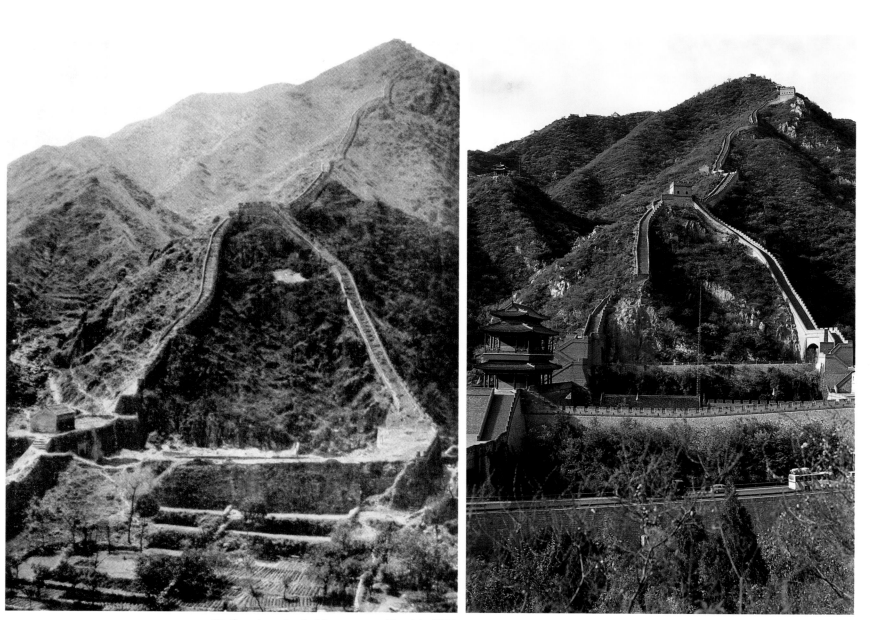

Northwest quadrant of Juyongguan: Warwick, 1922.

Northwest quadrant of Juyongguan: Lindesay, 2005.

Base of Juyongguan Gate Tower: Cheng, 1979.

Juyong Fortress Gate

The original photograph was taken by photojournalist Cheng Dalin in 1979 (see page 158). With the Cultural Revolution (1966–76) over and a growing awareness of the history it had destroyed, Cheng was continuing with his long job to document the Great Wall in photographs for the state news agency. He took this photograph of the remaining base of the fortress gate bearing the pass name with his agency-owned Linhof camera.

He would come back to Juyongguan on scores of occasions, both as a photographer and a leading adviser during its reconstruction in the mid-1990s.

Returning in autumn 2004 with a copy of his old photo, he looked up at the reconstructed gate tower and expressed satisfaction at the eventual result that he said he could never have imagined happening back then. But looking around within the fortress at what he called inappropriate and excessive tourism and entertainment facilities, he felt dismayed at the uncomfortable juxtaposition.

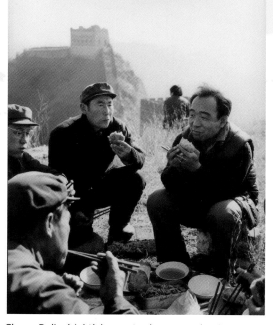

Cheng Dalin (right) began to document the Great Wall in photographs from the late 1970s.

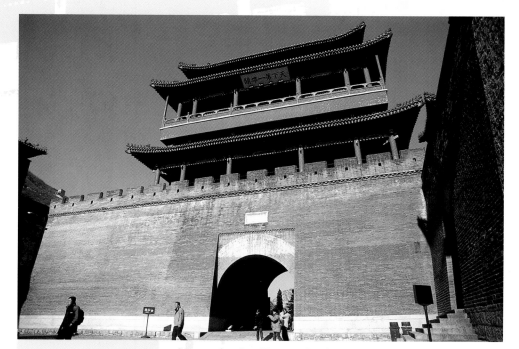

Juyongguan Gate Tower with rebuilt upper structure: Lindesay, 2004.

177

Shuiguan

The original photograph is a finely composed image preserved as a richly-toned albumen print, and although undated and unsigned, is attributed to John Thomson, therefore 1871. The focus of the photograph, occupying the right half of the composition, is definitely that section of the rampart whose parallel battlements stand out saw-toothed against the surroundings. The position of the old Water Gate is obscured by trees on the far right side of the frame.

Water gates were built in many places along the Wall. Arching over streams their design permitted the passage of water under the fortifications.

For this case study I decided to depart from my standard goal of striving to achieve precise rephotography. Instead I took the liberty of standing back to provide viewers with a wider angle view (see page 52).

The new photograph therefore, a 'casual rephotograph', illustrates the transportation revolution that has occurred since Thomson's era. Dramatically captured are the northbound lanes of the Badaling Expressway, one of its many tunnels and the toll gate for vehicles leaving the road at the Shuiguan exit.

In the background the Wall itself is rebuilt, and provides one of four places in the Juyong valley for tourists to access the fortifications.

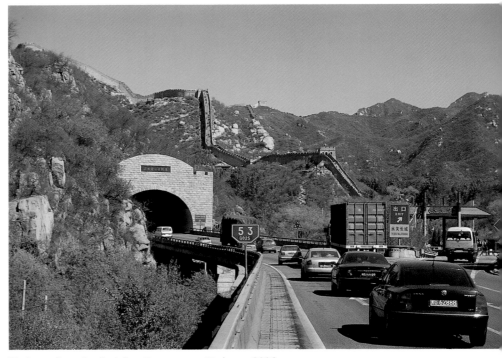

Shuiguan from the Badaling Expressway: Lindesay, 2006.

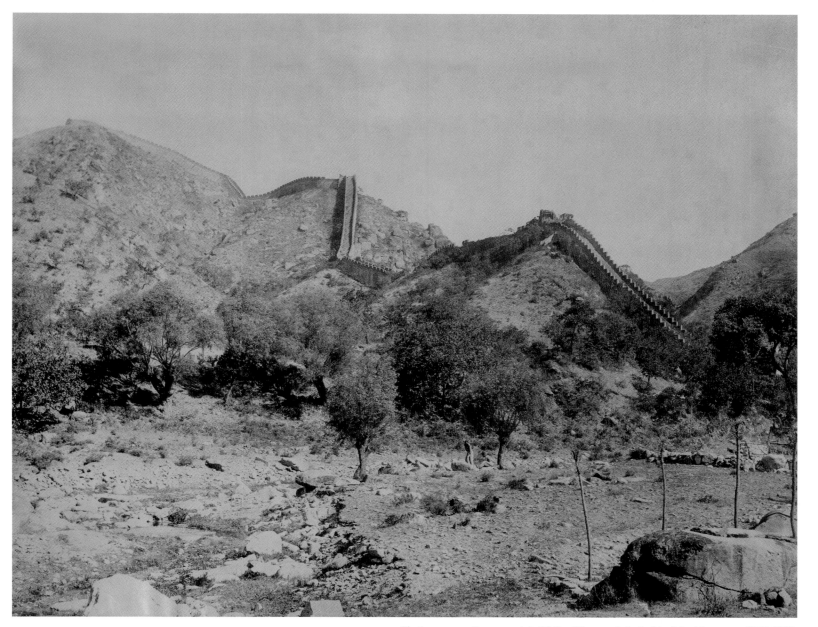

Shuiguan: an albumen print, 26.3 x 20 cm: attributed to John Thomson, 1871 (WL).

Shuiguan (view from the north)

The original photograph was taken by Herbert Ponting (1870–1935), a banker turned professional photographer from Great Britain, who migrated to the United States where his camera skills soon attracted commissions from publications including *Harper's Weekly and Leslie's Weekly*. In 1907 he travelled on assignment to Japan and China via the Trans-Siberian Railway.

Ponting took at least three successful photographs of the Great Wall in the area. As well as this lesser known Shuiguan view, he captured two other enduring images of Badaling (see page 204). He also travelled to Shanhaiguan in order to photograph the fortifications there, producing images which were eventually marketed by Underwood & Underwood in the United States as magic lantern glass slides (see page 44).

Later, Ponting achieved his greatest fame for photographs and films of the British Antarctic Expeditions led by Captain Robert Falcon Scott from 1910–14. He recorded that experience in a book, *The Great White South*, published in 1921.

In the foreground of Ponting's Shuiguan view is the valley road with several mule carts. The two vehicles closest to the camera were possibly used by his party making its way up to Badaling. In the background looms the Shuiguan Great Wall. The section on the far left descends steeply to the site of the water gate.

Owing to a change in level of the land, now lower due to the building of the road or railway line, it was difficult to obtain a more precise rephotographic result, particularly with regard to the relative positions of the Wall and the mountain behind it.

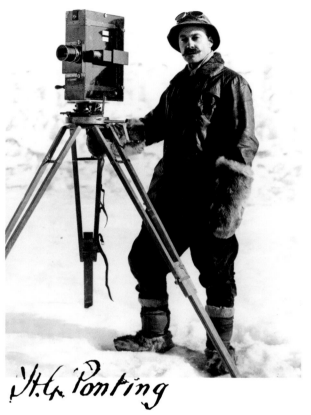

Herbert Ponting in the Antarctic c. 1910–14 (Royal Geographical Society).

Revisiting shows the Wall at Shuiguan to be rebuilt between the gate and for a short distance beyond the first tower. Further on the Wall exists in a wilderness condition.

The old rocky road has been replaced by a tarmac road. This in turn has become known as the old road, ever since the routing of the expressway up the valley, which is out of frame to the right.

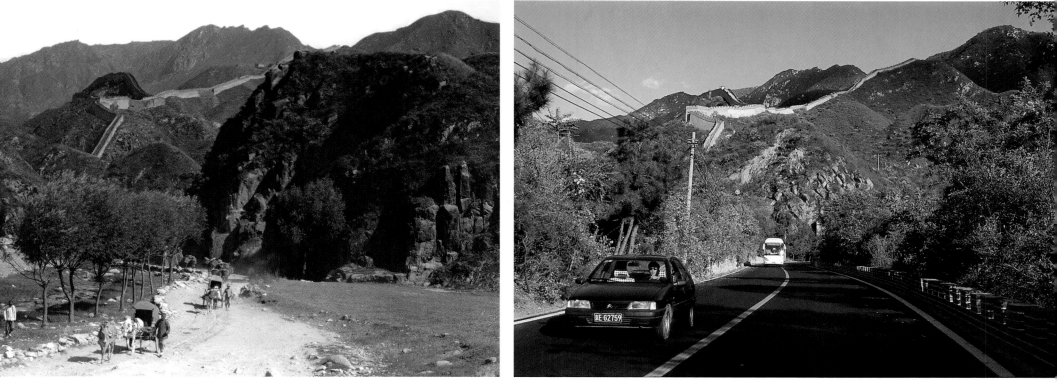

View south toward Shuiguan: a silver gelatine print,
Ponting, 1907 (Photolife Agency).

View south toward Shuiguan: Lindesay, 2005.

PEKING

Juliet Bredon: Taking Travellers for a Stroll at the Wall

Visitors to Peking in the early 20th century had a choice of either 'Baedeker's or 'Cook's as their guidebook. Or they could be guided 'personally' by Juliet Bredon, whose *Peking: A Historical and Intimate Description of its Chief Places of Interest* (Shanghai, 1919) aimed to fulfil the role of 'friend to visitor and resident alike, to take you by the arm and stroll through the city and its suburbs'.

With her penchant for being a painstaking observer, and as a resident and student of Chinese history, she doubtless made many trips to the Great Wall.

'I have no intention of giving long lists of temples or palaces which ought to be seen as quickly as possible…. Better far to leave half the monuments unseen and see well the rest; to see them not once but again and again, to watch them in many lights and moods till they become part of life and life's recollections'.

She recommended Badaling for the Wall, by train, and a two day trip if possible.

'The classical excursion from Peking which no tourist, however hurried, should omit, is to the Great Wall of China via the Nankou Pass. There are many other places where this impressive barrier may be seen, but nowhere is the fortification in better preservation, nowhere grander. And Nankou has the advantage of being easily accessible by train with clean and sufficiently comfortable hotels.

From Peking the trip to the Wall and back can be done in one day. But those who have the time will not regret giving two whole days to the expedition and an extra afternoon to wandering in Nankou itself. The quaint old town is the

Juliet Bredon in Peking, c. 1922: a small photograph tipped into a signed copy of her book and presented to a reader (WL).

first link in the chain of defences built across the narrow defile beyond to check barbarian invasions. A short distance above the town, the hills gather in and we come to the entrance of the gorge guarded by four watchtowers.

The journey to the top of the pass may be made by train. How prosaic, the stranger exclaims, to view such a renowned sight from a car window! But the railway line is interesting. All credit to the Chinese engineer who overcame enormous difficulties in building it – as the steep gradients, the numerous tunnels (one of which actually goes under the Great Wall) and the elaborate stone

revetment work, prove.

After an hour's climbing the train stops at the little station of Ch'ing Lung Ch'iao ("Bright Dragon Bridge"). Thence it is an easy walk of half an hour along the old highway to the Pa Ta Ling[1] gate at the top of the pass (2,000 feet above sea level). On either side, the Wall wanders along the crests of the hills, scaling peaks which it seems impossible even the foot of a man could climb. Not a soul can be seen save a donkey driver, who has tied his beast to the old cannon lying in the grass (the last of the treasures of antique weapons and armour discovered in one of the towers.) and a shepherd who has come up from his village in search of pasturage. He sits watching his flock scrambling among the broken bricks — a pretty sight! The stillness is broken only by the occasional whistle of a train softened by distance, or the shrill cry of a hawk pursued by a high-hovering eagle'.

[1] Badaling.

Donkeys that once grazed all day soon had new roles to play, providing photo opportunities to the friendly foreigners coming from the south. Locals acted as guides, walking the travellers along the ramparts. This interaction between visitors and locals marked the advent of tourism that would change the face of the Juyong Pass almost beyond recognition.

After the lull during the war, piecemeal reconstruction began in the 1950s, and with the building of an expressway in the late 1990s, access time from Beijing was reduced to less than two hours. Nowadays, the average foreign package tour visitor may be lucky to get 40 minutes on the ramparts, while many tourists with domestic groups are even more hurried. Bredon would have been horrified.

'It is not a hurried visit to one or two sights which will enable anybody to feel their spell, but a long and familiar friendship that endears them to us, and gives each a motive and significance entirely unrecognized and unsuspected by the passing eye'.

Cover of a brochure printed by China National Railways for a special excursion to the Great Wall at Qinglongqiao for passengers on the S.S. Resolute world cruise. Dated 11 April 1934, the brochure contains a menu, drinks list and timetable. Passengers first travelled by train from the port of Qinhuangdao to Peking (WL).

Long gone too is the stillness, now replaced by the drone of heavy traffic, the touting calls of vendors and the repetitions of tour-guides through megaphones. Above the din, dozens of foreign languages can be overheard on the crowded ramparts, and many Chinese dialects, hinting at the wide provenance of visitors from all parts of the country, all echoing the thrill and mystery of walking the Wall.

Without doubt, from its early serenity and wild grandeur of Bredon's era, to its mass convenience appeal for whistle-stop tourists today, with its repaved ramparts, and all the schlock that comes with modern tourism, Badaling has always been, is now, and will continue to be, the world's favourite part of the Great Wall.

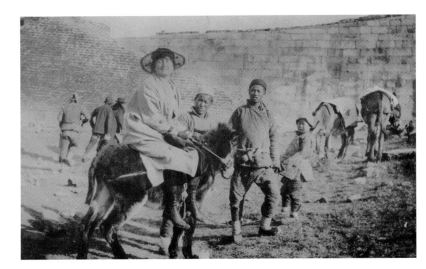

'A visit to the Great Wall', 1919 (WL).

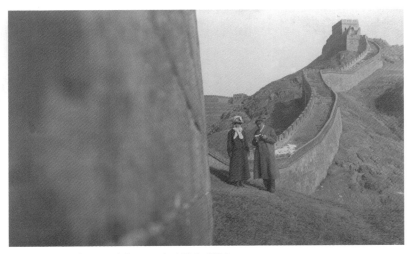

American couple at Badaling, early 1930s (WL).

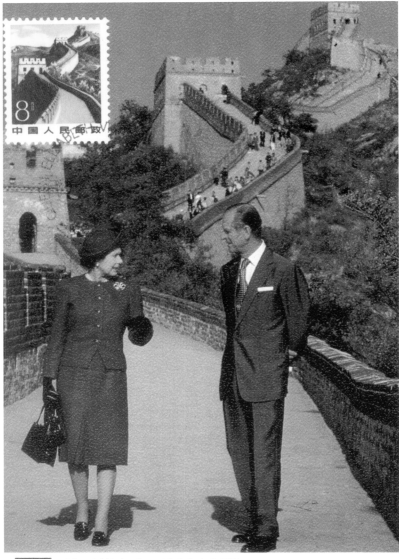

H.M. Queen Elizabeth II and Prince Phillip visiting Badaling, October 1986.

U.S. President Richard Nixon, accompanied by the First Lady, visiting Badaling, February 1972, 25 x 20 cm (White House Photo).

Qinglongqiao Railway Station

A train at Qinglongqiao railway station: Warwick, 1922.

The original was taken by Adam Warwick (see pages 46, 174, 266), on assignment for *National Geographic Magazine* in 1922, and shows a train at the 'Clear Dragon Bridge' Railway Station, the alighting place for passengers visiting the Great Wall at Badaling.

Departing Chien'men (Qianmen) Railway Station in the centre of Peking at 8.50 am travellers could reach Chinglungchiao (Qinglongqiao) at 12.15 pm, returning to the city on the 2.30 pm departure, arriving back by 5.55 pm in time for dinner. A day trip was therefore possible, although the itinerary only left visitors with 2 hours 15 minutes at the Wall. Fortifications hanging on the cliffs around the station were too steep to ascend, making Badaling, 30 minutes' walk away, the only plausible option. It is likely most arrivals rode mules up to the ramparts.

The station is no longer the busy terminal it was in the 1920s when the majority of visitors reached Badaling by train. By the 1950s some 32 trains a day passed through Qinglongqiao. Nowadays three to five trains pass through daily.

Revisiting at noon on a Monday shows the Beijing to Moscow train (Trans-Siberian) pulling into the station. Above, the Wall still clings to the steep mountainside. Although the tower has collapsed, the saw-tooth battlement below is now more complete, although there is no record of it ever having undergone formal renovation. This was probably the work of the railway bureau whose workers carry out revetment work on cuttings and cliffs throughout the valley to prevent rock-falls onto the line.

The Peking-Kalgan (Zhangjiakou) railway line, which passes through the Wall at Qinglongqiao and under it further north, was completed in 1909 under the auspices of Zhan Tianyou (1860–1919), who studied civil and railway engineering at Yale.

According to Qinglongqiao's stationmaster Yang Cunxin, the impetus behind the railway's construction was to provide a modern alternative to

The Trans–Siberian train approaching Qinglongqiao
railway station: Lindesay, 2006.

Yang Cunxin is stationmaster at Qinglongqiao, like his father
was before him.

camel haulage, which by 1905 was responsible for the transportation of
20,000 *dan* (100 *jin* / 50 kg capacity grain boxes) a day up and down the
valley, to and from Peking. The project, authorized by the Qing government,
was a rare example of the adoption of things modern by an imperial system
that had for so long shunned progress.

Yang explained that Zhan Tianyou's chosen route, though the shortest
of three he proposed, was technically the most demanding. His designs
overcame the problem of steep gradients in the Juyong Pass by using
two locomotives, one pulling and one pushing, as well as switchbacks
and tunnels. A bronze statue of the engineer, responsible for China's first
domestically-constructed railway, stands in the station garden.

The Old Road at Badaling

The original was taken by palaeontologist Roy Chapman Andrews (1884–1960) of the American Museum of Natural History (New York) in 1925 and shows six motor vehicles parked on the road just south of the Wall at Badaling.

Chapman Andrews was returning from one of his expeditions in Mongolia to Peking, where he had acquired a courtyard residence, his base for a series of sorties into the gobi during the mid 1920s. Utilizing motorized transport he succeeded in covering huge distances and collected large quantities of dinosaur fossils, among them the first dinosaur eggs, in his fleet of Dodge vehicles fuelled with gasoline provided by the Standard Oil Company. However, north of Kalgan (Zhangjiakou), beyond the reach of freighting via railway, the motor expedition became completely dependent on traditional desert transportation. Camels were used to establish gasoline dumps along pre-planned routes averaging 4,000 km in length.

The view captured by Chapman Andrews is typical of his character – unconventional – taken neither on the Wall nor from the road leading up to it, but from a prospect on a mountain overlooking it, and as such, a rare perspective. Looking toward the northwest we see the old road curving around and passing through the semi-derelict *guancheng*, or double-gated enclosure. To the left (southwest) the rampart climbs gently away and above the strategic pass.

Revisiting shows the Wall reconstructed, the road paved yet maintaining the same approach, and much thicker hillside vegetation signalling the onset of Beijing's golden autumn season. A car park, crowded with tour buses, stands less than 100 metres away from the Wall.

Chapman Andrews' motorcade may have been the first to drive through the ancient portal here, as vehicles still did at the time of writing, but these days are numbered. A new road will be routed under the Wall, part of a comprehensive redesign project planned for Badaling.

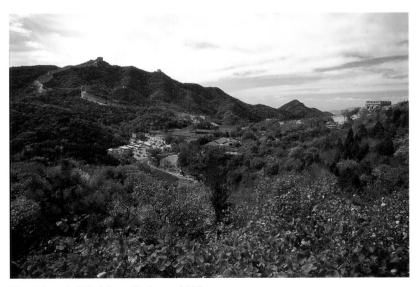

The old road at Badaling: Lindesay, 2005.

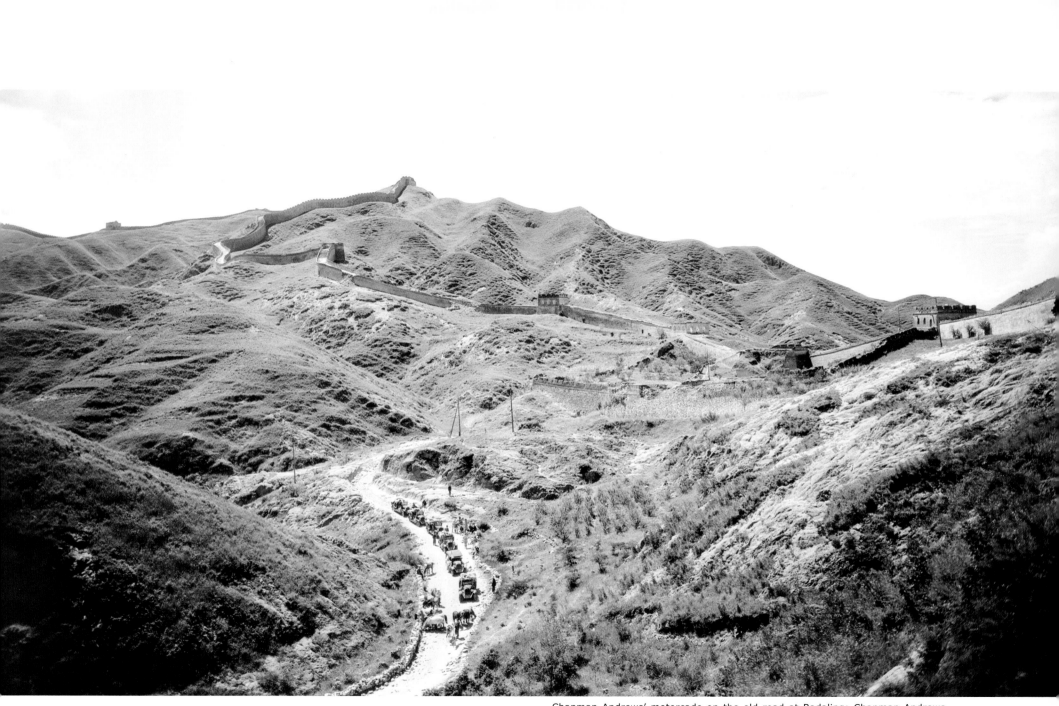

Chapman Andrews' motorcade on the old road at Badaling: Chapman Andrews, 1925 (American Museum of Natural History).

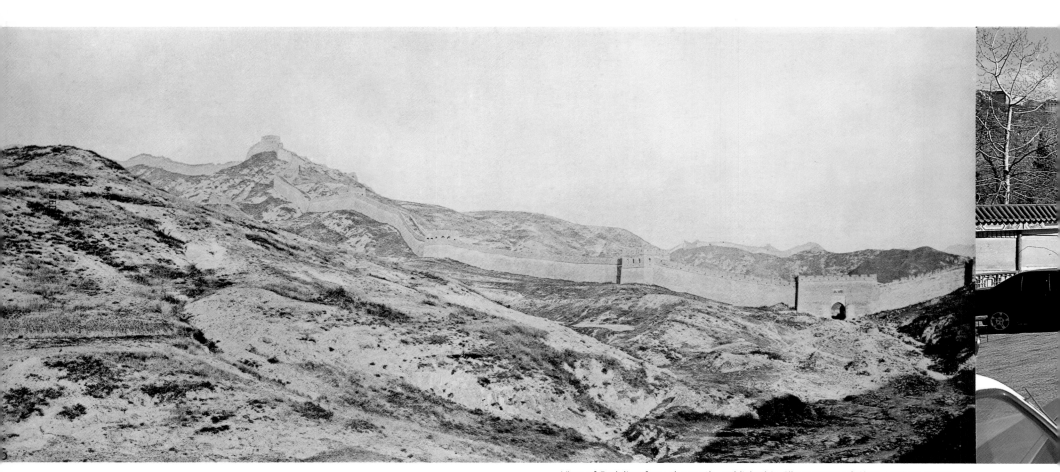

View of Badaling from the north, published in *Illustrations of China and Its People*, London, 1873: Thomson, 1871 (The British Library).

Badaling: View from the Outside

One of the earliest known photographs of the Great Wall and taken by John Thomson in 1871, this is a rare aspect from the northwest side (outside). Most photographers exposed their pictures from the southeast (inside) or from upon the ramparts.

Thomson's wide angle lens coverage contains a swathe of the ramparts from the main gate at the foot of the pass on the right to the fourth north tower on the summit to the left. The Wall continues away and out of frame to the left, eventually looping around to the right and reappearing on the skyline between the gate and first tower. The ramparts appear to be perfectly preserved throughout: the only noticeable damage is minor, to the battlement at the immediate right of the gate. In the shadow at the bottom right of the photograph is the rocky road leading through the Wall.

The Great Wall Nankow Pass 1871

View of Badaling from the north: Lindesay, 2006.

Due to considerable ground level changes – probably for construction of the road and car park – it was difficult to match Thomson's original position and elevation. I took the new photograph while standing on the barrel of a cannon displayed at the northern end of the car park opposite the Badaling Hotel, much to the amusement of tourists. The revisited scene shows the dramatic encroachment of tourism infrastructure. The eyes of those who view the repeat photograph focus on the car park crammed with vehicles and the row of vendors' stalls, rather than the Wall itself.

According to Li Man, director of the Badaling Great Wall Zone Office, two major changes are scheduled to take place in order to recover the landscape quality of the area, evident in Thomson's photograph. In compliance with a general planning blueprint of 2006, the commercial enterprises prevalent beside the Wall will be re-sited in a retreated position while the paved road – still in use to all kinds of vehicles – will be closed and a new one tunnelled under the Wall.

191

First Steps at Badaling

The original was taken c. 1885 and attributed to Thomas Child (see page 43). It shows a group of foreign visitors accompanied by locals posing at the top of a flight of steps used to ascend the rampart. The platform to the group's left is that of the outer gate, and beyond this a string of four towers can be seen across the North Mountain.

In the centre of the *guancheng* enclosure is a contemporary building constructed with Great Wall bricks, probably made and used by locals awaiting the arrival of visitors in the hope of acting as their guides. Between the first and second towers a pavement collapse can be seen.

Revisiting finds a slight departure from the original arrangement of steps leading up to the platform in the foreground, while the two lonely trees in the *guancheng* area that once greeted visitors have now been replaced by thousands on the hillsides all around.

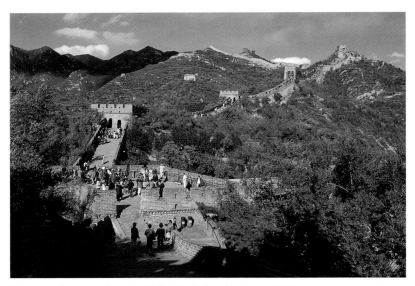

The steps for ascending the Wall at Badaling: Lindesay, 2005.

Right: European visitors on the steps at Badaling: an albumen print, 25 x 20 cm, Child, c. 1885 (WL).

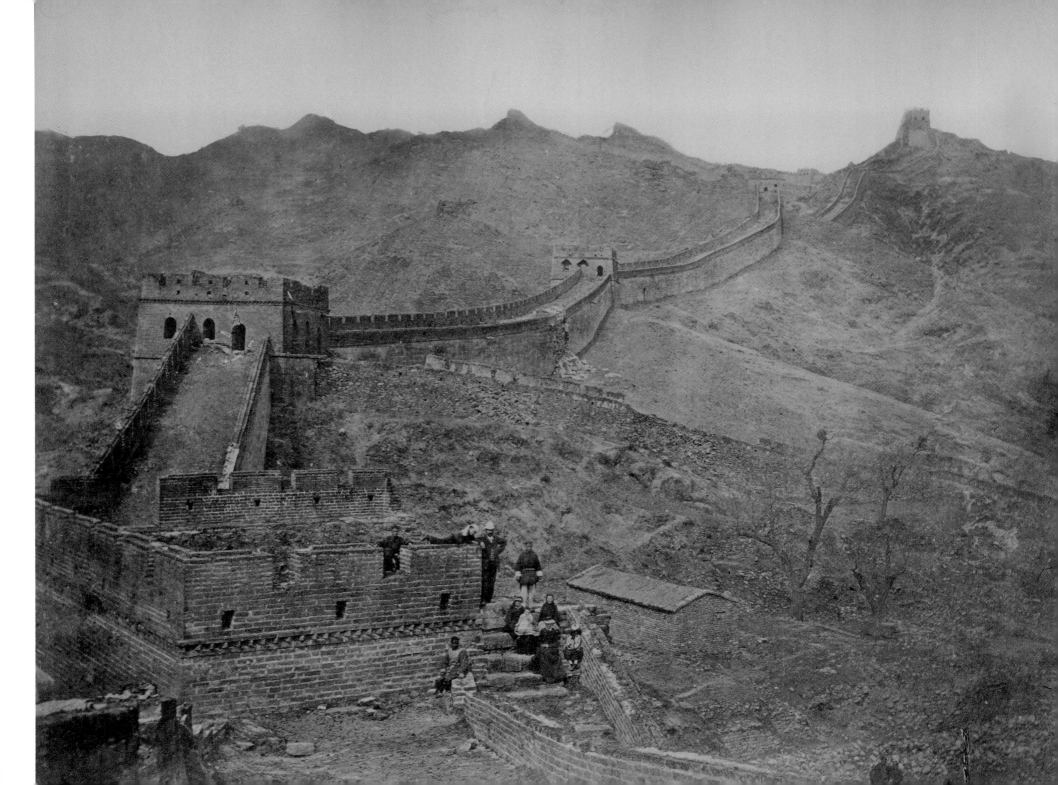

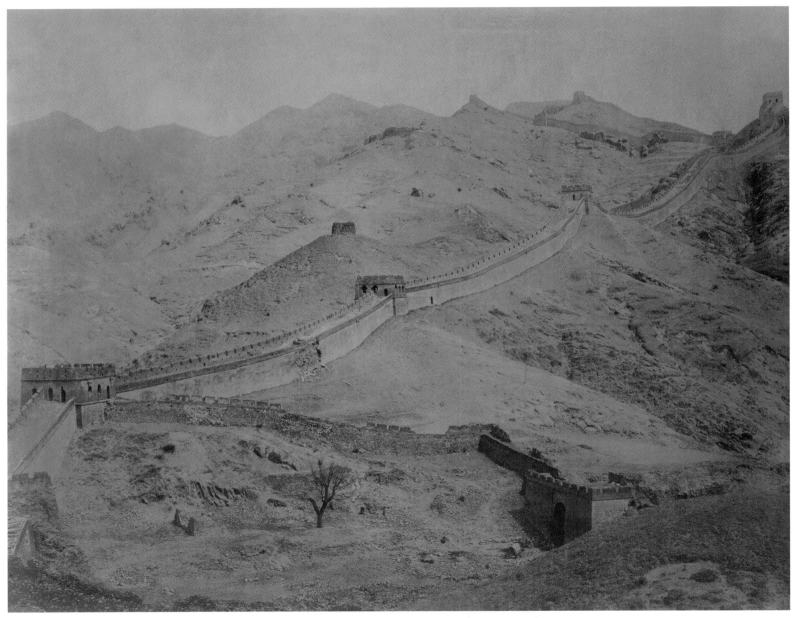

The first of a much imitated photographic view of Badaling: an albumen print, 26.3 x 19.5 cm, Yamamoto, 1895 (WL).

Badaling Postcard

The original, taken c. 1895, bears the purple cartouche of 'Photographer, S. Yamamoto, Peking' on its reverse.

Little is known about Yamamoto, other than his listing as a member of the Japan Photographic Society, and proprietor of a small studio within Peking's Legation Quarter (to the east of today's Tiananmen Square) during the late 19th and early 20th centuries, as well as a second studio, within the British Concession in Tien'tsin (Tianjin), where he sold albumen prints, postcards and illustrated books, such as *Views and Custom of North China*.

This is one of Yamamoto's three memorable pictures of Badaling. His eye for composition is particularly evident from this image, reproduced and sold as a postcard, depicting what has since become firmly established as a classic view – a grand procession of watchtowers marching up the North Mountain. Exhibiting a preference for using the full frame to capture maximum interest, the viewer's eyes are drawn to ascend the Wall diagonally across the print, from the bottom left to top right corner.

In the foreground, the interior of the *guancheng* enclosure can be seen. The inner gate (on the right) appears to still be in good repair. A solitary leafless tree stands beside the ruin of a structure built with Great Wall bricks that stood some years before, which was seen by earlier photographers. A telegraph post stands on the Wall in front of the second tower (middle of frame) which was not present in the 1885 image exposed by Thomas Child (see page 193).

Revisiting shows considerable changes to the *guancheng* area, crowded with service buildings and functioning as the main access point for the majority of visitors. The old road, though hidden from view, is still present and in use, following a left to right line at the base of the flag pole.

Reconstruction of Badaling commenced soon after the foundation of the People's Republic of China (October 1949).

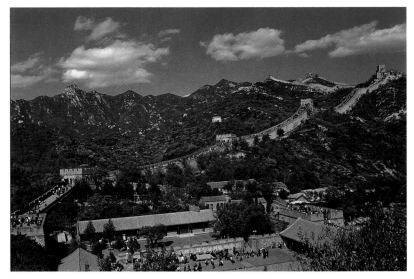

The 'postcard view' of Badaling in autumn splendour: Lindesay, 2005.

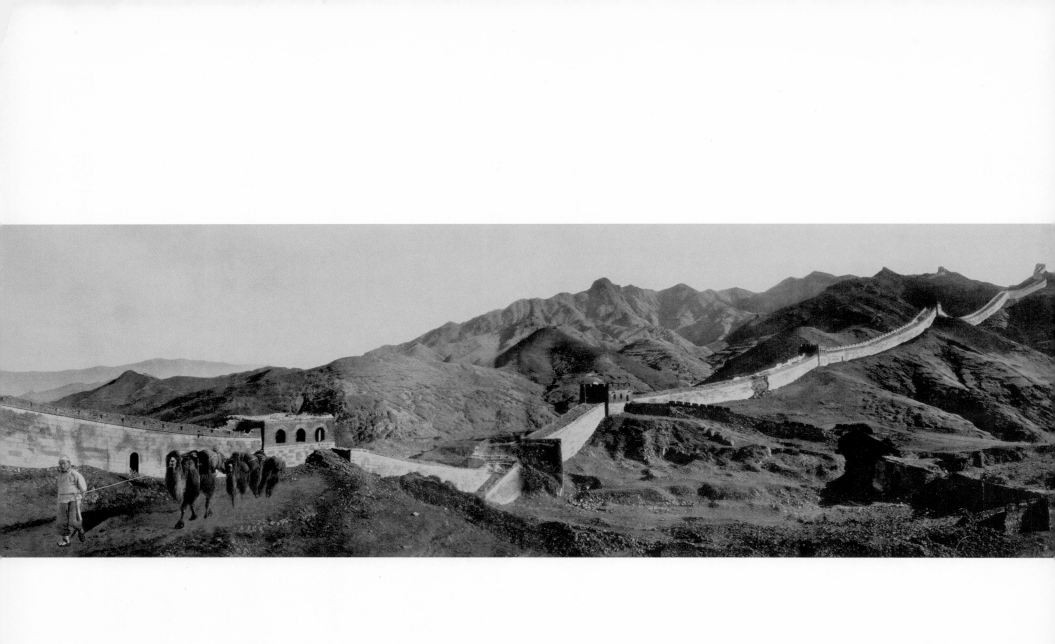

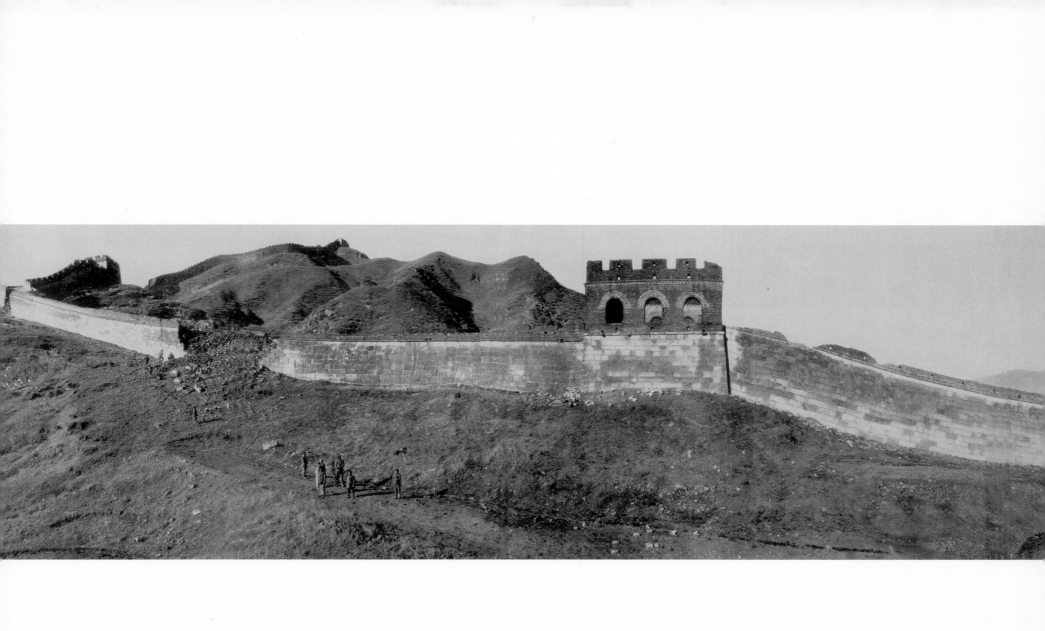

180° Panorama at Badaling

This technical masterpiece was printed using the photogravure process and included as a supplement, 45½ x 9½ inches, within the February 1923 issue of the *National Geographic Magazine*. The method of reproduction, involving the transfer and etching of the negative onto a metal plate, produced a marketed image of unprecedented clarity. Readers of the magazine could see the shades of quarried granite blocks on the Wall's face, and make out individual bricks on the tower closest to the camera.

The archive department of the National Geographic Society, publisher of the magazine, could not provide any details about this photograph – either whose work it was or even what camera was used. It may have been the work of the article's author and principal photographer Adam Warwick.

The view is a panorama across Badaling, probably taken in 1922. Examination appears to confirm that it is a single panoramic shot, and not composed of smaller frames spliced together. However the publisher did paste in the image of the farmer and camels in the centre of the photograph in order to add scale and human interest.

The most widely-used panoramic camera of the early 1900s was the Cirkut Rotation Camera, patented by the Rochester Panoramic Company in 1904 and then produced for Eastman Kodak in several updated models. Film of different width and length was pulled by a motor through the camera in synchronization with the rotation of the entire camera mounted on a tripod. Although capable of exposing a full 360° view, the Cirkut won popularity for photographing large groups of people, and presents itself as the most likely candidate tool for capturing this stunning Great Wall landscape.

(Fold-out panorama) *The Great Wall of China Near Nankow Pass* (actually Badaling) 45½ x 9½ inches, probably exposed using the Cirkut Panoramic Camera: by an unknown photographer for the National Geographic Society, 1922 (WL).

(Fold-out panorama) Badaling, a digitally-stitched panorama: Lindesay, 2006.

The sweep of the Cirkut's 180° rotation in this case dramatically encompasses the North Mountain on the right and the South Mountain on the left, with the lowest part of the strategic pass in between.

Analysis of the battlements show them to be somewhat damaged as compared with much earlier photographs, for example by John Thomson (see page 190), taken half a century before in 1871. Two collapses (washouts) on the inside-facing containing wall can be seen: one at far left of frame, the other at the far right. The latter seems to have worsened somewhat since its capture in the c. 1885 image by Child on page 193. The steps leading up to the platform above the outer gate are now in ruins compared to the same photograph.

Revisiting shows reconstruction, discussed elsewhere, while much of the Wall closest to the camera is now obliterated from view by the thick forest cover. Various buildings have appeared in the lee of the Wall: at far right are those clustered around the main entrance area, while the small wall in the left corner encloses a plinth erected to commemorate Deng Xiaoping's campaign to 'Love China, Rebuild the Great Wall'.

Cirkut Panoramic Camera, Series 10.

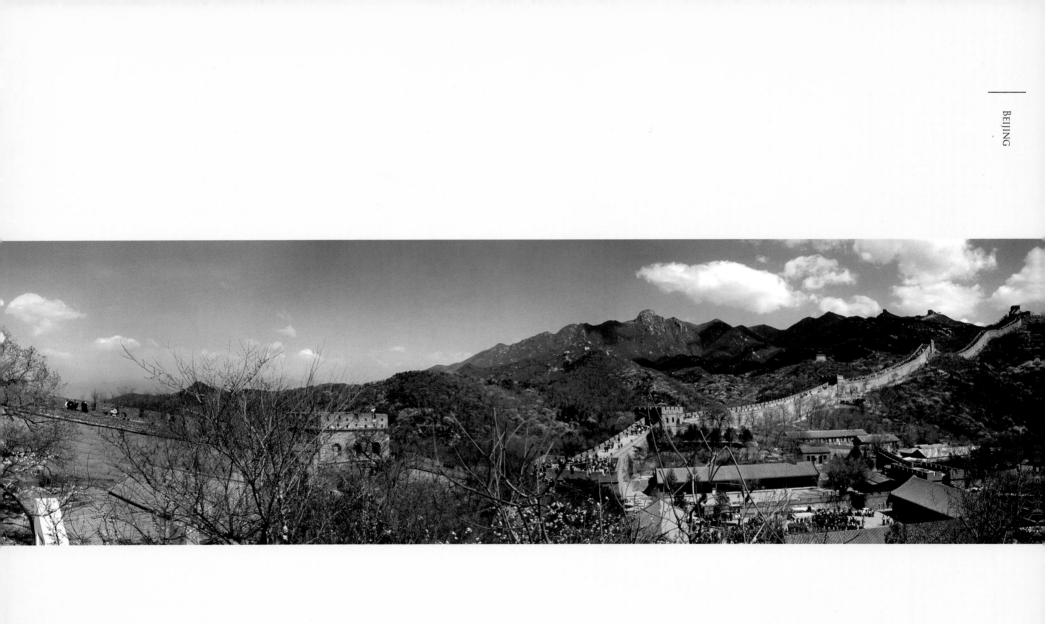

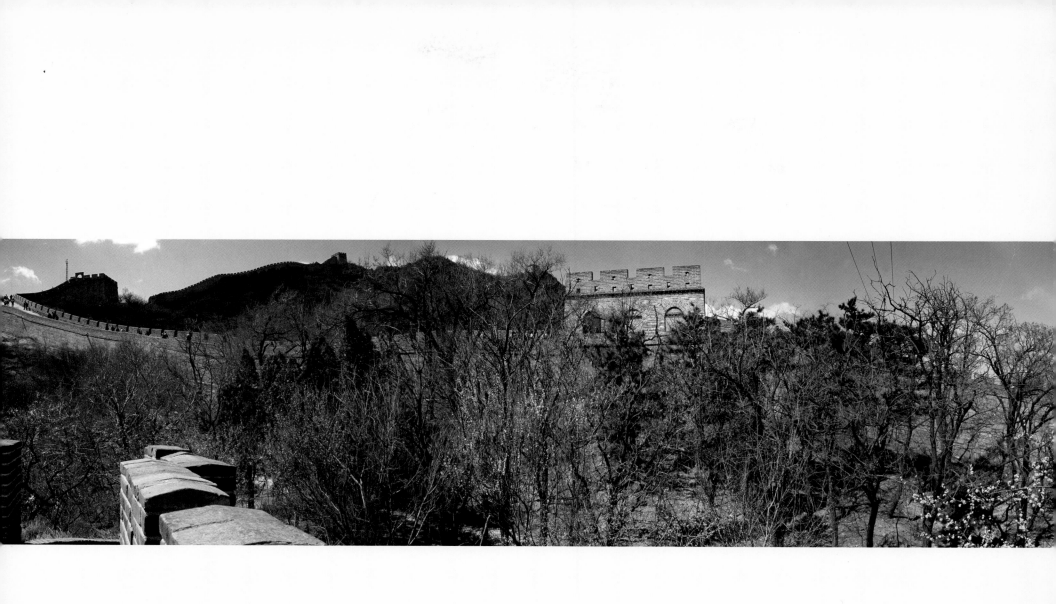

Procession of three fine towers on the North Mountain at Badaling: an albumen print, 23.5 x 16.8 cm, by an unknown photographer, c. 1880 (WL).

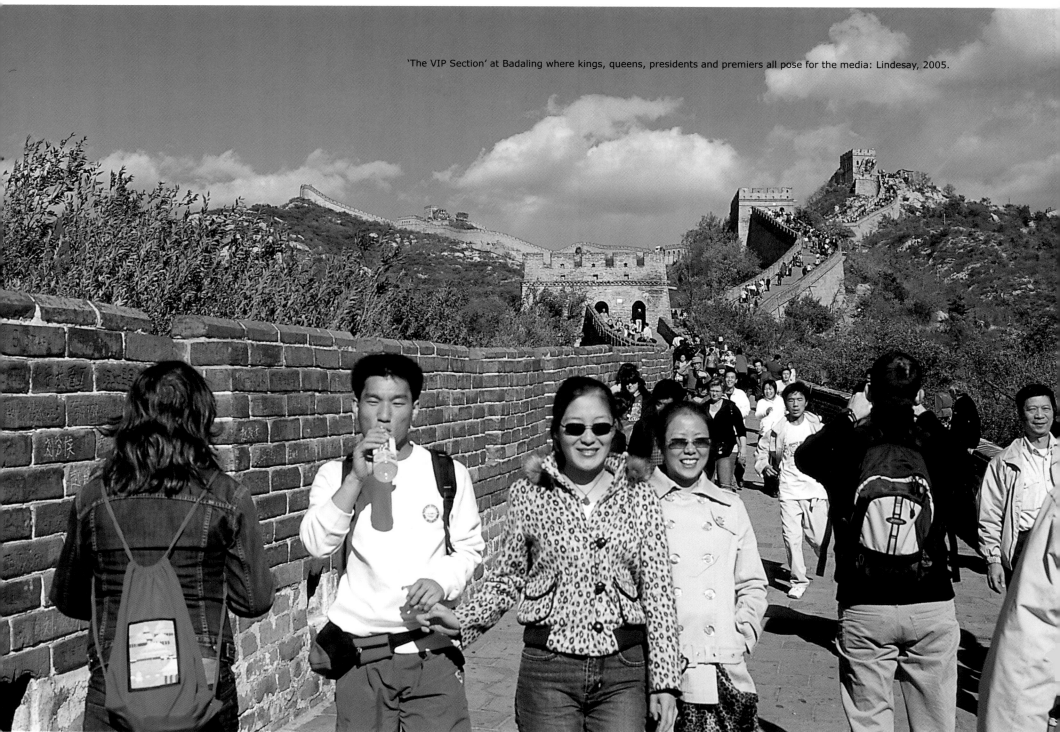

'The VIP Section' at Badaling where kings, queens, presidents and premiers all pose for the media: Lindesay, 2005.

The 'VIP Section'

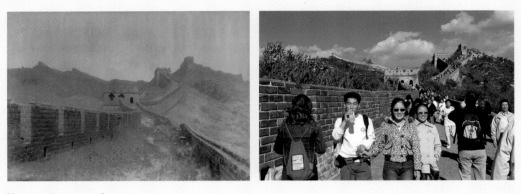

(See previous pages)

In this 1880s original photograph not a single person, local or visitor, was in view. Badaling lay an arduous two-day trek into bandit country from Peking. Those willing to endure the discomfort of rocky roads, as well as the threat of robbery, probably numbered less than 100 per year – mainly foreigners.

This serene and grand view shows the North Mountain's gently-curving ramparts and three towers in an almost perfect state of preservation, with the exception of a washout in the foreground on the right. The outer face of the fortification is easily identified by the high battlement on the left, while the inside has a much lower battlement without embrasures. This arrangement is a design characteristic of the Badaling section.

Today, largely as a result of reconstructed ramparts now extending to 3.5 km in length, expressway access and visits by more than 500 heads of state over recent decades branding it a 'VIP' section, Badaling has become the top choice for China's burgeoning numbers of domestic tourists. Revisiting in 2005 found the ramparts crowded with tourists enjoying fine autumn weather.

During the previous year, 2004, visitor numbers reached a record 4.5 million, with peak days of 100,000 being recorded during the golden weeks of early May and October. The government introduced its so-called 'holiday economics' policy, giving seven days' vacation, to spur people to travel and spend. On such days access to Badaling is not so swift, and tourists jamming the Wall almost obliterate the view.

Bird's Eye View of Badaling

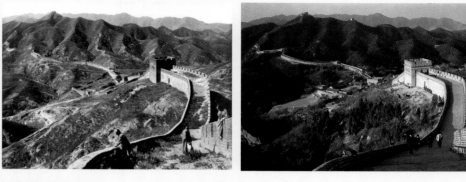

(See following pages)

The original photograph was taken by Herbert Ponting in 1907 and shows why the British photographer described his occupation not as 'photographer' but as 'camera artist'. His view looking west across Badaling stands as a masterpiece in terms of composition, exposure, interest and enduring popularity. It was published in 1909 as the frontispiece of William Geil's British edition of *The Great Wall of China*. Half a century later in 1954 the same picture was selected by sinologist Joseph Needham for inclusion in the first volume of *Science* & *Civilisation in China*.

In similar style to Yamamoto, Ponting utilized the full frame of his lens and chose a position on the ramparts from where his field of view could capture the dramatic writhing of the stone dragon snaking its way across the pass.

Standing in the middle of the Wall's pavement he exposed an image which takes the eyes on a journey, stepping down the rampart past the three locals (clearly hired to pose) to the fine tower, then down to the floor of the pass and up the opposite mountain.

Revisiting shows the encroachment of tourism facilities on both sides of the Wall. On the left is a car park, while the *guancheng* enclosure is now crowded with administrative buildings. Beside the nearest tower is a platform for the sale of souvenirs and photo opportunities on horses and camels. To the right of the Wall, roofs of several buildings can be seen in the commercial area.

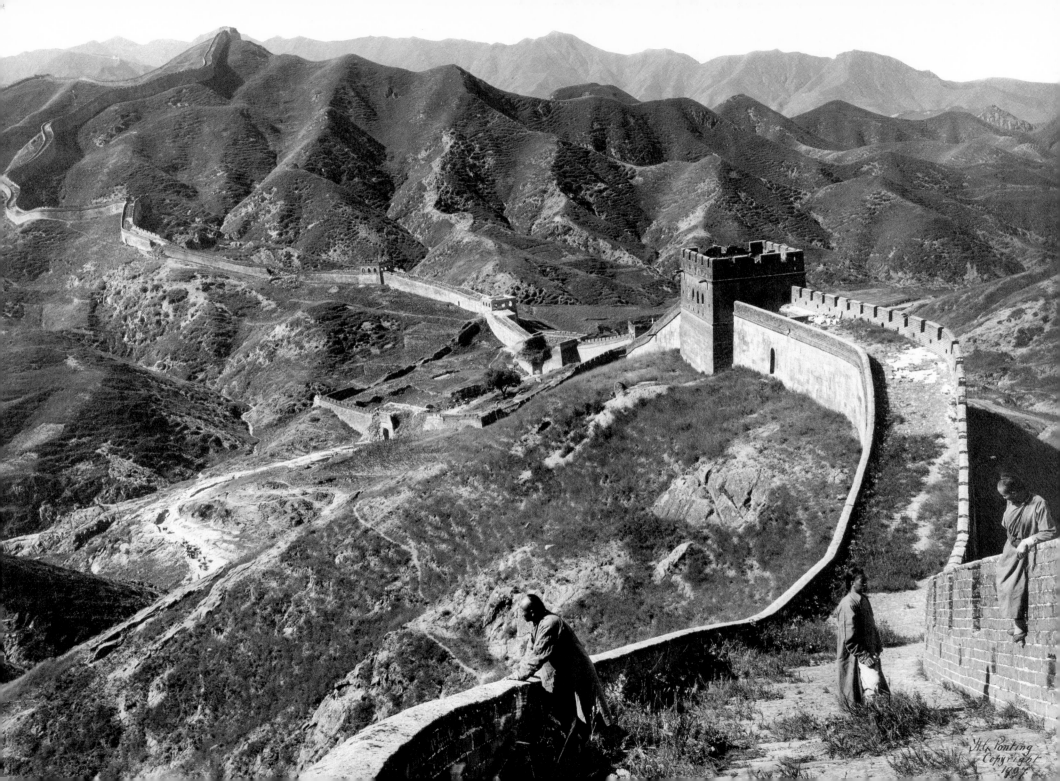

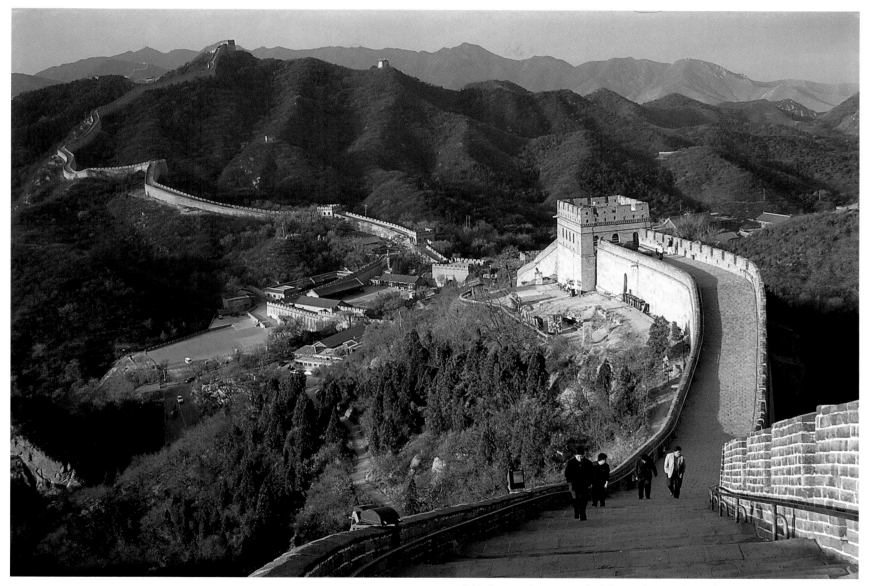

A bird's eye view across Badaling, taken in the early morning before the crowds arrive: Lindesay, 2006.

Left: A bird's eye view across Badaling: a large sepia print, Ponting, 1907 (Royal Geographical Society).

North Mountain

The original was taken c. 1895 and is chopped on the reverse with the purple oval cartouche of S. Yamamoto, Peking.

By utilizing the full height and breadth of his frame, Yamamoto provided his viewers with a photograph that strongly exudes the Great Wall's scale, grandeur and antiquity. From the foreground, he draws his viewers' eyes away and along the Wall, past a tiny figure.

The ramparts appear in perfect condition except for the damage at the foot of the incline. This was caused by the infiltration of water into the body of the structure, which flowed downhill to collect in the trough, eventually freezing and forcing, by expansion, the displacement of foundation blocks, causing the collapse of the pavement.

Revisiting shows the Wall rebuilt, already described for other locations, and a vast change in the surrounding vegetation. Soon after the establishment of the People's Republic of China in 1949, the management of the Wall at Badaling was delegated to the Ministry of Forestry. Large quantities of saplings were planted, and today the forests beside the Wall are probably thicker than they have been at any time since the building of the Wall, some 600 years ago. During construction, the area was deforested to provide timber to fuel kilns for the baking of bricks and burning of lime for mortar.

206

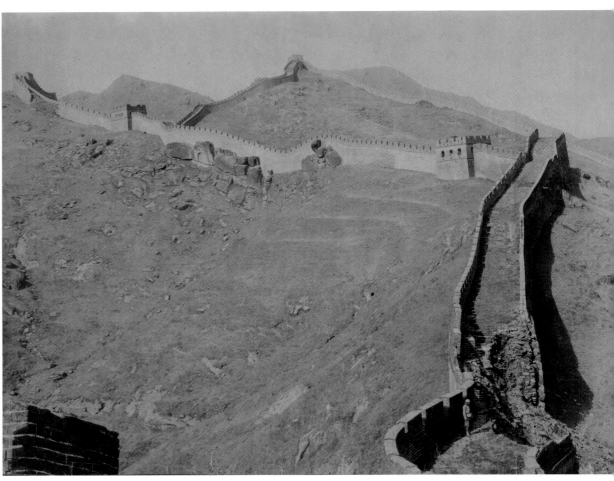

View of the North Mountain at Badaling: an albumen print, 26.3 x 19.5 cm, Yamamoto, c. 1895 (WL).

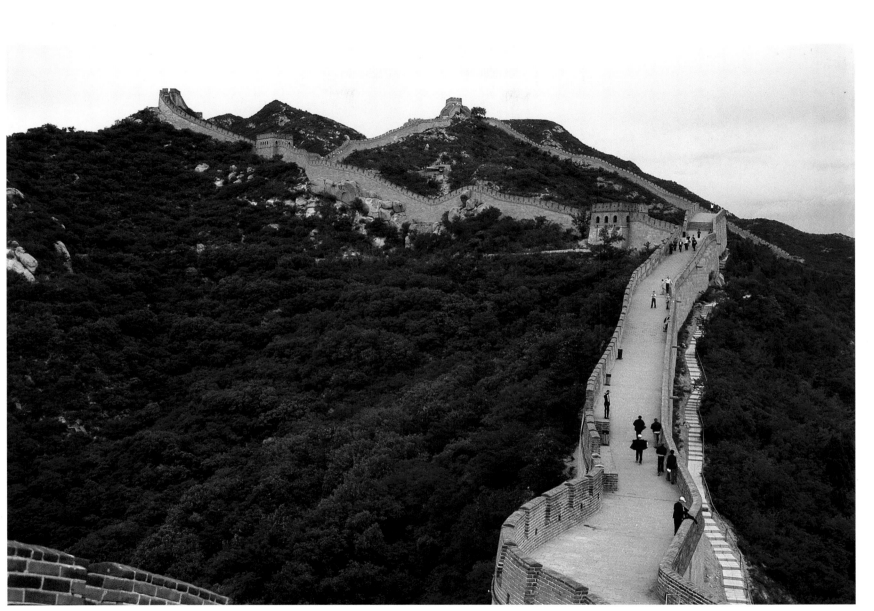

View of the thickly vegetated North Mountain at Badaling in midsummer: Lindesay, 2004.

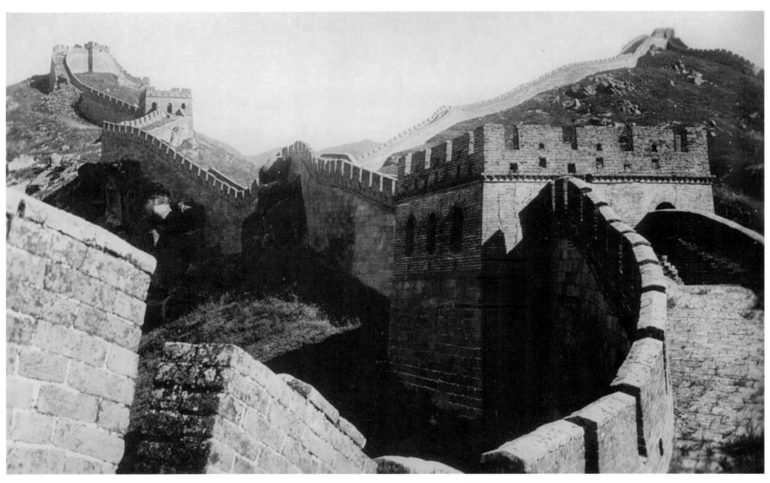

Battlements and towers at Badaling: a silver gelatine print, 10 x 6.5 cm, Jung Chen Studio, early 1930s.

Battlements and Towers

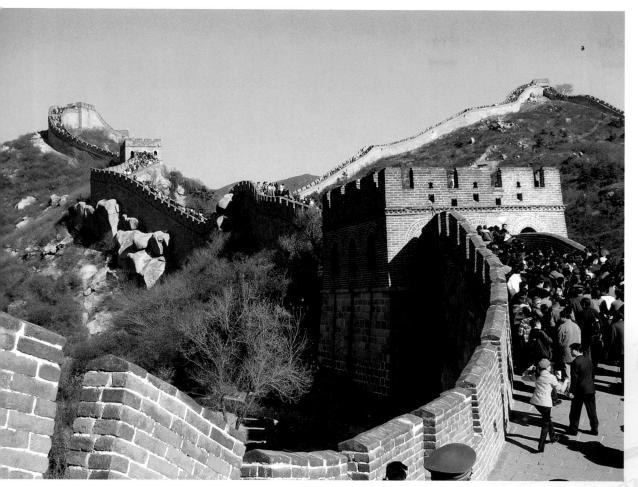

Battlements and towers at Badaling: Piao, 2006.

The original photograph is a miniature contained within a set of photos depicting Badaling and sold by the Jung Chen Photographic Studio in Beijing during the 1930s.

This image shows battlements and towers half way up the North Mountain, which appear in almost pristine condition with the exception of some cracks on the left face of the tower in the foreground, and a washout on the Wall's pavement below the hump between the second and third towers.

Revisiting on an early winter's day finds the ramparts still crowded with tourists queuing up to proceed through the narrow entrance of the tower, whose face was rebuilt. On the upper storey there is now one loophole less. Obtrusive above the tower in the background is the conspicuous bright blue of public lavatories. The majority of the battlements are original while the pavement has been replaced, in some places several times because of wear and tear by the high volume of foot traffic.

Mutianyu: A Series of Five Views

All five original photographs in this series are the works of William Geil and represent a selection of images exposed on a day's excursion in the vicinity of Mutianyu, probably during the early summer of 1908. Together with his narrative (extracts below from *The Great Wall of China*) they combine to describe a circular route, beginning and ending in Lianhuachi, and encompassing a walk along the Wall starting at the eastern end of the Mutianyu section, proceeding westwards to the top of the Oxhorn, and returning to the starting point via a valley route, totalling a distance of approximately 16 km.

Geil lodged for the night in Lianhuachi, the hamlet of 'The Lily Pool'. There was no inn, so he was taken in by the 'rich man of the place', where he became a centre of attention.

'The whole population was permitted to come and look over us. As often as we have been subjected to that annoyance, we have never brought ourselves seriously to object to such a practice. Our arrival was to that hamlet what a circus, years ago, was to Doylestown, Pennsylvania. The size of my boots amazed the populace'.

The next morning Geil set off, hoping to locate the major eastern division — the Beijing Knot — which he dubbed the Y, the point at which a single, major line of Wall from the east bifurcates into the northern and southern lines (Outer and Inner Walls, see page 164).

'Shanhaikwan and Tsunhwa[1] were easy to find, but the Y of the Wall was a troublesome matter. It was a long and difficult search. Several times we were led astray by natives who affirmed they knew the exact spot where the Wall forked. In answer to their confidence, the climb was made, only to enjoy the superb scenery and be disappointed in the quest for the two Walls from the west and one towards the east'.

[1] Zunhua.

The Lily Pool

In the original photograph the rampart climbs steeply out of the valley at Lianhuachi from a point where a stream flowed amongst boulders to feed the 'lily pool'.

Despite the proximity of habitation, the fortifications in 1907 appeared in a good state of preservation, with battlements standing intact as well as the mid-slope watchtower.

Revisiting finds a dramatic deterioration in both the quantity and quality of the fortifications. In the foreground the lower 20 metres of the Wall has collapsed, or was dismantled, with the foundations now reduced to a mound. The mid-slope watchtower has also collapsed, no longer retaining any internal chambers. Along the ridge at the top of frame, once-prominent crenellations have fallen, though the body of the rampart appears to be intact.

Development has encroached onto land beside the Wall. In the immediate foreground there is a swimming pool, and an obtrusive red corrugated iron roof to provide shelter from the sun to weekend day trippers from Beijing who now visit Lianhuachi not for its lily pool, but to eat roasted trout farmed in quantity along an increasingly crowded valley.

From Lianhuachi, Geil proceeded up a gully in the lee of the Wall to access the ramparts in the vicinity of Sanzuolou.

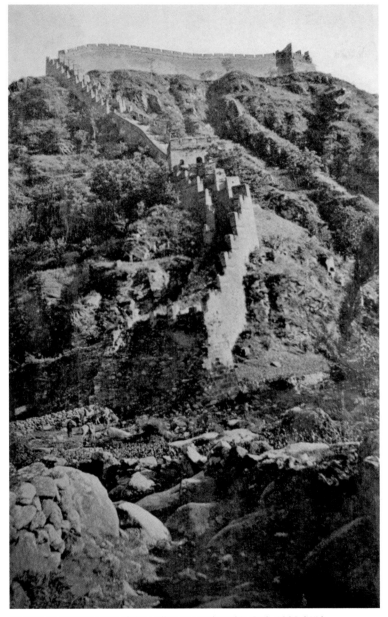

Ramparts climbing out of the valley at Lianhuachi: Geil, 1908 (WL).

Tourism development beside the Wall at Lianhuachi: Lindesay, 2006.

Mutianyu (looking west)

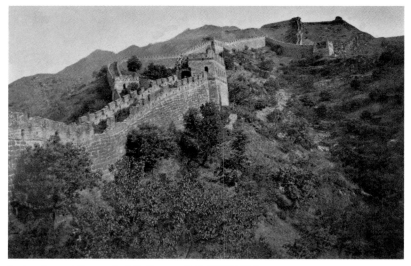

A view toward the west at Mutianyu: Geil, 1908 (WL).

This off-Wall view, and three other of Geil's photographs not utilized in this presentation to illustrate his route, suggest that he may have had to walk along the outside face of the Wall in order to find an access point at he could conveniently surmount the high rampart.

This view shows the Wall zigzagging uphill towards the west, and contains an example of a tail fortification, about 40 metres in length, departing to the right, whose terminus is marked by a watchtower. Behind this offshoot stands an independent tower on a hillock.

Rephotography shows that Wall has been rebuilt. Prior to the rebuilding work carried out from 1984, Wu Menglin was involved in the planning and development of Mutianyu as a section of the Great Wall selected for opening to tourism. Fearing that much of the section's history would be lost if no pre-construction study and excavation of cultural relics in the area were done Wu, who majored in archaeology at Peking University, surveyed the Wall from Dajiaolou, or the Large Corner Tower in the east to watchtower No.14 in the west, a distance of approximately 700 metres. She collected cultural relics from local people, including roof guardians, stone tablets, as well as weapons used by ancient Chinese soldiers guarding the Wall and articles for their daily use. Some details were replicated when the section was rebuilt (see page 214).

Wu Menglin estimates that about half the bricks in the reconstructed pavement and battlements are new. The contrast between the old and new can be seen quite clearly on the face of the nearest watchtower. In the distance to the left of the Wall one of Mutianyu's two cable-car stations can be seen.

From here Geil ascended the rampart and photographed the east end of Mutianyu at Sanzuolou.

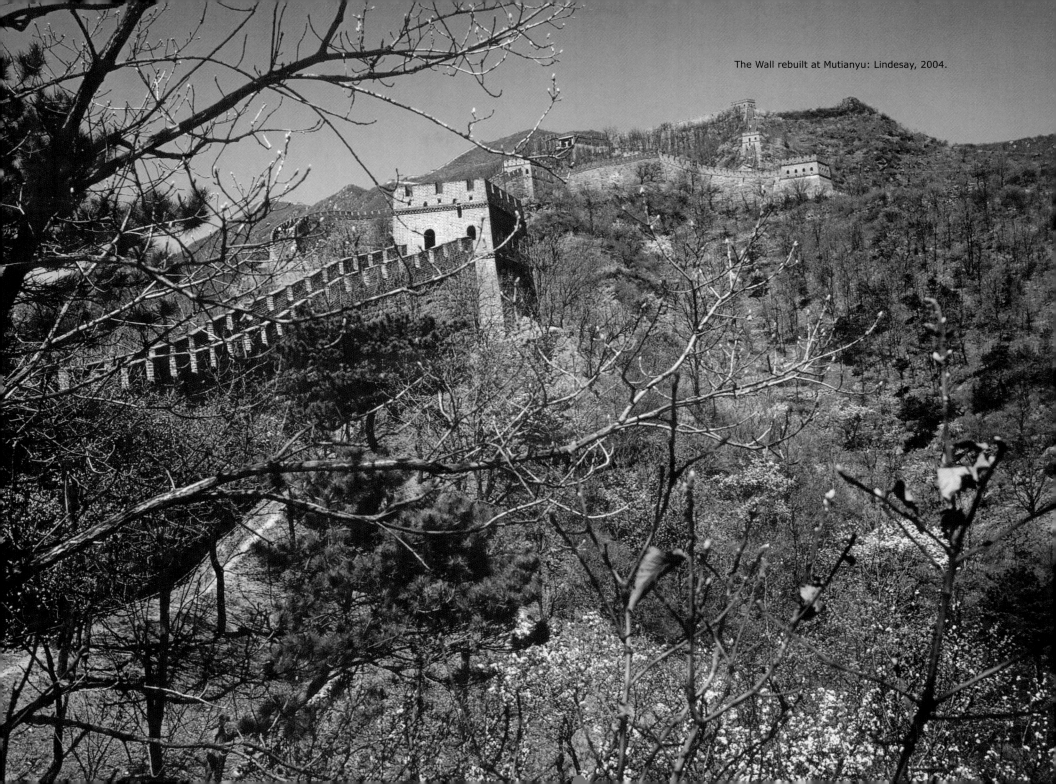

The Wall rebuilt at Mutianyu: Lindesay, 2004.

Mutianyu Sanzuolou

William Geil took this photograph while standing on the Wall, rather than from beside it. He was looking east at a short section of the rampart which steeply ascends as a curve from Sanzuolou (Three Towers Together) in the foreground to Dajiaolou (Large Corner Tower) on the ridge, via two mid-slope watchtowers.

From this perspective the wilderness condition of the rampart's pavement can be seen in the foreground. The ground is thickly overgrown with grasses. Several metres away from the lens is a mound, and behind this the remains of Sanzuolou, a large tower constructed at this low point on the rampart's line on account of the location's vulnerability to attack.

Revisiting shows reconstruction: the site is located at the eastern end of the Mutianyu tourist section. The mound in the foreground is a *paotai*, or cannon platform, which has been rebuilt. The three adjacent roofs of Sanzuolou can be seen clearly. Inspection found project designers had paid close attention to detail by replicating roof guardians and monster-face tile ends on the roofs (see pages 212). Surrounding slopes are thickly forested.

Mutianyu was the first section of the colossal structure to be rebuilt in answer to Deng Xiaoping's call to 'Love China, rebuild the Great Wall'. The campaign ushered in a new era for the treatment of the nation's cultural heritage which had been greatly damaged during the times of Chairman Mao Zedong whose policies (see page 46) encouraged people to demolish historical buildings, even the Great Wall, and re-use ancient masonry for contemporary building materials.

Deng Xiaoping's campaign gave local farmer Fu Linjian of Lianhuachi his first job for cash, earning RMB 8 yuan (US$1) per day for his bricklaying efforts. During 1984 he worked on the very section depicted in the old photograph. Asked if he felt proud to be a modern builder of the Great Wall he answered that at the time he considered it just a job. Now an employee at Mutianyu, Fu says he realizes the importance of his work when he sees visitors from all around the world walking on 'his' section of the Wall.

Fu Linjian, a former bricklayer who in 1984 rebuilt the Mutianyu ramparts.

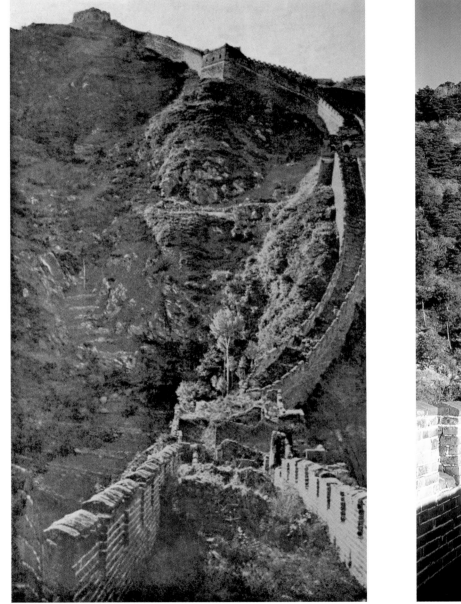

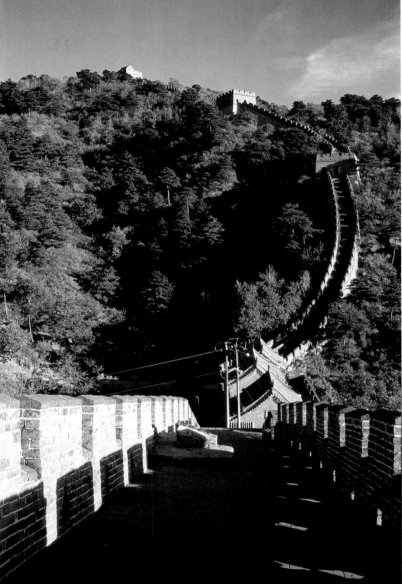

Sanzuolou (Three Towers Together) at the east end of Mutianyu: Geil, 1908 (WL).

Sanzuolou at the east end of Mutianyu: Lindesay, 2004.

215

Right: *Deng Xiaoping*, a watercolour by an unknown artist, 78 x 47 cm, c. 1985 (WL).

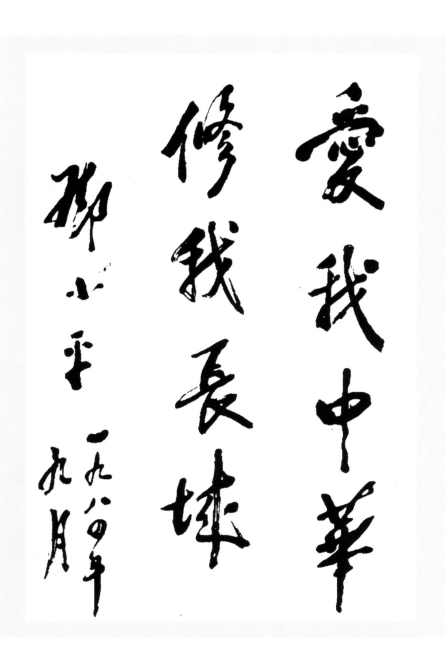

Love China, Rebuild the Great Wall written in the hand of Deng Xiaoping.

The Figure Three

This view depicts a peculiar shape, describing a 'Figure Three', a name first provided by Luther Newton Hayes (1883–1978) who accompanied William Geil for several weeks during the early part of his 1908 journey. Newton Hayes explained the origins for his Great Wall interests thus:

'For a certain foreign lad born many years ago in China, this engineering masterpiece of a bygone age held a peculiar fascination. One of his early ambitions was some day to make an extended journey along its course; partly for his own pleasure and partly in order to make its meaning more comprehensible to others. In the years that have passed since the desire for that journey was first entertained, the youthful wish has been gratified, and the one who made the wish has had the satisfaction of travelling several hundred miles along the course of the Wall'.

According to Newton Hayes' wife and biographer Rhea Pumphrey Hayes, her husband travelled with Geil for three weeks 'beginning from where it (The Wall) emerges from the sea at Shanhaikwan … until urgent duty prevented him from making the entire thirteen hundred miles to Kansu (Gansu)'.

Newton Hayes was born in Suzhou, Jiangsu Province, to American missionaries who had arrived in China in 1882 for their honeymoon, and ended up staying there for 50 years. In his early twenties he was sent to the United States to be educated at Wooster College, Ohio. Soon after graduating, in 1906 he was invited to tutor the grandsons of Li Hongzhang, former Prime Minister of China under the Empress Dowager Cixi. He lived with the Li family in their palaces in Peking and Nanking, and it is likely this commitment limited his extended participation on Geil's expedition.

Portrait of Luther Newton Hayes, c. 1940, aged 57 (WL).

On account of his scholarly interest in the Wall he was either given or bequeathed 75 of Geil's magic lantern glass slides. Newton Hayes had the slides hand coloured by a Chinese artist in Shanghai, and probably used them to illustrate a lecture delivered on the premises of the North China Branch of the Royal Asiatic Society, also in Shanghai, in November 1927. Two years later he expanded his materials into a book, *The Great Wall of China*, published by Kelly & Walsh in the same city. The pocket volume

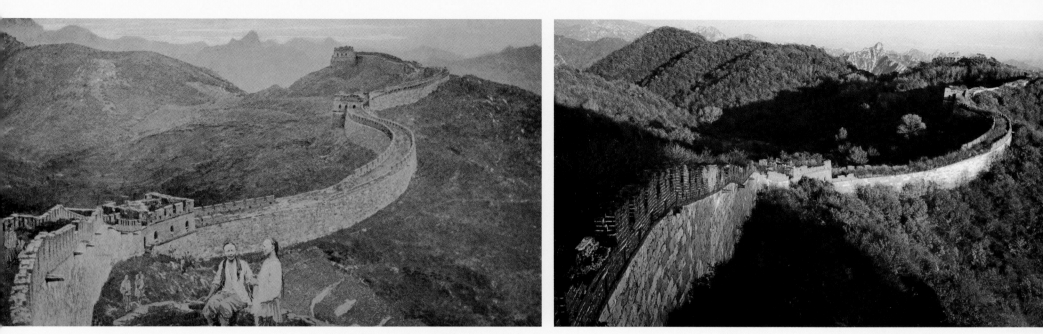

The Figure Three section of Wall: Geil, 1908 (WL). The Figure Three section of Wall: Lindesay, 2004.

contains images that are exclusively the works of Geil, but Newton Hayes fails to provide further clues on the route the two men may have covered together during their three weeks of Wall travel.

Revisiting the Figure Three reveals a general overall, but not immense, deterioration in the quality of various architectural components and design features. Two persons in the foreground, wearing traditional Qing attire and long plaited hair in the form of queues, were drawn in, possibly at the request of Geil's publisher to add human interest.

Looking at the inside face of the rampart descending to the first tower, about half of the original protruding water spouts can still be seen. All three towers in view show advanced states of dereliction. In Newton Hayes' caption he drew the attention of his readers to the purpose of locating the towers at turns: 'The degree of projection made it possible for archers to sweep with their arrows the outer bases of the adjacent lengths of wall'.

In the distance on the right the county seat of Huairou, indicated by its newly constructed white buildings, can be seen faintly in the haze.

The Oxhorn

The location of this photograph in relation to the image he exposed of the Figure Three is an example of Geil's preference for convenience by taking several pictures in close proximity, thus dispensing with troublesome unpacking and packing up of camera and lenses, as well as erecting and dismantling a tripod. This photograph was taken just 25 metres from, and in the opposite direction of, his previous exposure.

The view shows the open end of a pronounced loop section of the rampart, which, if fully visible from the west, or from the air, is similar in form to an ox's horn. This peculiar shape was created by a routing practice which observed a fundamental art of war stratagem to occupy high ground, thus enhancing the performance of weapons used by its defenders, such as bows, crossbows and stone grenades.

A well-preserved rampart edged with standing battlements complete with capstones, wide in the foreground, turns to the right and reveals the outside face of the structure. The rampart proceeds steeply uphill via a tower, eventually reaching a peak (well out of frame, at 1065 m), from where it turns back on itself, descending and returning to view as a second line of Wall running across the right-centre part of the skyline, reaching a four-eyed (windowed) watchtower in the centre of the photograph. From here the line of the Wall proceeds to the left and then into the distance, disappearing in a long dip before emerging in the form of a watchtower at Zhengbeilou, or the Main North Tower, at the far left of the photograph on the horizon.

The most striking difference when revisiting concerns the much thicker vegetation both beside the Wall and upon its pavement. Since the Wall's abandonment as a defence line more than 360 years ago, it has been claimed by nature, becoming wilderness Wall. Loess carried by northern winds over the centuries has accumulated to form a soil, sometimes several centimetres in depth; this has been colonized by plants sprouted from seeds either blown by the wind or contained in bird droppings. Revisiting found a varied assemblage of plants ranging from grasses and flowers to bushes and trees, the latter including apricot, lilac and oak. Some had achieved an estimated 30 years' maturity and possessed large root systems, thereby holding the internal masonry of the structure in a life and death embrace.

Of the three towers visible, on close inspection only Zhengbeilou was found to be well preserved, with its ground floor corridors around a central chamber remaining intact, as well as two staircases affording access to an upper storey. Designated to garrison the sectional commander on account of its vantage, and providing panoramic views in all directions, it was built to higher standards than surrounding structures. However, it does exhibit various structural problems, including severe bowing, many cracks and weak bricks with reduced load-bearing capabilities. A survey in 2005 carried out by Tsinghua University's Department of Ancient Architecture to explore its stability, commissioned by International Friends of the Great Wall and funded by the World Monuments Fund, predicted that the most serious threat to its future will be earth movements.

Connecting the past to the present with these two photographs prompts one to contemplate whether the tower on the horizon will still be standing if a follow up visit was to be made in another 96 years.

From here Geil proceeded to the top of the Oxhorn, where he exposed his final photograph of the day before hurrying back to Lianhuachi by nightfall. He failed to reach the Y, but captured timeless images of the Wall.

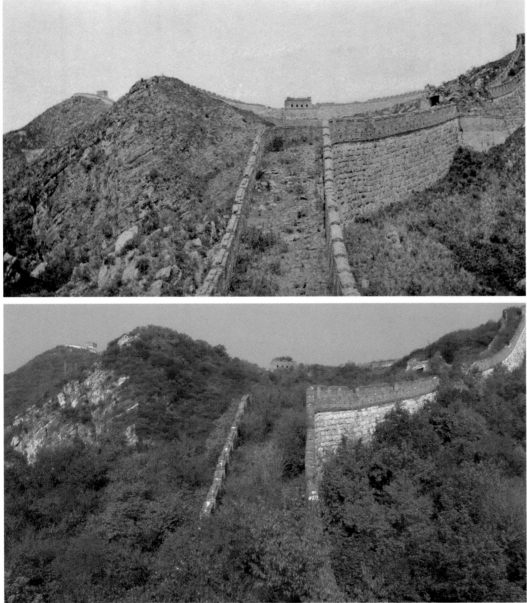

The Oxhorn: Geil, 1908 (WL).

Local farmer Chang Jinwang works as a ranger at the Oxhorn.

The Oxhorn: Lindesay, 2004.

GUBEIKOU

Gubeikou

- Temples & Town
- Sister Towers
- Sister Towers f. river
- Crouching Tiger Mountain
- Beimenkou
- ErDao Men

Wohu Shan, or Crouching Tiger Mountain, from the west. Behind the mountain is the Chao River Valley, and beyond the ramparts twist and turn their way toward Jinshanling (Lindesay).

Located 120 km northeast of Beijing, Gubeikou, along with Juyongguan, was one of only two major valley routes that presented invading armies from the north with a relatively straightforward and direct route between their steppe homeland and China's dynastic capital, sited from the early 15th century on the edge of the North China Plain.

The name Gubeikou, meaning 'the ancient north pass', describes a site where the Chao River cuts a wide, flat valley through the Yan Mountains. In the mid–late 14th century, as ousting of remnant Yuan Dynasty forces was continued by Hongwu (1368–1398), founder of the Ming and restorer of native Han rule, the emperor authorized construction of border defences.

Due to its strategic importance Gubeikou was among a handful of places selected for construction of what initially were piecemeal fortifications. The majority would eventually be linked to create a sub-continental scale defence system, the Ming Great Wall.

Like Juyongguan, the location assumed even greater strategic importance early in the 15th century when Yongle (1402–1423), the third emperor of the Ming, decided to relocate the dynastic capital from Nanjing in the south to the north to facilitate his war plan of conquering the steppe. Instead of being cushioned by more than 1,200 km of territory, the new imperial capital of Beijing now lay 120 km away from the volatile frontier.

The seat of imperial government demanded better protection from fortifications. Gubeikou was initially improved by lateral extensions aimed at foiling attempts by the enemy to sidestep the main riverside defences and exploit minor, adjacent valleys and gullies.

A major breach of Gubeikou's defences nevertheless occurred in 1550. In response to this military debacle, the last major revamp took place, during the reigns of the Longqing and Wanli emperors (reigned 1568–1572 and 1572–1620 respectively).

Qi Jiguang (1528–1585), a general in command of border defence in the Jizhou military region, scrutinized existing fortifications. He concluded that although a huge amount of time, money and manpower was invested in construction, the outcome of a conflict in the Great Wall theatre of war could not be guaranteed in China's favour.

William Geil wrote that 'men are stronger than mortar', and his words can be considered a summary of Qi Jiguang's main concern, and the guiding principle of the commander's redesign work. Gubeikou was reshaped by constructing more watchtowers, thus providing more places for permanent garrisoning, rather than relying on the availability of men stationed behind it as reinforcements. Towers were built close together, so that guards in adjacent structures could actively defend the outside face of the Wall in between with their overlapping bow or crossbow fire. Qi Jiguang also required the rampart to be built higher and wider; the existing Wall was encased in bricks. Battlements atop the Wall had a number of new design features added, such as merlons with angled edges to provide wider-angle observation and firing opportunities for defenders, and openings at pavement level for them to drop rock bombs.

Gubeikou was the prototype for Qi Jiguang's various improvements, later implemented elsewhere, and it is was the remains of his grand architectural vision here that early British visitors to Gubeikou saw in the late 18th

century (see following pages).

It was not until the early 20th century that the first photographers arrived at Gubeikou. The round trip journey from Peking took six days, compared to the four days required to see the Wall at Nankow Pass. Relatively few travellers were willing to endure the prolonged hardship.

Rare images of Gubeikou were exposed by Frederick Clapp in 1914 and Hermann Consten, a German anthropologist, who passed through the town in 1928 en route to Mongolia. Their coverage was limited in extent to scenes of the Wall that lay immediately beside the road, which followed the river.

These vintage photographs of Gubeikou are precious for their close up depiction of some of the Wall's architectural components, particularly towers and gates.

The 'brick renovation' of Qi Jiguang at Gubeikou saw existing fortifications being encased with bricks.

William Parish: A British Officer's Wall Survey

In the collection of Qing (1644–1911) antiquities at the State Museum of China, on the east side of Tiananmen Square in Beijing, is a one-metre length silver sabre with a jasper handle inlaid with gold and encrusted with gems from India, presented to the Qianlong Emperor (1736–1795) from King George III (1760–1801). It was the most precious gift delivered by a roving British Embassy, which passed through the Great Wall at Gubeikou in the late summer of 1793, en route to the mountain resort of Jehol (Chengde) for an imperial audience.

The goal of the embassy was to break down trade barriers and counter the growing influence of European rivals, particularly the Dutch East India Company, as well as gather knowledge on the Chinese Empire. However, to gain an audience with the emperor the British claimed their purpose to be delivery of greetings on the occasion of Qianlong's 80th birthday. While journeying to the venue of the meeting the greatest barrier on earth was sighted, investigated, measured, drawn and painted.

Leading the embassy was Earl George Macartney (1737–1806), appointed 'Ambassador Extraordinary and Plenipotentiary from the King of Great Britain to the Emperor of China'. Macartney was well qualified and connected for his difficult task, having served in India as Governor of Madras, where he cultivated good relationships with directors of the British East India Company, a business empire in itself, which had also been awarded a government-granted monopoly to trade with China. However, restrictions imposed upon it – and all foreign traders – by the Cohung system (a monopolistic guild of merchants) at the entry-port of Canton (Guangzhou) prevented trade volume increasing during the 1770s.

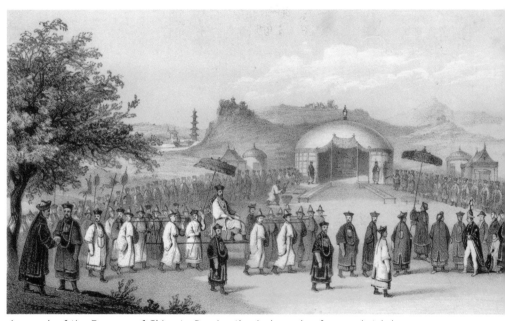

Approach of the Emperor of China to Receive the Ambassador, from a sketch by William Alexander, late 18th century. The meetings between the Qianlong Emperor and Lord Macartney in 1793 took place in a Manchurian yurt erected in the 'Garden of Ten Thousand Trees' (WL).

The 84-member embassy, including deputy ambassador Sir George Staunton, Captain William Parish of the Royal Artillery, infantrymen, two Chinese interpreters trained as missionaries in Naples, a botanist, mechanical engineer and six musicians, arrived in Peking in late summer 1793, only to discover that the Qianlong Emperor was summering at the imperial mountain resort of Jehol, 270 km north of the capital. The Britons procured permission to travel there, and after several days approached the Wall,

an experience recorded by embassy secretary Sir George Staunton in '*An Authentic Account of an Embassy from the King of Great Britain to the Emperor of China*' (London, 1798):

'After passing through another gate nearer to the old Tartar boundary, and going through a perpendicular defile, formed by high and massy walls, the travellers arrived at Koo-pe-koo[1] *which was the residence of the strong garrison placed for the defence of the outer wall in this part of it. It was enclosed by concentric works, united with the main wall. Military honours were paid to the Embassador on his arrival at this northern boundary of China proper.*

"The troops were drawn up", as Captain Parish remarked, "in two lines, facing inwards. They were formed by companies, each of which had its leader, its standard and five camp colours. In entering the lane formed by the two lines, there were mandarines on each side, then music, tents and trumpets, pai-loos or triumphant arches, twelve companies in succession on each side, and lastly, about ten small pieces of various forms and constructions. The number of the whole amounted to twelve hundred".

Near to Koo-pe-koo were some breaches in part of the great wall, which afforded an easy opportunity of ascending and examining it. All the Embassy went to visit it; but Captain Parish was particularly attentive to its construction and dimensions.

The body of the great wall, he observed, "was an elevation of earth, retained on each side by a wall of masonry, and terraced by a platform of square bricks. The retaining walls, continued above its platform, form its parapets.

The brick wall is placed upon a basis of stone, projecting about two feet beyond the brick work, and of which the height is irregular, owing to the irregularity of the ground over which it runs; but not more than two courses appear above the sod, amounting to somewhat above two feet. The bottom of the cordon is upon a level with the terrepleine of the wall.

The bottom of the loopholes is on a level with the terrepleine of the wall; and from thence they are sloped downward, so as to discover an enemy within a few yards of the basis of the wall. It will perhaps be thought that this position is much better calculated for the use of fire arms, than for that of bows and arrows.

Bricks differ in dimension according to the situations in which they are placed. Those for terraces of the wall and towers, differ only from the former in being perfectly square, each side containing fifteen inches.

Wherever, for finishing the tapering tops of the parapets, bricks of the usual dimensions would not answer: instead of rudely chipping off these to the form required, as has been sometimes directed by negligent or ignorant artists, care was taken to mould other bricks purposely of the form and size proportioned to each separate use. The cement or mortar between the different layers of brick, was upward of half an inch in thickness, and had a very small proportion of any ingredient in it, to alter the perfect whiteness of the calcined limestone".

From the detail which Captain Parish has entered with so much care, an accurate idea may be formed of the state of architecture, and mode of defence among the Chinese, prior to the Christian era.[2] *And a general consideration of this barrier, evinces the resolution and comprehensive views of that government, which could embark in so vast an undertaking; the advanced state of society, which could supply the resources, and regulate the progress of such a work; and the vigour and perseverance with which it was carried to perfection'.*

[1] Gubeikou; [2] Staunton was informed by local mandarins via his interpreters Ke Zongxiao and Li Zibiao that the Great Wall was built during the reign of Emperor Qin Shihuang (221–210 B.C.). However, the Wall at Gubeikou seen by the Britons was of Ming age (1368–1644), and had undergone renovation as recently as the 1580s.

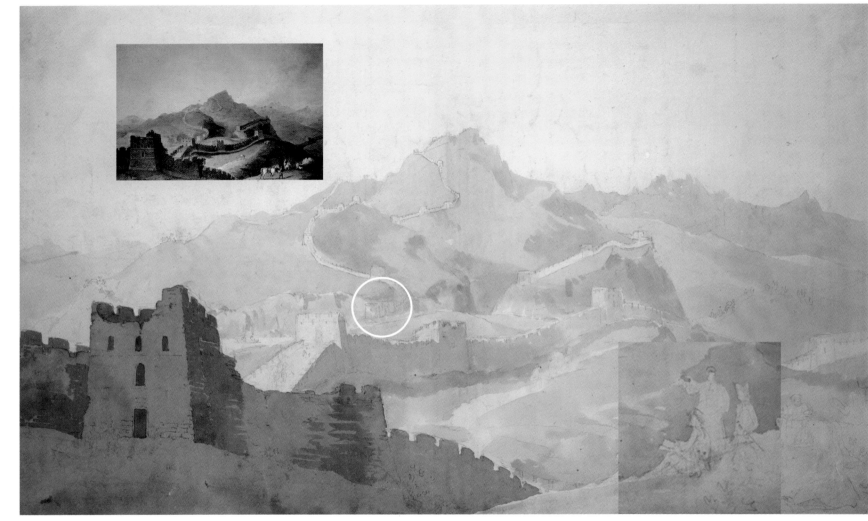

Watercolour painting from the field sketchbook of Captain Parish, and used by William Alexander for production of a copperplate engraving (top inset) *View of the Great Wall of China, called Van Li Tching, or Wall of Ten Thousand Lee, taken near the Pass of Cou-pe-koo*, published 1798. Parish included an image of himself, sitting and sketching, highlighted at bottom right. The Sisters Towers (see page 234) are circled at centre. (The British Library).

At Jehol the Qianlong Emperor granted the mission two audiences in Wanshu Yuan, (Ten Thousand Trees Garden), where Earl Macartney presented Great Britain's requests: stationing an envoy in Peking, abolition of export-import duties, the opening of more ports to trade, reduction of customs duties and freedom for missionary work. All were rejected, and Macartney was told China had no need for the British Empire's manufactures. On their return to Peking, members of the embassy saw the Chinese Wall at Gubeikou in a very different light: it symbolized in a spectacular way the difficulty of trading with China, one soon to be overcome with resort to force.

Captain Parish's descriptions, measurements, drawings and paintings were nevertheless more successful. He used his paint box, tape measure and quill to provide the outside world with detailed and numerous views of the Great Wall. The officer's watercolour painting in particular, depicting a classic Wall view, reached a large audience, being reproduced as a large copper plate engraving within a folio to supplement Staunton's writings. In recent years it has been repeatedly dismissed as inaccurate, most recently in *The Great Wall, China Against the World 1000 B.C. – A.D. 2000* (London, 2006) where the British captain's work is flippantly described thus:

'*…Lieutenant* (sic) *William Parish busied himself producing equally fanciful and romantic paintings of the wall festooning bosomy hills as far as the horizon stretched, interrupted by artistically ruined towers, their square stone edges becoming frayed*'.

To find out if the British officer had engaged in such embellishment, the original watercolour collected by the British Library was scrutinized in London, and I carried a copy to the field location it is purported to depict.

The view, looking west, shows the Wall on both sides of the Chao River. With a magnifying glass, a boat can be seen on the river, and two towers are depicted standing side by side on its far bank at the foot of cliffs. They are the Sister Towers (see page 234). Beyond, one is struck by the tremendous accuracy with which the artist captured the form of Wohu Shan, or Crouching Tiger Mountain, in particular the twisting path of the fortification snaking its way toward the 665-metre summit, and the recession of craggy mountains, not 'bosomy hills'.

This fieldwork confirms that Parish's work is remarkably accurate, and the earliest known realistic depiction of the Great Wall.

Parish also drew architectural plans, elevations and sections of the locality's rampart and watchtowers as well as producing a long list of various measurements, also checked and found to be within centimetre-accuracy, ranging from brick size to wall height, archway span to frequency and size of loopholes and merlons.

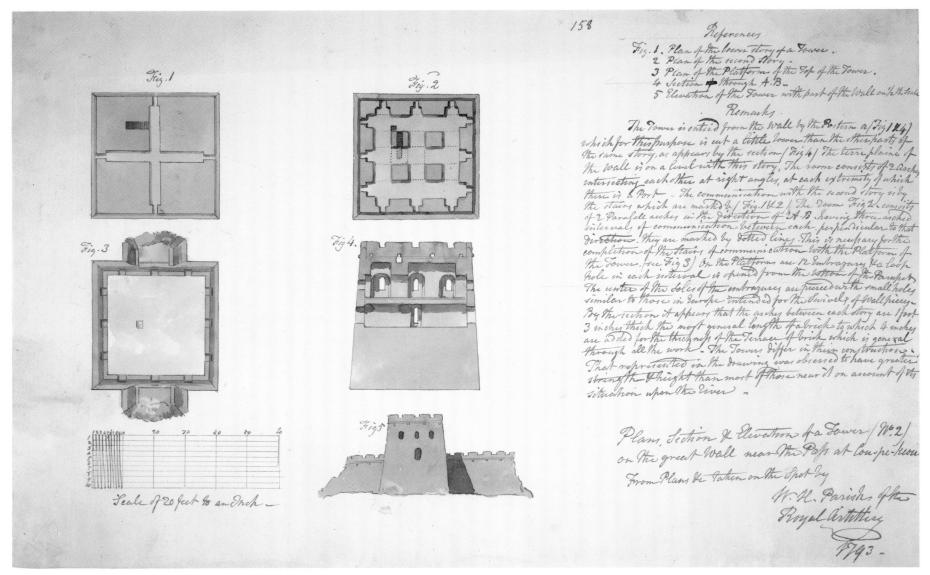

Plans, sections and elevations of a watchtower at Gubeikou 'made on the spot' by
Captain Parish in 1793 (The British Library).

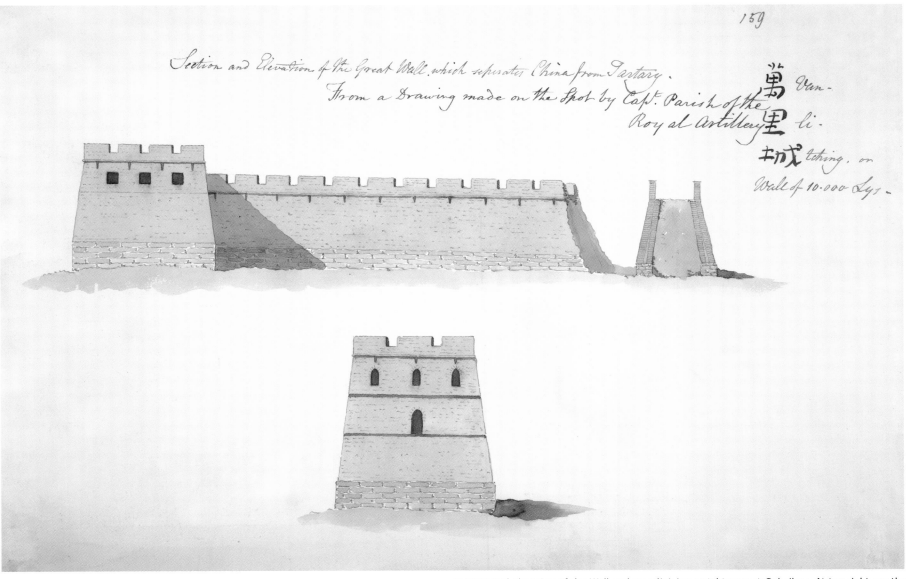

Section and Elevation of the Great Wall which seperates China from Tartary.
From a Drawing made on the Spot by Capt. Parish of the
Royal Artillery

萬 Van-
里 li.
城 tching, or
Wall of 10.000 Lys.

Section and elevation of the Wall and an adjoining watchtower at Gubeikou. At top right are the three characters 'Wan Li Cheng' which translate literally as '10,000 Li Wall', and metaphorically as 'The Endless Wall' (The British Library).

Gubeikou's Temples and Town

The original 1920s photograph provides not only a view of old town of Gubeikou, but vividly illustrates the strategic importance of the Chao valley location. It is also a very unusual image, showing the Great Wall and contemporary buildings of a large town juxtaposed.

The photograph was taken from high up on the Gubeikou fortified town wall, looking north across the town. In the immediate foreground are three temples: one far right, one bottom left and the third about 100 metres away from where the photographer stood. Talking of Gubeikou the townsfolk say: 'Take three steps and you reach three temples; take another three and you can enjoy clear water from three wells'.

From the mountain on the left the Great Wall can be seen snaking down to the water's edge. The Sister Towers are visible beside the Chao River. To their right (east), a water gate would have formerly prevented attackers charging down the river bed, but at the same time portcullis gates would have allowed the

river to flow through. In the upper right part of the photograph, immediately north of the town, the continuation of the Wall on the east bank of the river can be seen. It is in this area that two other sites, Beimenkou and Er Dao Men, were revisited.

Rephotography shows that a large part of the old town remains intact, with the three temples, Yaowang (The Medicine King), Caishen (Prosperity) and Ji Gong (a Chinese saint), preserved or rebuilt. The line of the Wall on the west bank is preserved, although the Sister Towers have gone. Fortifications on the east bank appear much less prominent. Please learn of the fates, or fortunes, of Beimenkou and Er Dao Men on pages 242 and 244.

Daoist from the Temple of the Medicine King (located bottom right of photographs opposite).

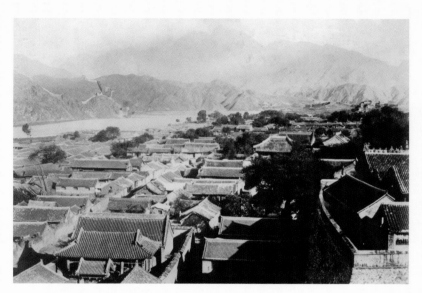

View across Gubeikou: a silver gelatine print, 15 x 10.5 cm, by an
unknown photographer, late 1920s (WL).

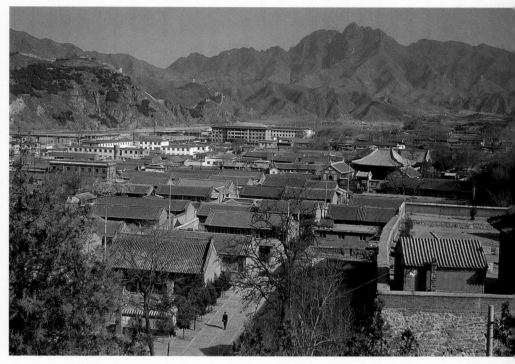

View across Gubeikou: Lindesay, 2006.

KUPEIKOU

Just beyond the Great Wall behind Peking, the
stage of Kupeikou is situated, the first stage on the
northward route outside the Wall. It stands along
the Chao river. The sight of the Great Wall
creeping along the top of the range of hills rising
on the river bank tells tales of many pillages and
raids by the "Northern Barbarians." The contrast
between the Peking, the Center of the Chinese
civilization, and Kupeikou, somber and solitary,
with the Great Wall intervening, seems to speak
eloquently of China's history for 2,000 years past.

The caption attached to the back of the above photograph.

The Sister Towers

"The Sister Towers aren't here anymore, they're gone," lamented 82-year-old Lu Wencai when the 75 years' old photograph placed in his hands came into focus. The watchtowers, one large the other small, side by side and overlooking the Chao River, may have constituted a unique architectural assemblage on the entire Ming Great Wall.

According to Lu Wencai, who lives in the hamlet of Xishuimen, just 200 metres away from the site, the Sister Towers were first damaged by Japanese bombers as the modern invaders targeted Chinese forces using the towers as machine-gun posts during the Anti-Japanese War (1931–45). Later, in the early 1970s, when soldiers of the People's Liberation Army constructed a railway up the valley, they dismantled the towers and adjacent Wall for bricks, using the masonry for building makeshift shelters.

"Once the army left, we farmers collected the bricks and used them ourselves," said Lu, explaining the 'great wall' surrounding the family farm. "I hope that one day our country is rich enough to rebuild the Sister Towers," he added.

It was no surprise after Lu Wencai's explanation that revisiting found the Sister Towers to be derelict. The larger sister had lost its top half of bricks, levelled to just a few courses, though its quarried block base was still intact. The smaller sister was reduced to a mound of rubble.

Lu Wencai outside his farm surrounded by its own 'great wall'.

Right: "The Sister Towers aren't here anymore," said Lu Wencai.

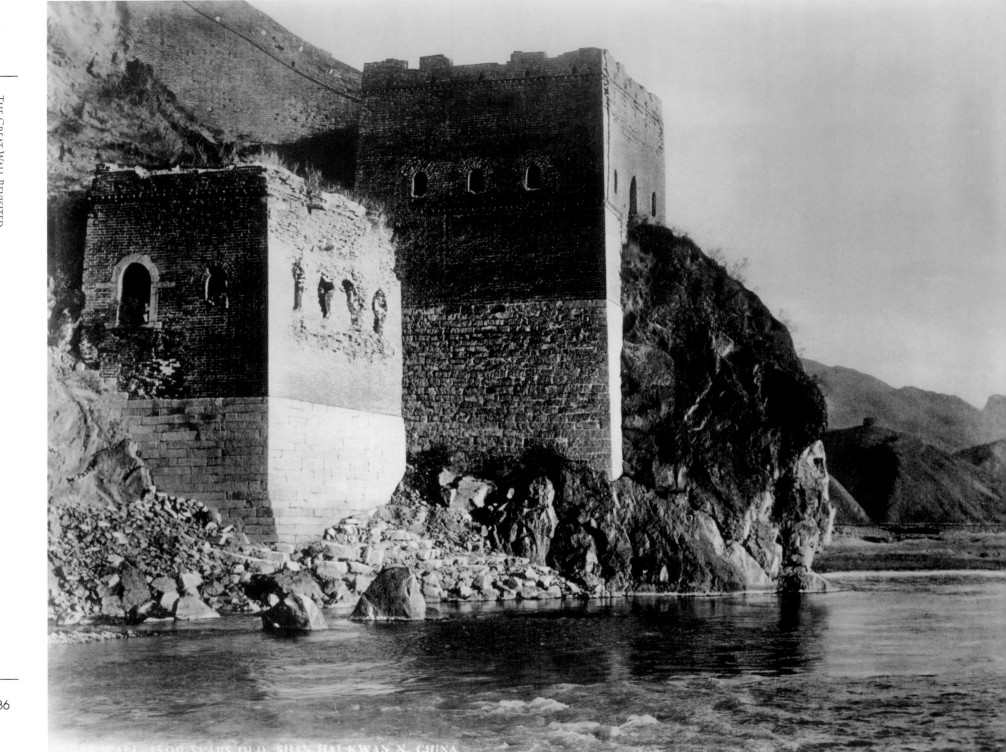

THE WALL 1500 YEARS OLD. SHAN HAI KWAN N. CHINA

The fallen Sister Towers at Gubeikou: note the course of the Chao River had been diverted by gravel and pebble extraction: Lindesay, 2004.

Left: The Sister Towers at Gubeikou: a hand tinted silver gelatine print, 24.7 x 19.5 cm, by an unknown photographer for A.H. Fung, early 1930s (WL). Note the presence of water, actually the Chao River, led to the erroneous caption of 'Shan Hai Kwan' where the Ming Wall reaches the sea (WL).

Riverside View of the Sister Towers

This middle distance view of the Sister Towers was taken by Hermann Consten (1878–1957) in May 1928 as the German Mongolist was travelling from Peking to Mongolia.

Local legend has it that the Ma family had two daughters. Although the girls were separated by several years they looked like twins, one tall and one short. One of the girls met Hong Xi, a sectional commander at Gubeikou appointed by Qi Jiguang, regional military commander of Jizhou, who was given the task of designing the layout of defences on Wohu Shan, Crouching Tiger Mountain.

Given the extreme vulnerability of the land beside the wide, flat river bed, Hong Xi was at a loss as how to defend it. The Ma sister suggested he build not one, but two towers beside the river, just like the sisters: one large and one small, but similar in appearance. He decided to proceed with the suggestion – it had strategic logic and it had never been done before, and that was regarded as a new, acceptable approach to solve the problem. And in recognition of the girl's suggestion Hong Xi named the structures the Sister Towers.

Revisiting found the Sister Towers to have been destroyed (see page 234) and the natural course of the river diverted by dredging for sand and gravel.

Portrait of Hermann Consten in 1907, aged 29 (The Consten Estate).

View of the fallen Sister Towers and no river: Lindesay, 2006.

Hermann Consten

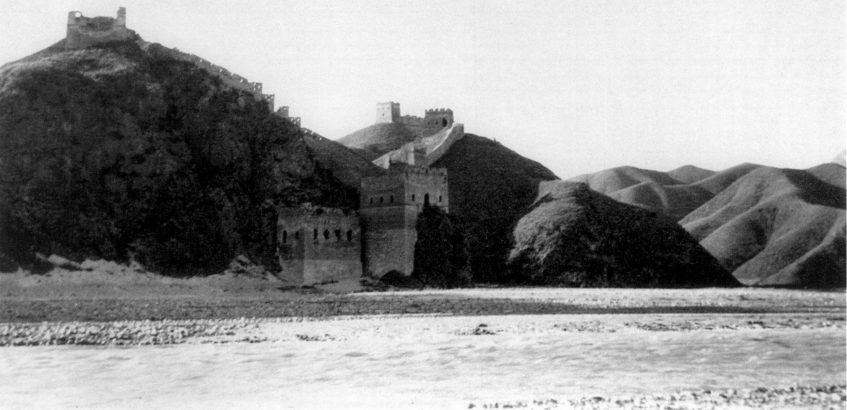

View of the Sister Towers from the river: Consten, 1928 (The Consten Estate).

Wohu Shan (Crouching Tiger Mountain)

The original photograph was taken by Frederick Clapp, (see page 120) who reached Gubeikou in the spring of 1914, two months after setting off from Shanhaiguan. He wrote:

'Our next view of it was at Kupeikow[1] on a balmy day in April when wheat was green in the valleys, spring vegetables were up and fruit trees, violets and dandelions were in bloom. About noon we caught sight of a long line of watchtowers on the crest of distant mountains; at two o'clock we arrived close to the wall in the valley of the Chao Ho[2] and saw the frowning battlements, the watchtowers and the long snakelike line of brick and stone winding up the hillside from crest to crest'.

[1] Gubeikou; [2] Chao River.

Ninety years later, revisiting this section of the Wall showed exploitation of the Chao River flowing below Crouching Tiger Mountain, as its bed was being dredged for sand, gravel and pebbles to satisfy Beijing's massive demand for construction materials. On a follow-up visit to the site shortly before going to press, I saw the results of work carried out to repair the degradation inflicted upon it by dredging and quarrying. This latest rephotograph is provided to evidence the improvement.

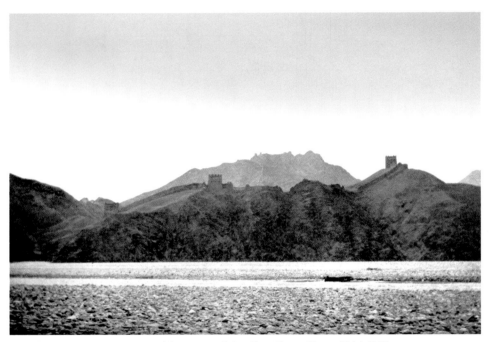

Crouching Tiger Mountain viewed from east of the Chao River: Clapp, 1914 (WL).

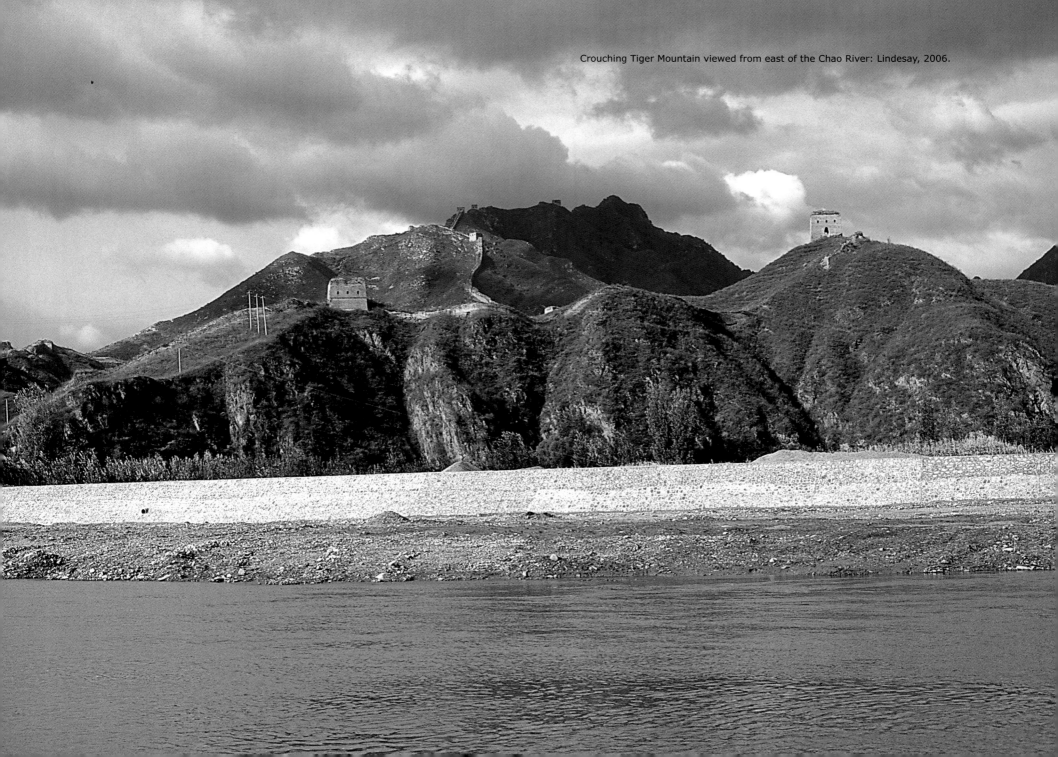

Crouching Tiger Mountain viewed from east of the Chao River: Lindesay, 2006.

Beimenkou: North Gate of Gubeikou

Beimenkou villager Liu Yongping, aged 92 years, leads the way to the missing North Gate.

None of the study's expert group could pinpoint this location, although the caption of Hermann Consten's photograph (if correct) revealed that it was at Gubeikou. I received initial pointers to its position from a group of locals in the town centre who gathered around me and the photo, curious to discover what I was doing, and what the town of their grandfathers' had looked like.

They advised me to head along to Beimenkou village. There I found 92-year-old Liu Yongping, basking in the spring sunshine. He immediately recognized the location.

"Perhaps that's me right here!" he exclaimed, pointing to the boys standing in front of the gate in the photo. He may have been right. He would have been 14 years old when the German adventurer passed through the town in May 1928.

"As a boy I saw lots of foreigners in my home town. I'm old now, but I hope I'm not too old to see the Wall around here standing up once again," he said.

Revisiting Beimenkou, or the North Gate, as it turned out to be, found only the rock outcrop on which the fortifications once stood.

The bed of the Chao River, on the left hand-side of the original photograph, has been land-filled to accommodate the G 101 road, the main traffic route between Beijing and Chengde. The gate has been demolished, but the new concrete road follows its alignment to a village. The watchtower, above and behind the gate, has also disappeared.

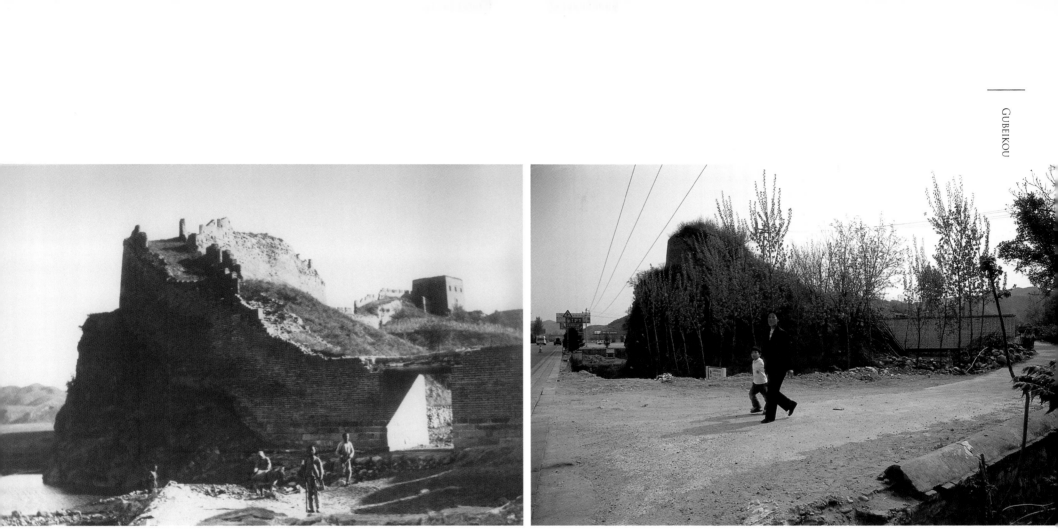

The North Gate at Gubeikou: Consten, 1928 (The Consten Estate).

The mound crossed by a barely discernible Wall, with no North Gate: Lindesay, 2006.

Er Dao Men ('The Second Gate Seen on Arrival')

The original photograph taken by Frederick Clapp in 1914 is a rare image. It combines linear Great Wall fortifications in the background, recognizable from its hallmark watchtower architecture and battlemented adjoining rampart, and a straight section of another wall running across the foreground of the photograph, containing a square gate, and thought to be part of the town wall that once enclosed Gubeikou.

Once again, although captioned as being in Gubeikou, none of the expert group assisting in identification could place the site. This time I knew exactly who to ask, so I returned to Beimenkou village.

Three generations of villagers gathered around Liu Yongping and I, eager to discover why a foreign photographer, carrying an old photograph, was so interested in what the 92-year-old man had to say.

"It's the second gate seen on arrival in Gubeikou", he announced, "I'll lead you there now."

Liu climbed on his tricycle and rode down the lane leading from the village towards the road and river, passing farmyards behind their own great walls. He turned through where the old North Gate had once stood, and pushed his cart along the road. Huge trucks roared by, blasting their claxon horns.

"That's where it used to be", Liu shouted, pointing across the road. "It's almost all gone now, you look – no tower, no Wall, no gate, it's all vanished!"

I tried to reach the place where Clapp had stood with his camera on that

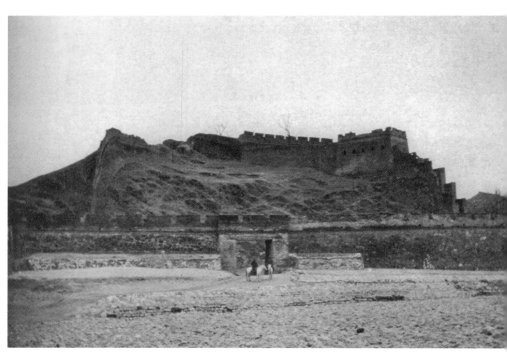

'The Second Gate Seen on Arrival' in Gubeikou: Clapp, 1914 (WL).

balmy April afternoon of 1914. The river bed of old had been decimated, and the mounds of gravel, dredgers and deep pools of stagnant water made it impossible to venture toward the place where he'd stood. I had to settle for a point much closer to the Wall.

"From here", said 'Old Liu', "you can show people the plinth that tells everyone this is the Great Wall of China."

'The Second Gate (no longer) Seen on Arrival' in Gubeikou. Note the concrete plinth at far right marking the position of the *Wanli Changcheng*: Lindesay, 2006.

'Geil's Tower', Luowenyu

William Geil and I travelled along the Great Wall in 1908 and 1987 respectively, and both recorded our impressions in books (see pages 276, 278). It is likely that our paths, although 79 years apart, crossed in many places. On a remote section of Wall in Zunhua County, Hebei Province our meeting was verifiable, and most fortunate. In *The Great Wall of China* Geil had captioned one of his photographs 'East of Mule Horse Pass'. I had photographed the same view and included it my own book, *Alone on the Great Wall*, captioning it as 'Luowenyu'. This 'coincidental rephotography' reveals the disappearance of a watchtower. I dubbed the tower 'Geil's Tower' because he was probably the only person who ever preserved it on a photograph.

It was this perchance collaboration and the thoughts of change which it provoked that prompted me to source vintage Great Wall photographs with the intention of embarking upon systematic and broad rephotographic documentation.

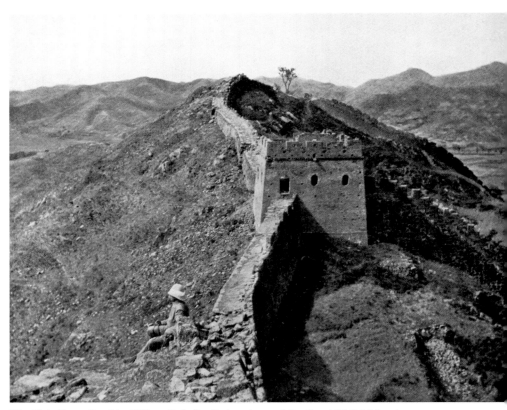

'The Mule Horse Pass' by William Geil, the first explorer of the Great Wall (sitting in foreground): Geil, 1908 (WL).

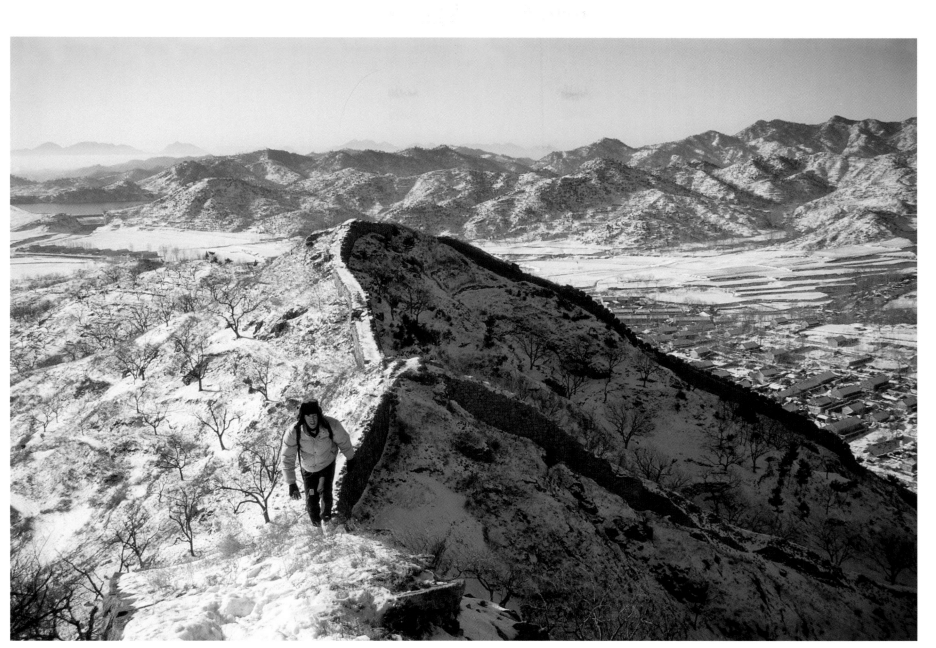

Coincidental rephotograph of Geil's 1908 view by William Lindesay in 1987.

SHANHAIGUAN

Shanhaiguan

- Yiyuankou
- Series of Views
- Jiaoshan (looking up)
- Jiaoshan (looking down)
- Coastal Plain
- First Pass Under Heaven
- Fuyuanmen
- On Bohai Coast
- Old Dragon's Head

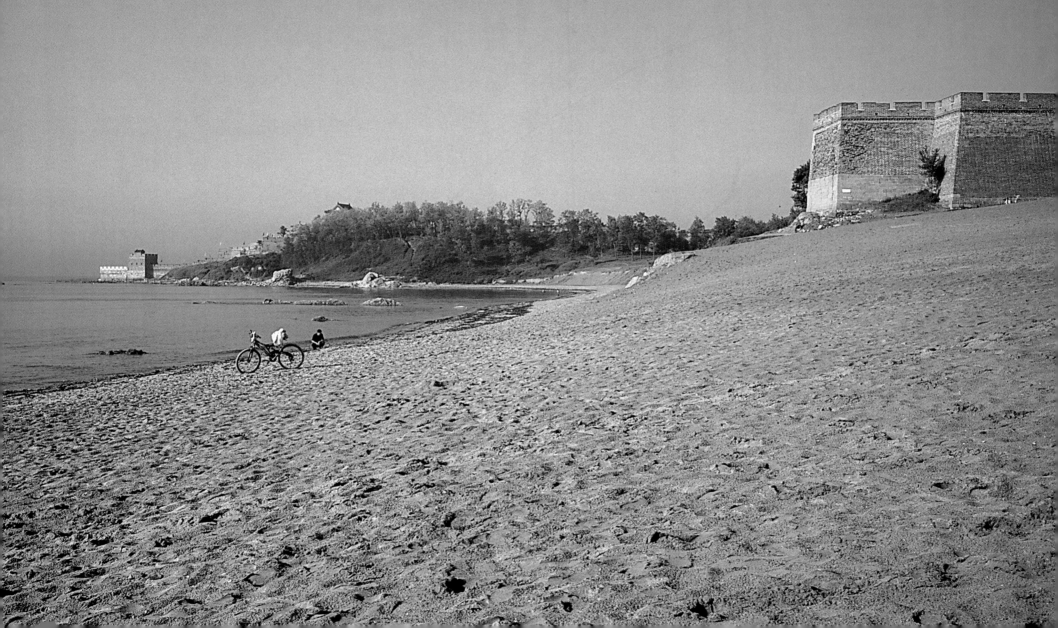

Old Dragon's Head, the seaside terminus of the Ming Great Wall, rebuilt in 1987 (Lindesay).

Fortifications revisited at Shanhaiguan mark the most easterly of seven regions incorporated into this rephotography study.

Shanhaiguan lies on the narrowest part of the coastal plain between Bohai, a gulf of the Yellow Sea, and the Yanshan range of northeastern Hebei Province. With its literal meaning 'mountain sea pass' the name describes accurately the topography of the land, long targeted by northeastern nomads as an inroad to access the North China Plain, and long identified by China as a pass of paramount importance that required impregnable fortification.

Remains of the extensive and various component defences here are among the most famous on the entire Ming Great Wall, and vaunted as marking its eastern terminus. On the coastline lies Laolongtou, or Old Dragon's Head. On the fortified town's wall stands the gate tower *Tianxia Diyiguan*, the First Pass Under Heaven. Providing a bird's eye view of the 10-kilometre-width plain between mountain and sea is Jiaoshan, dubbed the first mountain traversed by the Wall. However, late in the Ming, in response to the rise of the Manchu nomadic federation as a border threat, fortifications were extended from Shanhaiguan in a northeasterly direction to the Yalu River, the present-day border between China and North Korea. This section is known as the Liaodong (Manchurian) extension.

It would be more precise therefore to describe Shanhaiguan as the seaside terminus of the Wall, or the terminus of its main line. Without doubt it is the most easterly *guankou*, or major strategic pass, and lays claim to being one of the Ming Wall's oldest sections. As early as the 14th year of the Hongwu Emperor (1381), Xu Da, who earned himself the title *cheng lu da jiangjun*, or 'barbarian quelling general', for his efficient purging of remnant Mongol forces from the north back to the steppe, arrived here to oversee construction aimed at barricading this loophole between the natural defences. Over the

ensuing two and a half centuries, fortifications at Shanhaiguan grew more complete and complex, right up to the 'brick renovation' implemented by Commander Qi Jiguang in the mid-late 16th century (see page 224).

Today, reminders of Shanhaiguan's position in Great Wall history are visible in every vista and casual glance; as the awe-inspiring serpent of stone winding to the summit of Jiaoshan; as a bushy, velvety mound standing amidst maize fields on the plain either side of town; and as tall brick facades punctuated by gate towers and archways which comprise the town's enclosing fortress.

A stroll around the fortified town wall provides snapshots of the Wall's history. On some sections, bricks stamped at their time of manufacture (mainly early Wanli period, c. 1584) reveal when the wall was improved by the addition of bricks. For long stretches, thousands of weathered bricks show how the damp, salty breeze blowing onshore has contributed to the natural ageing process, while diagonal rents akin to geological faults record the sudden force of earth movements.

More recent damage was inflicted by early 20th century warfare. At the turn of the 19th century armies of eight allied nations, attempting to expand their territorial claims, were active in the area, often engaging in combat with Chinese forces. In 1933 Shanhaiguan was the scene of a major battle as Japanese invaders pushed south from Manchuria, the region of China's northeast, which they annexed in 1925. These conflicts all left scars, from thousands of bricks pockmarked by bullet holes, to larger wounds inflicted by shelling or complete collapses.

Ironically, with reference to the brief discourse above on Shanhaiguan's position as terminus, it is accepted as the place where the fate of the Wall's long functional history was sealed. In 1644, Manchu armies were allowed to pass

through one of the town's fortified gates, Fuyuanmen, a location covered by rephotography (see page 266), after the commander of the Shanhaiguan garrison, Wu Sangui, took his strategic decision to ally with the nomads as a means of putting down a peasant rebellion, led by Li Zicheng, whose army had routed Beijing, forced the emperor to commit suicide, and brought the Ming dynasty to an end.

The alliance achieved Wu Sangui's goal of restoring stability swiftly to the empire: the Manchus established the Qing Dynasty (1644–1911), one of the longest lasting in dynastic history. Early imperial courts debated whether to maintain the border defence system they had inherited. As nomads themselves they opted for a more aggressive policy for dealing with the inevitable problem posed by the Mongols. They aimed to conquer the steppe by force, and eventually succeeded. The Qing Empire grew to be the largest in Chinese history.

Qing emperors made regular journeys from their imperial capital at Beijing to their ancestral homeland in the northeast, often passing through Shanhaiguan, where they rested to enjoy the coastal scenery and therapeutic sea air.

Early images of Shanhaiguan's fortifications were mainly produced by foreigners who had reached the town by sea, and most of the originals used for rephotography were produced by this circumstance.

Battle scene between foreign forces at Shanhaiguan's main gate tower, The First Pass Under Heaven, from the Italian newspaper *La Domenica del Corriere*, 1933 (WL).

大英欽命督領列那爾火輪官船水師都督克爾克喇孚頭首拜

'Naval Commander Cracroft, appointed by Her Majesty of Great Britain to command the steamship Reynard, bows his head and pays his respects'.

Mr Smythe: A Day Ashore at Old Dragon's Head

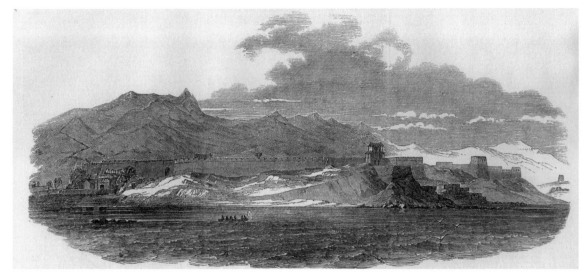

General View of the Great Wall of China from the Sea, actually Old Dragon's Head (WL).

In May 1908 William Geil found nothing but 'tumbled granite blocks that all awry now mark where the massive masonry once extended into the waters'. Old Dragon's Head had been destroyed by 'troops of certain European powers (that) summer on the shore of the Yellow Sea, giving a belligerent appearance to an otherwise peaceful place'. Geil was there too late with his camera, but an artist by the name of Mr. Smythe made a series of sketches in 1850 which he contributed to the *Illustrated London News*. These drawings probably provide the only visual record of how the coastal fortifications at Shanhaiguan appeared before their destruction in 1900.

Smythe was aboard H.M Steamship Reynard, which 'early on the morning of the 13th (June), anchored in three fathoms, about 1,000 yards distant from the Great Wall'.

Far left and right: Greetings exchanged between the Tou-tai, or Governor of Shan-hae-wei and Captain Cracroft of H.M. Steamship Reynard, included in the *Illustrated London News* correspondence of October 1850 to provide readers with 'hints upon etiquette' useful while encountering Chinese mandarins (WL).

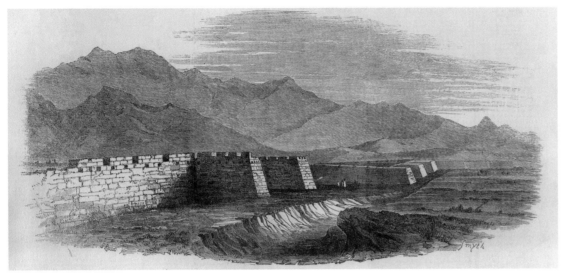

View inland from the top storey of the second tower (WL).

The accompanying report, written by an anonymous correspondent, presents itself as an inseparable supplement to the sketches, which now follows in its entirety.

'Viewed from the water, the terminus appears to consist of a fortress some 300 yards in length, having a large gateway in the southern face, close outside of which, and between it and the sea, is a permanent joss house, or temple, while the northern end is surmounted by a modern two-storied guardhouse; immediately beneath, the Wall projects seaward.

At 10.00am we landed a large party to the right of the joss house on a steep sandy beach, and were civilly received by a white-buttoned mandarin and a small party of soldiers, who informed us that we were perfectly at liberty to inspect the Wall at our leisure. We therefore soon ascended to it by a broad inclined plane outside the fort, and found ourselves on a rectangular platform, about 60 feet in length, paved by dark blue-coloured bricks. This portion of the structure, from its apparent age and condition, seems to have been the original terminus of the main wall; while, owing probably to the receding of the water, the before-mentioned lower continuation

大清欽命直隸清河道前任浙江寧紹台道陳之驥拜

'Chin Zhiji, the Tou-tai (Governor) imperially appointed by the Great Qing Empire in the administration of Qinghe in the province of Zhili (Hebei), he that formerly occupied a position in Ningbo, Shaoshing and Taeshow in Zhejiang Province, bows his head.'

253

projecting seawards – now a mass of ruins half buried in the sand – appears a less durable construction, of much later date.

The first objects that arrested our attention on the platform were three monumental slabs of black marble; two standing close to the wall, the third removed from its base: a curiously carved altar shaped pedestal lay extended on the ground. On one of the standing slabs is deeply inscribed the sentence: "Heaven created Earth and Sea;" and on the other, "Only a Spoonful." The import of this latter sentence we were at a loss of conjecture: it may have reference to the placid waters of the Gulf of Leotong; or, perhaps, is intended as an allusion to the nothingness of this vast structure (Great Wall) when compared with the works of Creation. The fallen monument, having a very long inscription, we left to be deciphered on our return from the survey of the Wall, which we could no longer delay.

Ascending again by a broad flight of steps from the platform to the top of the fort, we walked past the guard house (a dilapidated building) down another shorter inclined plane, and then along the Wall, which we found, for about 800 yards, in a very ruinous condition, the first part of it being little better than an embankment of sand, broken at intervals by projected masses of ruined bulwark.

At half a mile's distance from the fort, however, the Wall commences to show a better state of preservation; here we found it measures 39 feet across; the platform was covered with mould, and variegated with flowers of every hue. The Wall on the Tartar side, at this point, shows a well-built foundation of hewn granite, surmounted by a slanted brick facing, measuring together 35 feet in height; above this is a brick parapet, 7 feet in height and 18 inches thick, divided by small embrasures at regular intervals, from 8 to 13 feet apart.

At intervals, varying in distance from 200 to 500 yards, the Wall is flanked, on the Tartar side, by towers of brick, 45 feet square and 52 feet high. The one we examined was entered from the Wall by an arched granite doorway, 6½ feet high and 3½ broad. The construction of this arch is most remarkable for the Chinese have ceased to use key-stones in their arches. A flight of steps to the right, within the doorway, leads up to the flat roof of the tower, which is surrounded by a parapet like that upon the Wall. The body of the tower is intersected, at right

The second tower inland to be investigated by the British visitors. Only the foundations of towers can now be found on this section (WL).

angles, by low arched vaults, each terminating in an embrasure, of which there are three on each outer face. From the construction of these vaults they seem to have been built for archers and spearmen, and not for any kind of artillery; there was no vestige of a parapet on the Chinese side of the Wall, except on the low towers on this face, which intervene midway between those on the outer, but are not vaulted.

Monumental Slabs at the Eastern Terminus, two of which had their inscriptions copied by the British visitors. The third, lying on the ground, has a longer inscription. The Britons planned to copy its contents after investigating the fortifications inland, but this was not possible after they received their marching orders from the local mandarin (WL).

From this tower, which is the second inland, the Wall continues apparently more or less in a ruined state for about three miles in a N.N.W. direction, over a fine undulating country. It then takes a sudden curve to the S.W., passing near a large town called Shan-hae-wei. Then it ascends directly up a bleak, rugged range of mountains, almost 3,000 feet in height, creeping up the side like a giant serpent, and disappearing over the summit of the ridge.

The general features of the country about the Wall are very pleasing; the land, rising slowly from the sea up to the foot of the mountain range, is well wooded, and apparently densely populated on the Chinese side. On the Tartar side it undulates gently into the distance, and appears rich and well cultivated, and dotted here and there with villages, the houses of which have roofs exactly similar in shape to those of our omnibuses at home. The only gate through the wall in this district is about three miles inland, and is called the Shan-hae-kwan. This we intended visiting had not the mandarins prevented us. We observed, while loitering about the Wall, troops of mounted Chinese galloping out from the interior in the direction of the fort; but supposing there were only hastening to have a view of us before we left, we took no further notice of them. Before, however, we had proceeded one mile and a half inland three mandarins overtook us, and informed us that the Too-tung, or Tartar General in command at Shan-hae-wae, had come down to the fort, and it was his wish that we should proceed no further. We accordingly descended from the Wall, and returned through the fields to the terminus. Here we found the General and a numerous suite assembled, with a crowd of mandarins and soldiers; and the bustle and confusion occasioned by their presence unfortunately prevented our taking a copy of the inscription of the third tablet, which, there is little doubt, would have afforded much interesting information. But we were thankful to have seen as much as we did; for had the General arrived a couple of hours earlier, our landing at all would have been doubtful. We returned to our boats, therefore, satisfied with the result of the expedition, having, perhaps, seen more of this portion of the Wall than any European before us; and, as all of this part of China is still by treaty a sealed country, it may be years before another Englishman enjoys the same privilege. At three P.M. the anchor was weighed, and before dark the Great Wall of China had faded from our view'.

Yiyuankou, Funing County

The caption on the reverse of this photograph, 'The Great Wall of China', is quite typical of a 'clue' that gave no help whatsoever in pinpointing its location. The view confounded many of the experts assisting with identification. At first glance, the mountain bears a slight resemblance to Jiaoshan, the first summit ascended by the Wall southwest of Shanhaiguan, a guess made all the more reasonable given the photo was among an auction lot of three in which the other two images (see pages 258, 262) indeed depicted the Wall in the vicinity of Shanhaiguan. But not so this third image. The elusiveness made me more determined to locate and include it in the study to widen its geographical scope.

In practical terms it seemed likely that the image was exposed by a traveller en route between Peking and Shanhaiguan. Beautifully composed, this Great Wall landscape print exudes the skill of an unknown 1920s photographer who probably travelled to what was, at that time, an off-the-beaten-track location, with a large part of his luggage space given over to professional camera equipment.

The location was finally identified by Cheng Dalin, who produced a photograph of his own taken from a similar position: it was Yiyuankou, a minor strategic pass in Funing County, about two hours drive inland from Shanhaiguan.

Of the six towers visible in the original, three of them appear in good condition with their enclosed space still intact. The fourth tower from the top appears to have an engraved tablet still in situ. Mid slope battlements are in good condition.

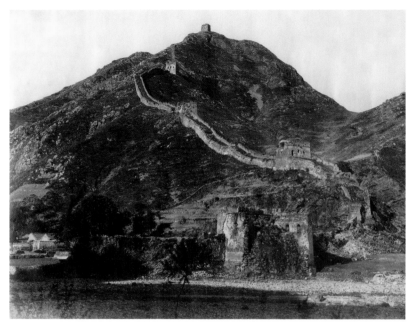

Yiyuankou in Funing County: a silver gelatine print, 27.2 x 21 cm, by an unknown photographer, c. 1920s (WL).

Revisiting identified a number of changes inflicted by man and nature, common to many sections of the Wall, which seem to summarize degenerative problems that have caused downfall of the structure during the 20th century.

High level towers remain in better condition than lower level ones, suggesting demolition of the latter by locals in search of handy building materials. While the line of the Wall is still completely discernible, the wider lower level ramparts are now without battlements, and the higher level and narrower section has lost its structure and become overgrown.

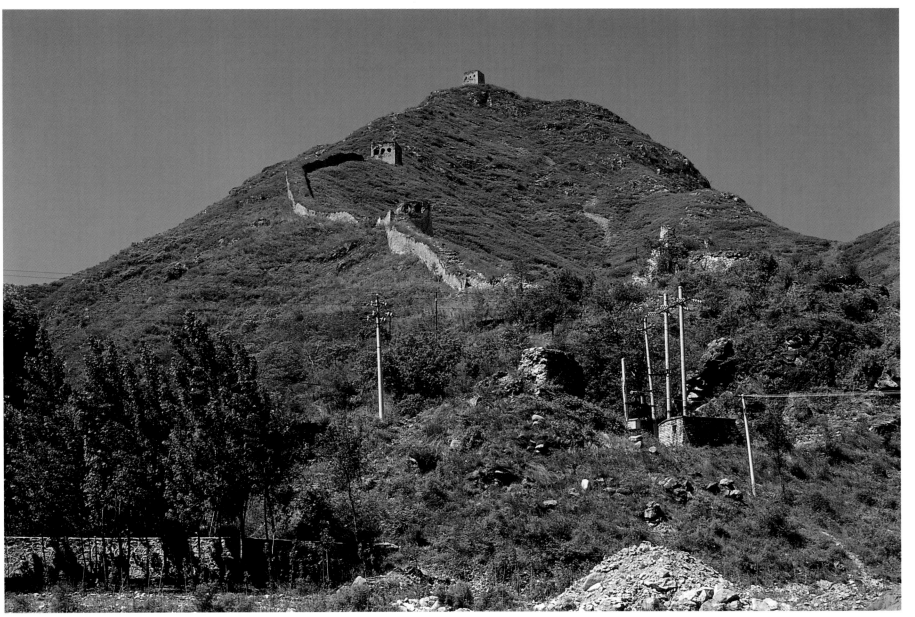

Yiyuankou in Funing County: Lindesay, 2006.

Four Views across the 'Mountain Sea Pass'
(c. 1920s, 1986, 1987 and 2006)

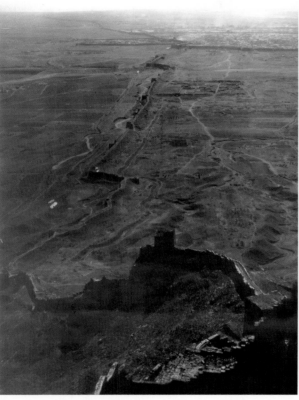

View across the 'Mountain Sea Pass' of
Shanhaiguan: a silver gelatine print, 27.2 x 21 cm:
by an unknown photographer, c. 1920s (WL).

Lindesay, 1986.

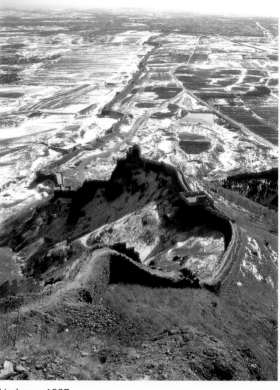

Lindesay, 1987.

The pair of photographs which I exposed in the mid-late 1980s turned out to be purely coincidental rephotographs of the oldest, taken by an unknown photographer c. 1920s. All four illustrate the geography of the 'mountain sea pass', providing a bird's eye view of Shanhaiguan on the coastal plain, with the coastline of the Bohai Gulf beyond, at the top of the frame.

The 1920s view shows fortifications on the plain, between Jiaoshan and the fortressed town of Shanhaiguan, to be cased in bricks (see 'reverse direction' view, taken by the same photographer on page 262), while the bases of towers, buttressed to the north (left), still stand out quite prominently. Towards the top of the frame, the shape of Shanhaiguan's main fortress wall can be discerned, with its northern flanking segment on the left. Most buildings remain clustered within the fortress walls. Above and beyond the town the fortification can be seen continuing virtually unbroken down toward Old Dragon's Head. One break is however visible, an opening for the railway line.

Revisiting in August 1986, which was coincidental, shows the lower section of the Jiaoshan Wall up to the No. 1 watchtower to have been renovated. Owing to the lushness of the vegetation at this time of year it is difficult to identify further changes on the plain. Buildings in Shanhaiguan seem to have spread outside its fortressed walls, and clouds of smoke from early morning fires, kindled to cook breakfast, pollute the air and shroud the form of the Wall.

Returning in December 1987 reveals a further 150 metres of Wall to have been renovated in the foreground. The brick casing of the Wall crossing the plain appears almost absent, while two metal footbridges cross gaps made by roads punched through the fortifications. Growth in the size of Shanhaiguan town can clearly be appreciated by the overflow of buildings on to land outside the fortress walls.

Revisiting Jiaoshan in 2006 shows the site functioning as a tourist location, an essential stop on the so-called 'Great Wall Museum' itinerary for visitors to Shanhaiguan.

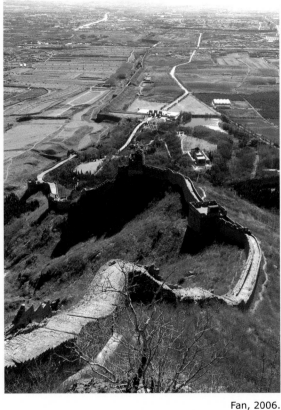

Fan, 2006.

Jiaoshan (two views)

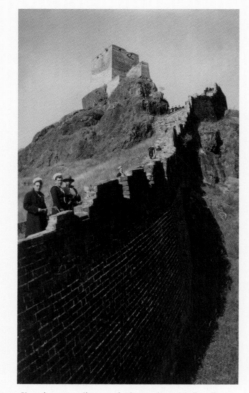

View looking up Jiaoshan: a silver gelatine print, 11.5 x 7 cm: by an anonymous British Naval officer, late 1920s (WL).

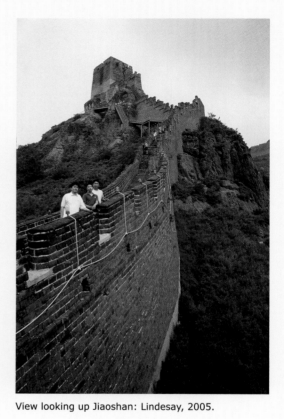

View looking up Jiaoshan: Lindesay, 2005.

The originals are a small but high-quality pair of silver gelatine prints from a series of 12 photographs in an album of personal photographs captioned in English and probably taken by a British sailor during the early 1920s.

The series records the visit of a ship's crew to the Great Wall at Jiaoshan, four kilometres west of Shanhaiguan, the first mountain crossed by the Great Wall as it proceeds inland, an event recorded by one of the vessel's camera-owing officers. British forces were active in the area in 1922 and 1924 as they supported a warlord contending for power against another warlord backed by the Japanese.

The first of the pair shows a view looking up Jiaoshan towards the No. 1 watchtower. Several sailors pose with their Chinese guide. The outside face of the Wall shows battlements partially intact.

The second photograph, taken from a position about 30 metres higher up and looking in the opposite direction (down towards the coastal plain), reveals the poorer condition of the lower-level fortifications. At the foot of the mountain more than 20 mules graze. They carried the early tourists from their coastal mooring, or barracks, probably at Old Dragon's Head.

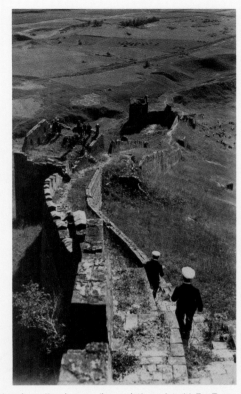

View looking down Jiaoshan: a silver gelatine print, 11.5 x 7 cm:
by an anonymous British Naval officer, late 1920s (WL).

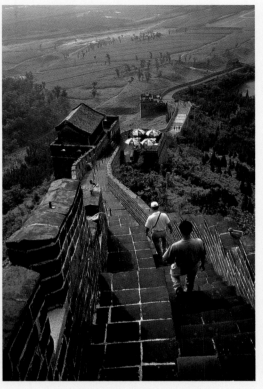

View looking down Jiaoshan: Lindesay, 2004.

Revisiting shows reconstruction made in response to Deng Xiaoping's call to 'Love China, Rebuild the Great Wall'. Work at Jiaoshan began at its foot in 1984 and worked its way upwards over a period of several years.

Complying with Venice convention guidelines concerning renovation work on UNESCO World Heritage sites, the reconstructed parts of the Wall are clearly discernible by the colour of new bricks, grey compared with the buff of the originals. Large light bulbs, connected by thick white electrical wiring, are placed on the capstones of battlements, and the once-inaccessible top watchtower is now accessible by the placement of a metal ladder and elaborate walkways.

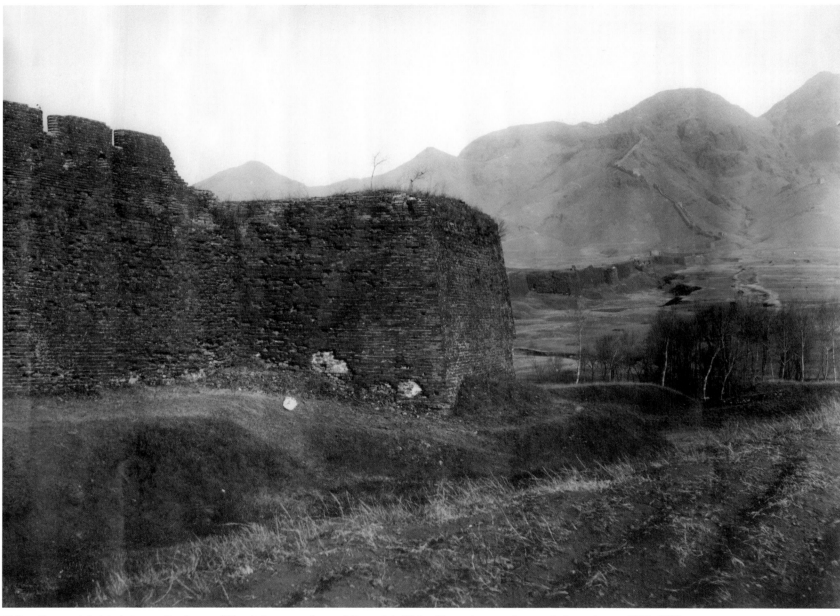

Wall on the coastal plain between Jiaoshan and Shanhaiguan: a silver gelatine print, 27.2 x 21 cm: by an unknown photographer, c. 1920s (WL).

Wall on Coastal Plain

Wall on the coastal plain between Jiaoshan and Shanhaiguan: Fan, 2006.

The original was taken by a photographer who also exposed pictures at Yiyuankou and from atop Jiaoshan c. 1920s, both included in this study (see pages 256, 258). It shows the fortifications on the coastal plain between Jiaoshan and the fortified town of Shanhaiguan.

At far left of the frame the outside face of the entirely brick rampart remains in good condition, with merlons and loopholes of the battlements still in tact. The tower protrudes towards the outside, but its upper structure had already collapsed. Beyond, the Wall makes its way to the break of plain, thereafter ascending Jiaoshan.

Revisiting finds the collapse of the battlements close to camera. Removal of debris, which was grassed over in the 1920s, has exposed the very lowest courses of the tower's foundations, composed of quarried rock blocks. The apparent distance between the tower and break of plain is foreshortened in the new photograph, attributed to use of a lens of quite different focal length.

The First Pass Under Heaven

The original, captioned 'Gateway at Shanhaikwan' is annotated on the reverse with 'fighting was heaviest at this gateway'. The scene depicts the famed *Tianxia Diyiguan*, the First Pass Under Heaven, announced by the calligraphic plaque adorning the building's upper eave.

This is the most important and famous gate tower on the 4.7 km circumference wall around Shanhaiguan. The left foreground of the original incorporates an entrance, indicated by guardian lions and ramp, to a school, that was formerly a temple during the Ming. Quarried blocks pave a road through the arched gateway; on the right wall five painted-metal advertisement plaques are attached. A foreigner, wearing a cap, white shirt and tie and knee breeches poses beneath the towering gateway, and he is passed by a Chinese man and boy.

According to Wang Xuenong, curator of the Shanhaiguan Great Wall Museum, the gate has been renovated on a number of occasions since 1644. He notes that while the gate tower itself stands much the same as it did a century ago, the surroundings have changed enormously. No longer is the archway under the gate tower one of the town's thoroughfares, as the site is now only accessible to tourists purchasing tickets.

The First Pass Under Heaven, the main gate tower in Shanhaiguan: a sepia photograph made into a postcard, 13.5 x 8.5 cm, written by 'Harold', c 1905 (WL).

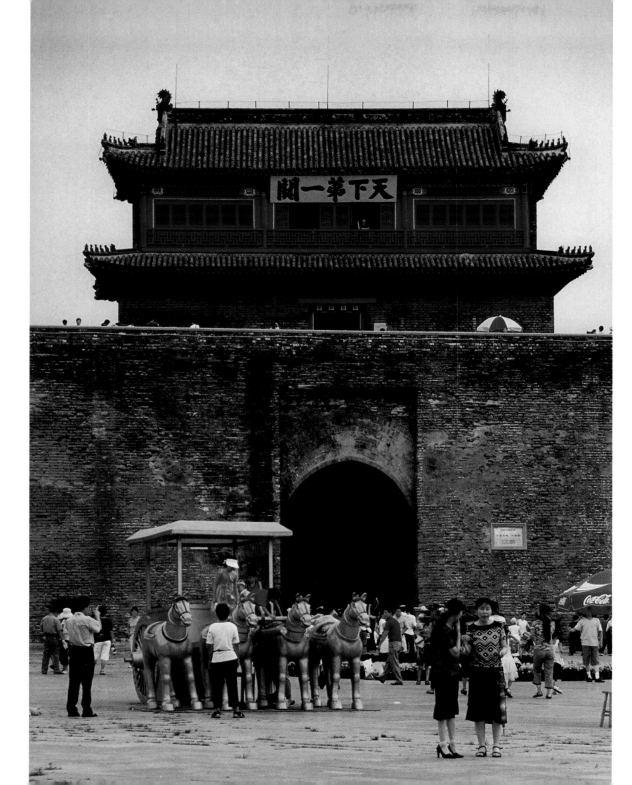

The First Pass Under Heaven, a must on the itinerary for tourists in Shanhaiguan: Lindesay, 2004.

Fuyuanmen

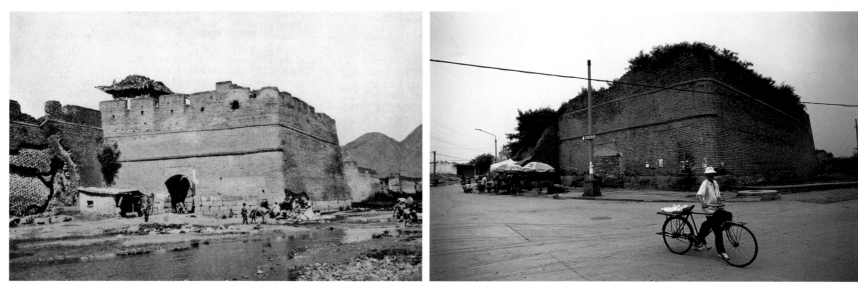

Fuyuanmen, a gate on the fortress wall of Shanhaiguan: Warwick, 1922.

Fuyuanmen in ruins: Lindesay, July 2004.

The original photograph, published in the February 1923 issue of the *National Geographic Magazine* to illustrate an article entitled 'A Thousand Miles Along the Great Wall of China' written by Adam Warwick, was credited to the author and captioned "City Gate of Shanhaikwan and First Gate of the Great Wall'.

Although officially known as Fuyuanmen, the photographer's caption 'City Gate of Shanhaikwan' should not immediately be dismissed as a general name. Inside this gate, atop one of its archways, is an engraved tablet, facing inwards, bearing the three characters 'Shan Hai Guan'.

Fuyuanmen undergoing renovation: Lindesay, June 2006.

Fuyuanmen renovated: Lindesay, November 2006.

The original photograph must have been taken sometime during 1922, factoring in the time required for the author to forward material to the Washington headquarters of the National Geographic Society in the United States.

Warwick's view shows the gate's spatial relationship with the adjoining wall: offset to the outside to enable defenders it to issue enfilading fire (along the outside face of the wall). On top of the gate, remains of the roof can just be seen. The archway through the gate even in 1922 was the only way local people in this area could enter the fortified town.

On both sides of the gate, the adjoining wall can be seen. On the left, whole sheets of outer-casing bricks have exfoliated; exposing the structure's older, inner bricked surfaces. To the right, the wall and protruding buttresses recede inland. A stream, perhaps in flood after a summer downpour, flows parallel to the fortifications.

An initial revisit was made in July 2004. The gate was to be found in advanced disrepair. While its adjoining wall to the right was still complete,

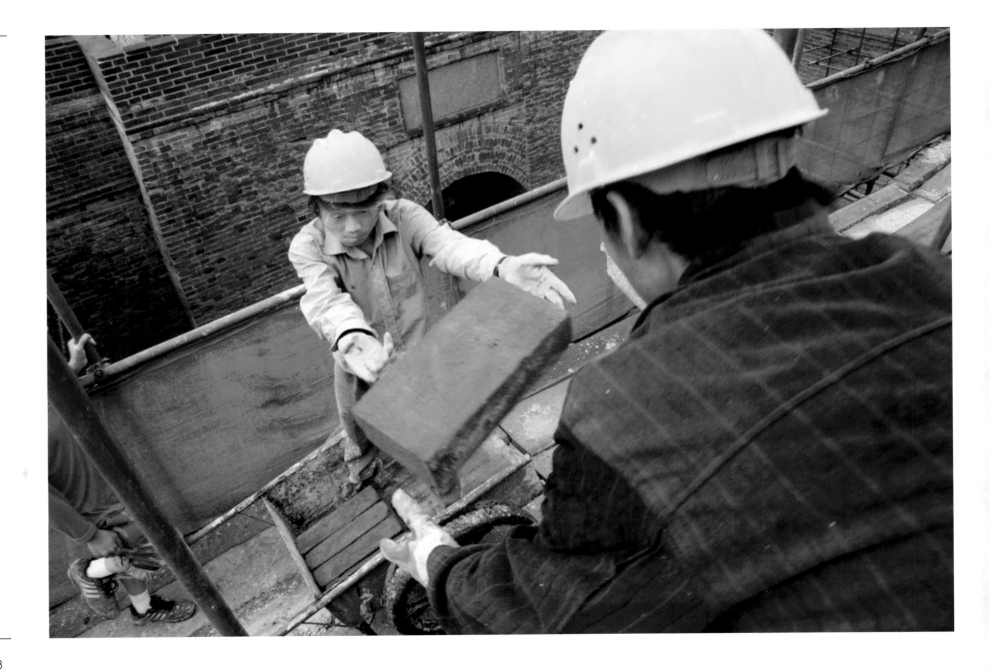

Left & above: Workmen from the Hebei Ancient Buildings Construction Group renovating Fuyuanmen, midsummer 2006.

that to its immediate left had been demolished for passage of a road, replacing the old and narrow archway entrance, now bricked up, under the gate tower. The gate itself exhibited further damage, particularly to its upper sections: gone were remains of the tower's roof structure and battlements.

On learning that Fuyuanmen was undergoing renovation as part of a major project to renovate the entire Shanhaiguan fortress wall, I made a second revisit in June 2006. Work was still in progress at this time. The gate was clad in scaffolding, although obscured by blue netting to minimize dust pollution. A safety fence enclosed the rebuilding site.

The reconstruction method was in observance of traditional methods and under the auspices of the Hebei Ancient Buildings Construction Group. According to the design manager in charge, lime mortar was being made in a

traditional way, and once the bricks were laid a mortar liquid was poured on for it to trickle down into any voids. Glutinous rice porridge was used with lime mortar for laying the upper courses and pavement, in order to minimize the infiltration of water. The wooden roof structure had emerged. It was to be left bare for a 12-month period in order to weather before the application of paint.

Apart from the modern concession of an electric elevator to lift materials, work was proceeding in a traditional way, right down to the use of hand tools.

A third and final revisit was made in November 2006 to see the renovated Fuyuanmen. For the first time, I found the precise position of the original photographer by aligning the point of the completed roof eave with the intersection of Wall and tower.

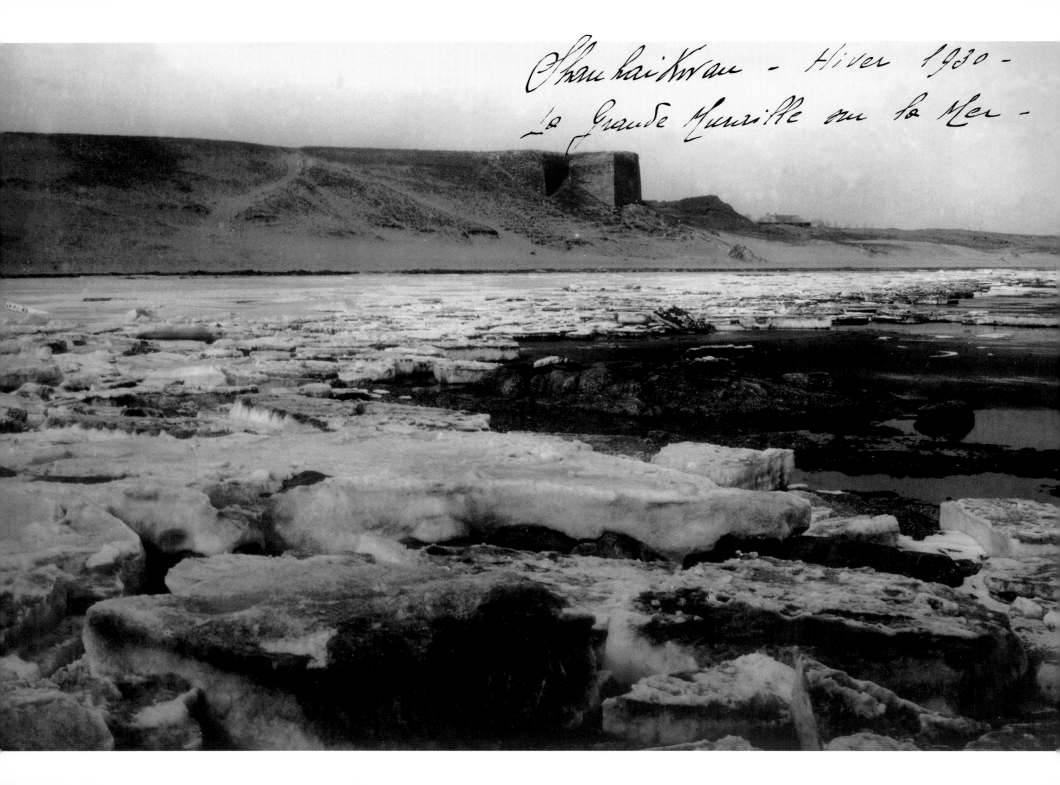

Shankaikwan - Hiver 1930 -
La Grande Muraille sur la Mer -

The Wall on Bohai Coast

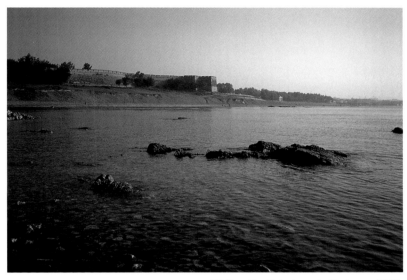

Wall on the Bohai coast: Lindesay, 2006.

From the caption on the reverse of this small, silver gelatine postcard-sized print we know the image was exposed by a French photographer in winter 1930 at a time when the sea was frozen.

The view depicts approximately 100 metres of the Wall paralleling the coast to the immediate northeast of Old Dragon's Head. Without the straight form of the prominent buttress at right of centre of the photograph it would be difficult to identify the seaward facing mound on its left as part of the Wall, then banked up by wind-blown sand and grassed over.

Revisiting shows excavation of the once-buried rampart and its upper renovation. Even from a distance of approximately 200 metres the new grey bricks forming the parapets can easily be distinguished from the lower courses, buffed and weathered by centuries of sea-spray and sand-laden winds.

Left: Wall on the Bohai coast: a silver gelatine print, 13.8 x 8.8 cm: by an anonymous French photographer, winter 1930 (WL).

Old Dragon's Head

Despite its importance and unique seaside aspect, photographs of Old Dragon's Head are extremely rare. The ruins appear to have attracted the attention of only a minority of photographers. This original is a postcard scene, probably from the 1930s, and shows a view of the seaward-facing buttress on the far right and ruins of Old Dragon's Head at far left, receding thinly into the waters of the Bohai.

Revisiting shows major change in the form of reconstruction, carried out in 1987. The buttress base is now clear of drift sand, while its top courses have been re-bricked, and parapets are now visible. At far left, even from a distance of almost 400 metres, the reconstructed Old Dragon's Head can be seen. The beach in the foreground is now sandy, and crowded in summertime. Rocks, semi submerged at low tide, were most useful fixed points for using perspective to pinpoint where the original photographer had stood.

* * *

I arrived at the beach before 5.00am on a midsummer's morning, hoping to steal some clear light before the humidity rose and made distant objects invisible to even the sharpest of lenses. I expected to be alone at that hour. Surprisingly, there were a few score others who had not only risen early to see the day dawn, but to see the rise of the dragon's head out of the sea.

I first saw Old Dragon's Head in August 1986, exactly 20 years before, when its foundation blocks of granite lay half-buried on the beach and submerged by the tide. I only bothered with one photograph. I expect I

was put off by the dullness of the scene. What I saw was not so much ruins – stones aged naturally by the sheer vicissitudes of time – but the debris of war. It was a pitiful sight, one made more painful in the knowledge that my countrymen were responsible for its bombardment. British forces shelled the site from their gunboats in 1900, rendering the dragon headless. The caption on the postcard read 'Coastal Scenery at Shan–hai–kwan'. After its destruction the dragon even lost its name.

This was the concluding rephotograph of my long quest, for the time being at least. I now faced the task of organizing the many photographs and piecing together the stories I had gathered, allowing others to travel back in time the way I had done. Only by doing this could these photographs of the Great Wall, taken long ago, and taken to the all corners of the globe, make their final, most important journey, returning to China to be seen by a people in whose hands a better future for the dragon now rests.

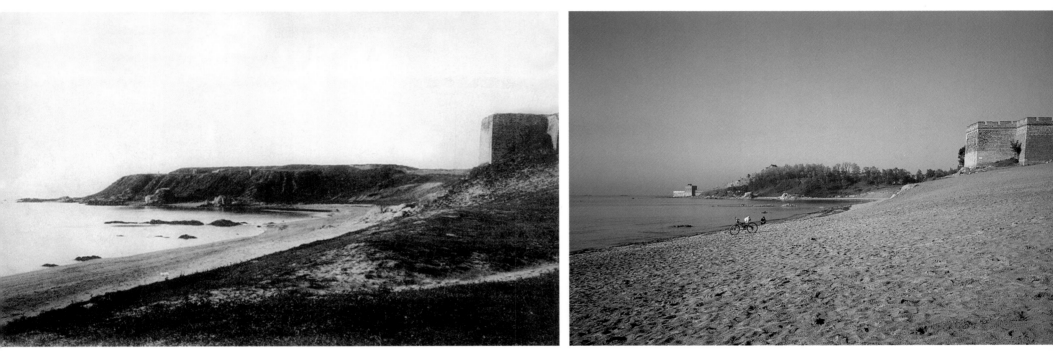

Old Dragon's Head, the seaside terminus of the Ming Wall: a postcard, 14 x 9 cm, c. 1930 (WL).

Old Dragon's Head: Lindesay, 2006.

THE GREAT WALL REVISITED......

A WORK IN PROGRESS......

EPILOGUE: CONTINUING TO REVISIT THE GREAT WALL

It's been 15 years since Marjorie Hessel-Tiltman introduced me to William Edgar Geil. Marjorie passed away in 1999, aged 99 years, but the seed she sowed by presenting me with Geil's book has flourished. Fittingly *The Great Wall Revisited: From the Jade Gate to Old Dragon's Head* is published, in both Chinese and English language editions, while a national exhibition was staged at the Capital Museum in Beijing, on the eve of the centenary of William Geil's milestone journey, which began in the spring of 1908.

From early 2004 I began to use several weeks each spring and autumn to systematically rephotograph the Great Wall. Without Geil's photographs, and our mutual destiny, I might never have gone back in time. I've been privileged not only to have made one great journey alone on the Great Wall in 1987, but another in the company of pioneers, for a second look, at a time when, I think we can all now see, it was a little bit greater.

In presenting this state of the Great Wall report, I have fulfilled multiple roles of photographer, rephotographer, journalist and researcher. It's said that a camera never lies. The simplicity and strength of rephotography is that viewers can look at old and new photographs for themselves and decide what is good or bad.

Writing is not that straightforward. As author, I have chosen historical extracts, gathered contemporary stories and seized on poignant quotes made by eyewitnesses. I have tried to be objective. While some rephotographic pairings reveal loss, some show gains, in more ways than one. I have tried to avoid giving my own opinions, I have tried to avoid being subjective, and have tried to describe just what I saw and report just what I heard. In many cases judgment is a matter of taste, of one's own conservation view.

But I have inevitably written a book with feeling, because the subject matter – the future of the Great Wall – is a passionate concern of mine, of International Friends of the Great Wall and of our supporters.

I am solely responsible for any mistakes, misinterpretations, inadvertent expression of personal opinion or suggestions, and must emphasize that this book does not necessarily reflect the views of our supporters. We have united as partners to make *The Great Wall Revisited* an international contribution to influencing a better future for the Great Wall, and while we share a common goal to be good caretakers, we may differ as to how this should be achieved. As Professor Luo Zhewen noted in his foreword, the material gathered by this study will generate a forum among researchers, experts and officials.

In the course of rephotographing 150 sites I have travelled more than 35,000 kilometres between the Jade Gate and Old Dragon's Head. Many locations were revisited again and again to get a more precise result in terms of framing, lighting, shadows or seasonal likeness, yet still, as I write these concluding words, I do not consider *The Great Wall Revisited* to be complete as a study. If I did, I would have missed the essential lesson of the technique: that the moment 'now' is only temporary, and that the only permanent thing is change. Unseen vintage photographs will turn up from time to time in galleries or auctions; museum collections may become more accessible through digitalization. But most of all, photographs taken a relatively short time ago will, on account of the relentless nature of change, become vintage themselves, for good or bad reasons.

The Great Wall Revisited is a work in progress. This book can be considered a launch report, but slowly and surely its coverage will be

broadened and more detailed. I will continue to rephotograph sites whenever I have the opportunity, and for however long I can. I expect a third 'William' to come along in the future, in cause not necessarily name, to continue what William Geil did and what I have done. When Geil photographed he noted down place names which he sometimes used in captions; when I rephotographed I noted down all the GPS data in my notebook, so that the third William will know exactly where to go.

Nevertheless, the decision to publish GPS data was a difficult one, and in the end turned out to have been taken in vain. GPS was made legal in China just a few years ago, and its use has grown swiftly. By publishing data I was primarily concerned about fuelling exploitation of Great Wall locations and its negative impact.

However, in the last three years there has been a phenomenal growth in dissemination of detailed travel-related information in China, especially circulated among Chinese themselves, ranging from hotel prices to GPS co-ordinates. Much information that was considered sensitive by early conservationists has been made widely public via the internet. At that time, I and others felt that geographical details and GPS coordinates exposed sites. I now believe it is time to use GPS information to our advantage to protect sites. Given that this book is dedicated to Wall conservation I concluded that it was absolutely essential to include GPS data to assist those working for its protection.

Then, shortly before going to press, as one of our experts was reading through the manuscript, my attention was drawn to a circular issued by the Ministry of Public Security in August 2006 concerning new restrictions on the use and publication of GPS data on China.

It is unfortunate therefore that at the present time I am unable to release this data for the protection of the Great Wall and the more convenient monitoring of the sites rephotographed in this book. I do believe, however, that as GPS functions begin to appear and become standard on mobile phones and even watches, China's restrictions will be relaxed. It may be possible to include GPS data in a reprint or update of the book.

Any update or a second volume will depend on the success of sourcing 'new' vintage photographs. If readers have rephotographed the Great Wall themselves, I would be happy to consider their work in future for inclusion alongside my own. If readers discover potentially useful vintage Great Wall photographs, I urge you to forward your materials to International Friends of the Great Wall so I may rephotograph the location. In this way, I can make public a growing archive and database to not only show how the Great Wall has changed, but make it more real-time, showing how it is changing.

You may find some advice on rephotography at the Great Wall at *The Great Wall Revisited* website, see address below, and you may forward any materials you wish to contribute to this work-in-progress to the e-mail address below.

http://www.2walls.org
william@wildwall.com

ACKNOWLEDGEMENTS AND PROJECT TIMELINE

*T*he Great Wall Revisited project operated by International Friends of the Great Wall (IFGW) encompasses picture research, rephotography, documentary filming, writing and translating. The publication of results in this book and the staging of a national exhibition in Beijing have been made possible by the joint efforts of Shell Companies in China, the Beijing Administration of Cultural Heritage and the Capital Museum. Acknowledgements here serve not only as an expression of thanks to all participants, but also present a timeline history of the project's foundations, evolution, development, conclusion and continuation.

I must begin by mentioning the kindness of Marjorie Hessel-Tiltman, who in 1991, after hearing me on BBC Radio Oxford speaking about my own journey along the Great Wall, and reading my book *Alone on the Great Wall*, kindly presented to me a copy of *The Great Wall of China*, written by William Edgar Geil. 'Perhaps it is too late to be of use', wrote Marjorie in her accompanying note, but destiny was to prove otherwise.

Seeing one of Geil's photographs beside my own picture of the same location made me realize how much the Great Wall had changed in the 80 years between our respective journeys. This experience eventually led me to

follow in Geil's photographic footsteps, and search for the tracks left by other early Wall explorers, to compare the Great Wall of today with that of yesteryear. I hold the early pioneers of the Great Wall in highest esteem: without their brave efforts the materials for rephotography would not exist. In recognition of William Edgar Geil being the first explorer of the Great Wall, this book is dedicated to him.

It took more than a decade after 1991 to launch the project. I mentioned the potential usefulness of such a study to Kong Fanzhi, then deputy director of the Beijing Administration of Cultural Heritage (BACH) in 2001, soon after IFGW and the administration signed a memorandum of understanding, pledging cooperation in Great Wall conservation efforts. The idea appealed immediately and with this government interest I began to identify potential sponsors.

The perfect opportunity materialized during the first half of 2003, as I assisted Shell Companies in China which was participating in a PetroChina-led environmental-impact assessment study on the construction of the West to East pipeline which would make 12 crossings of Great Wall remains as it carried gas from the Tarim Basin of Xinjiang to the Shanghai area. Arising

from this relationship, Shell indicated its interest to become involved in a public awareness raising project concerning the protection of the Great Wall. I suggested a rephotographic documentation study to Mike Seymour, social and environmental advisor at Shell, explaining that lessons learned from the past, poignantly evidenced by 'then' and 'now' images, could help influence both present and future preservation efforts. Mike liked the idea and obtained seed funding to allow us to undertake an initial study.

Results from our first year's work during 2004 were privately exhibited in February 2005 in order to gain feedback from Shell, our supporters in both the BACH and the State Administration of Cultural Heritage (SACH), as well as the growing number of experts and officials we had met in the course of identifying sites and actually finding them in the field. This event, graciously hosted by then-UK Ambassador to China, Sir Christopher Hum, and Lady Julia at the Ambassador's Residence in Beijing, proved to be a great success and brought encouragement from all parties to continue with the project, made possible by continued funding from Shell Companies in China. We must thank Nick Wood, external affairs director, who rallied our cause so tirelessly within the company at this stage.

During the rest of 2005 many new sites were rephotographed, and numerous repeat trips were made to sites to obtain better results.

Many new Wall friendships have been forged in the course of such extensive field work. I'll begin in Jiayuguan, at the western end of the Ming Wall. Over five visits there in two years, Wang Jin, a Wall enthusiast nicknamed '*Xibei Wang*', or Wang of the Northwest, welcomed me time and time again, providing practical assistance for my work in the area, as did Li Xiaofeng, then curator of the Jiayuguan Museum of the Great Wall.

At the opposite end of the Wall, Wang Xuenong, scholar and curator of the Shanhaiguan Great Wall Museum, helped me search for local sites, provided helpful staff and most valued friendship and support. Thanks also to Fan Hongliang at Shanhaiguan for his photographic support.

In Shaanxi, the geographical centre of the study, my thanks are extended to Gao Qiuyuan in Yulin who introduced local experts to help me find extremely difficult locations within the Ordos Desert, especially Kang Lanying, former director of the culture bureau, and Li Shengcheng of the Anbian Culture

Centre, who investigated all of Shaanxi's Great Wall on foot in the early 1990s, and knew the remains there intimately. Without the help of these friends in Yulin this study would lack rephotographed sites at 'the heart of the Dragon'.

The final field work of 2005 was as late as December, when Yan Xinqiang, writer and photographer, and member of the China Great Wall Society, kindly led me to several locations in Laiyuan, Hebei Province, photographed by Sha Fei in 1937–38. With images kindly provided by Wang Yan, daughter of the wartime photojournalist who visited me at my home in Beijing, Yan and I spent several days in Laiyuan's mountains during the coldest week of the winter. Not only my thanks, but great respect go out to Yan Xinqiang for enduring temperatures and wind chill at a high-level camp that made it impossible for us to take off our Windstopper gloves, even when using chopsticks! The bittersweet experience reminds me to express my appreciation to Nan Renhao whose company Black Yak has provided such great outdoor gear for my explorations for many years, as well the enthusiastic team at Gore-tex in Beijing whose wonder fabrics, especially 'the tent' and Windstopper jackets make it possible to survive such extreme weather conditions.

The longest-distance field trip I made was to Yumenguan with photographs taken by Aurel Stein. While a few of his century-old images were straightforward to find, others I dismissed as being impossible to locate in the featureless desert. Yet thanks to the earlier fieldwork and mapping carried out by Yue Banghu, of the Gansu Provincial Archaeology Research Institute, I succeeded in finding much more than I ever could have hoped for of the 2,100-year-old Han Wall in the gobi. I must also express my gratitude to Dai Wensheng of the Yangguan Museum, who assisted me by arranging transport and guiding me to these locations in the field, as well as arranging an unforgettable birthday lunch at such a magical location.

Closer to home, in Beijing, there were dozens of locations to rephotograph. Travel in this area was often facilitated by long-term supporter of IFGW, Wang Guangda, whose 4C Communication Company provided all kinds of filming equipment, and who often drove us in his Jeep, always encouraging our efforts.

Throughout my fieldwork I was accompanied by Wang Baoshan, resident film cameraman at IFGW, more often than not with young Wang Haitao working as assistant cameraman or sound recordist. Over the three years'

fieldwork for this project we have spent many happy times together in the shadow of the Great Wall, and the success of our documentary film effort is due primarily to Baoshan's tireless professionalism and skill.

Despite considerable progress in 2005 we entered 2006 with an inevitable backlog of fieldwork as well as high hopes of delivering all our results on schedule at the beginning of 2007 via an exhibition, publication of a book and production of a film. Before the new-year Nick Wood once again came up trumps by assuring us of continued support from Shell Companies in China with a pledge of funding to ready our mass of materials for show and publication.

We still needed to secure a venue and a publisher. Editor Jing Xiaomin at China Intercontinental Press in Beijing liked our materials. We reported this good news to the BACH, by this time directed by our old friend Kong Fanzhi. With spirited support by deputy director Yu Ping, as well as Fan Jun, foreign affairs office chief and departmental secretary Li Yixue, BACH entered into a co–publishing agreement with China Intercontinental Press. Meanwhile, the pledge by former bureau director Mei Ninghua to assist us in obtaining the

exhibition venue of the newly-opened Capital Museum in Beijing was carried through by Kong Fanzhi, whose staff liaised with Vice Director Yao An to seal the fabulous location.

IFGW is greatly honoured to receive such enthusiastic support and practical assistance for its work from such high-level government institutions in Beijing. It is an accolade shared by the officers and board of advisors of the society, without whose teamwork this project would have been much less effective. My heartfelt thanks are thus extended to IFGWs team of eminent 'ambassadors': Luo Zhewen, China's leading Great Wall expert, also chairman of IFGWs board of advisors; to Cheng Dalin, president of the China Great Wall Research Society and leading field expert in the discipline of Great Wall Studies; and Wu Menglin, former senior archaeologist at the BACH. Their advice, introductions and tireless lobbying have brought us success.

Many institutions and a few individuals have been exceptionally understanding of the conservation value of this project, and waived reproduction and copyright charges, and/or their staff have been extremely helpful in answering my questions. In this respect I'd like to express appreciation to the American Museum of Natural History in New York, to the American Geographical Society of New York, to the Wellcome Library, London, to the British Library, the Royal Geographical Society, the Victoria & Albert Museum and the Bodleian Library, Oxford. Thanks also to Wang Ning for letting me delve into his library of antique books so freely, and offering illustrations for reproduction and exhibition, to Wang Jin for his wonderful aerial view of Jiayuguan, to Li Shaobai for his Shaanbei view and to Maarten Buitelaar for kindly loaning his treasured copy of *Novus Atlas Sinensis* and other maps for exhibition.

A number of key individuals have been of great assistance in helping us communicate in various ways. Publishing this book in two languages has presented an additional challenge, with translating to be done as well as readings from specialists to ensure historical accuracy.

For translations I am greatly indebted to Li Zhurun, not only a great and speedy translator, but one whose historical advice has been most useful. Chang Dalin read chapter by chapter at short notice, bringing many points to my attention, while Zeng Huang checked through contents relating to photography. Zhang Dan then edited the text. All four gentlemen are former colleagues from Xinhua News Agency, where I worked as an editor at China

Features from 1996–2000. For editing my English version I extend my sincere thanks to Paul Mooney, the Beijing-based author and features writer, and to Liu Tao at China Intercontinental Press for his meticulous proofreading.

The above work left little time for book design, so I owe a big thanks is due to 'Shenzhen Speed' Yan Zhijie, founder of Beijing King-Sight Culture and Art Designs for being so relaxed, letting me go through the book with him page by page, and to his 'willing to work overtime' staff, especially Gao Bei.

For other forms of communication, Qi Fei has given loyal support throughout by working as a simultaneous interpreter of eloquence, while designer Ying Jun has been enormously creative with his support designs, ideas and patience.

A host of other friends and organizations have helped in various ways: Barbara Woodward of the British Embassy, Bi Lei of Shell, Guo Meiqing, He Shuzhong, Lin Gu, Yang Xiao, the British Council, Dennis George Crow, Henry Ng of World Monuments Fund, Kjell Stenstadvold, Magnus Bartlett, Uli and Tjalling Halbertsma, Guang Kaisheng, Piao Tiejun, Long Xiaojun, Wang Tong, Chang Jianjun, and Clifford Nelson of the United States Geological Survey.

Finally I must express my heartfelt and biggest thanks to my wife Wu Qi. Without her enthusiastic and hardworking efforts the project would have remained a disorganized pile of photographs. As project manager she has multi-tasked by liaising with our sponsor, experts and bureau chiefs, making travel arrangements, organizing the vast library of photographs past and present, as well as the Herculean task of preparing all materials for the book and exhibition. Quite simply she has brought order to chaos.

Now it only remains for me to express thanks in advance to the photographer, or photographers, who sometime in the distant future will decide to take a third look and go back to the sites I have covered in this study to record further changes, which I hope will all be for the better.

SELECT BIBLIOGRAPHY

CHINESE LANGUAGE SOURCES

* Bai Tian, *Gubeikou Lansheng* (View of Gubeikou), Beijing: Beijing Yanshan Chubanshe, 1993.

* Chen Hui, *Shandan Changcheng* (Shandan's Great Wall), Zhangye: Xibu Dadi Chubanshe, 2004.

* Gao Fengshan, *Jiayuguan Jiming Changcheng* (The Ming Great Wall of Jiayuguan), Lanzhou: Gansu Renmin Chubanshe, 1984.

* Wang Jin, *Tianxia Xiongguan,* (Martial Barrier Under Heaven) Lanzhou: Gansu Renmin Meishu Chubanshe, 2003.

* Wang Yan, *Sha Fei Sheying Quanji* (The Collected Photography of Sha Fei), Beijing: Changcheng Chubanshe, 2005.

* Wang Yan, *Wode Fuqin Sha Fei* (My Father Sha Fei), Beijing: Shehui Kexue Wenxian Chubanshe, 2005.

* Yue Banghu, et al, *Shulehe Liuyu Handai Changcheng Kaocha Baogao* (Report on Investigating the Han Dynasty Great Wall in the Vicinity of the Shule River), Beijing: Wenwu Chubanshe, 2001.

* Various authors from Dunhuang Shi Bowuguan, *Dunhuang Handai Yumenguan* (The Han Dynasty Yumen Pass near Dunhuang), Lanzhou: Gansu Renmin Meishu Chubanshe, 2001.

* Various authors, *Yulin Changcheng Yanjiu* (Research on Yulin's Great Wall), Xi'an: Sanqin Chubanshe, 2004

* Various authors, *Zhongguo Lishi Dituji* (Historical Atlas of China), Vols. 1 & 2, Beijing: Zhongguo Ditu Chubanshe (China Cartographic Publishing House), 1990.

* Various authors of *Zhongguo Changcheng Xuehui* (China Great Wall Society), *Changcheng Baikequanshu* (Encyclopaedia of The Great Wall), Jilin: Jilin People's Publishing House, 1994.

GREAT WALL HISTORY

* Barfield, Thomas, J., *The Perilous Frontier: Nomadic Empires and China*, Cambridge, Mass.: Blackwell, 1989.

* Cheng Dalin, *The Great Wall of China*, Beijing: South China Morning Post Ltd. and New China News Ltd., 1984.

* Franke, Herbert, and Twitchett, Denis (eds), *The Cambridge History of China, Vol.6 Alien Regimes and Border States*, Cambridge: Cambridge University Press, 1994.

* Hartog, Leo de, *Genghis Khan, Conqueror of the World*, London: Tauris, 1999.

* Lattimore, Owen, *Inner Asian Frontiers of China*, New York: American Geographical Society, 1940.

* Li Shaobai, *The Invisible Great Wall*, Beijing: Foreign Languages Press, 2004.

* Lindesay, William, *Images of Asia: The Great Wall*, Hong Kong: Oxford University Press, 2003.

* Luo Zhewen, et al, *The Great Wall*, London: Michael Joseph, 1981.

* Mote, Frederick, W., and Twitchett, Denis (eds), *The Cambridge History of China, Vol. 7, The Ming Dynasty, 1368-1644, Part I*, Cambridge: Cambridge University Press, 1988.

* Mungelo, D. E., *The Great Encounter of China and the West, 1500-1800*, Lanham: Rowman & Littlefield, 2005.

* Tsai, Henry, *Perpetual Happiness, The Ming Emperor Yongle*, Seattle: University of Washington Press, 2001.

* Twitchett, Denis, and Fairbank, John. K. (eds.), *The Cambridge History of China, Vol. 1, The Ch'in and Han Empires*, Cambridge: Cambridge University Press, 1986.

* Waldron, Arthur, *The Great Wall of China, From History to Myth*, Cambridge: Cambridge University Press, 1990.

* Wilkinson, Endymion Porter, *Chinese History, A Manual*, Cambridge Mass.: Harvard University Asia Center, 2000.

PHOTOGRAPHS AND EYEWITNESS ACCOUNTS

* Bredon, Juliet, *Peking*, Shanghai: Kelly & Walsh, 1919.
* Cable, Mildred and French, Francesca, *The Gobi Desert*, London: Hodder & Stoughton, 1942.
* Clapp, Frederick, G., '*Along and Across The Great Wall of China*', The Geographical Review, Vol. IX, No. 4 (April-May-June 1920): pp. 221-249.
* Clark, R. S., & Sowerby, A. de C., *Through Shen-Kan*, London: Fischer Unwin, 1912.
* Geil, William Edgar, *The Great Wall of China*, London: John Murray, 1909 & New York City: Sturgis & Walton, 1909. (N.B. different text layout and image selection in U.K. and U.S. editions).
* Götting, Doris, *Bilder aus der Ferne, Historiche Fotographien von Hermann Consten* (Images from Afar: Hermann Contsen's Historical Photographs of Mongolia) Bonn: 2005.
* Hayes, L, Newton, *The Great Wall of China*, Shanghai: Kelly & Walsh, 1929.
* Hayes, L. Newton, *Gentle But Valiant, Selected Writings of L. Newton Hayes*, Sante Fe: Vergara, 1979.
* Lindesay, William, *Alone on the Great Wall*, London: Hodder & Stoughton, 1989.
* Macartney, Lady Catherine, *An English Lady in Chinese Turkestan*, London: Ernest Benn, 1931.
* Nieuhoff, Johan, *History of China*, London: John Macock, 1669.
* Rohan, Charles E., *East Meets West. The Jesuits in China, 1582-1773*, Chicago: Loyola University Press, 1988.
* Ricci, Matteo, *China in the 16th Century, The Journals of Matteo Ricci*, Random House: New York, 1942.
* Sowerby, R. R., *Sowerby of China*, Kendal: Titus Wilson & Son, 1956.
* Staunton, George, *An Authentic Account of An Embassy from the King of Great Britain to the Emperor of China*, London: Nicol, 1797.
* Stein, M. Aurel, *Ruins of Desert Cathay, Vols. I & II*, London: Macmillan, 1912.
* Stein, M. Aurel, *Serindia*, Oxford: Clarendon Press, 1921.
* Stein, M. Aurel, *Innermost Asia*, Oxford: Clarendon Press, 1928.
* Thomson, John, *Illustrations of China and its People*, London: Sampson Low, 1873.
* Warwick, Adam, '*A Thousand Miles along the Great Wall of China*', The National Geographic Magazine, Vol. XLIII, 113-143, Washington D.C.: National Geographic Society, 1923.
* Whitfield, Susan, *Aurel Stein on the Silk Road*, London: British Museum Press, 2004.
* Wilson, Philip Whitwell, *An Explorer of Changing Horizons*, New York: George H. Doran Company, 1927.
* Yamamoto, S, *Views and Custom of North China*, S. Kojima: Tokyo Printing Co., 1909.

HISTORY OF CARTOGRAPHY

* Nebenzahl, Kenneth, *Mapping the Silk Road and Beyond*, London: Phaidon, 2004.
* Shirley, Rodney W., *The Mapping of the World, Early Printed World Maps 1472–1700*, Riverside: Early World Press, 2001.
* Smith, Richard J., *Images of Asia: Chinese Maps*, Hong Kong: Oxford Univ. Press, 1996.
* Van den Broecke, Marcel P. R, *Ortelius Atlas Maps, An Illustrated Guide*, Netherlands: Hes Publishers, 1996.
* Yan, Ping, et al, *China, In Ancient and Modern Maps*, London: Sothebys Publications by Phillip Wilson Publishers, 1998.

REPHOTOGRAPHY

* Klett, Mark, et al, *After the Ruins 1906-2006: Rephotographing the San Francisco Earthquake and Fire*, Los Angeles: University of California Press. 2006.
* Levere, Douglas, *New York Changing*, New York: Princeton Univ. Press, 2005.
* Various authors, *Grand Canyon, A Century of Change*, Phoenix: University of Arizona Press, 2005.

CONSERVATION

* Tung, Anthony M., *Preserving the World's Great Cities*, New York: Clarkson & Potter, 2001.
* Woodward, Christopher, *In Ruins*, London: Chatto & Windus, 2001.

CHRONOLOGY

Western Zhou Dynasty
1046–771 B.C.

Zhou Dynasty
1046–256 B.C.

Eastern Zhou Dynasty
770–256 B.C.

Spring and Autumn period
770–476 B.C.

Warring States
475–221 B.C.

Qin Dynasty
221–206 B.C.

Han Dynasty
206 B.C.–220 A.D.

Western Han
206 B.C.–25 A.D.

Eastern Han
25–220 A.D.

Three Kingdoms
Western Jin Dynasty
Eastern Jin Dynasty
Northern and Southern Dynasties
220–589

Sui Dynasty
581–618

Tang Dynasty
618–907

Liao Dynasty
907–1125

Five Dynasties
907–960

Northern Song Dynasty
960–1127

Southern Song Dynasty
1127–1279

Jin Dynasty
1115–1234

Yuan Dynasty
1206–1368

Ming Dynasty
1368–1644

Qing Dynasty
1616–1911

Republic of China
1912–1949

People's Republic of China
1949–

B.C. A.D.
0

−900 −600 −300 300 600 900 1200 1500 1800 2100

N.B. This chronology shows the co-existence of dynasties at certain periods.

SOURCES OF ILLUSTRATIONS

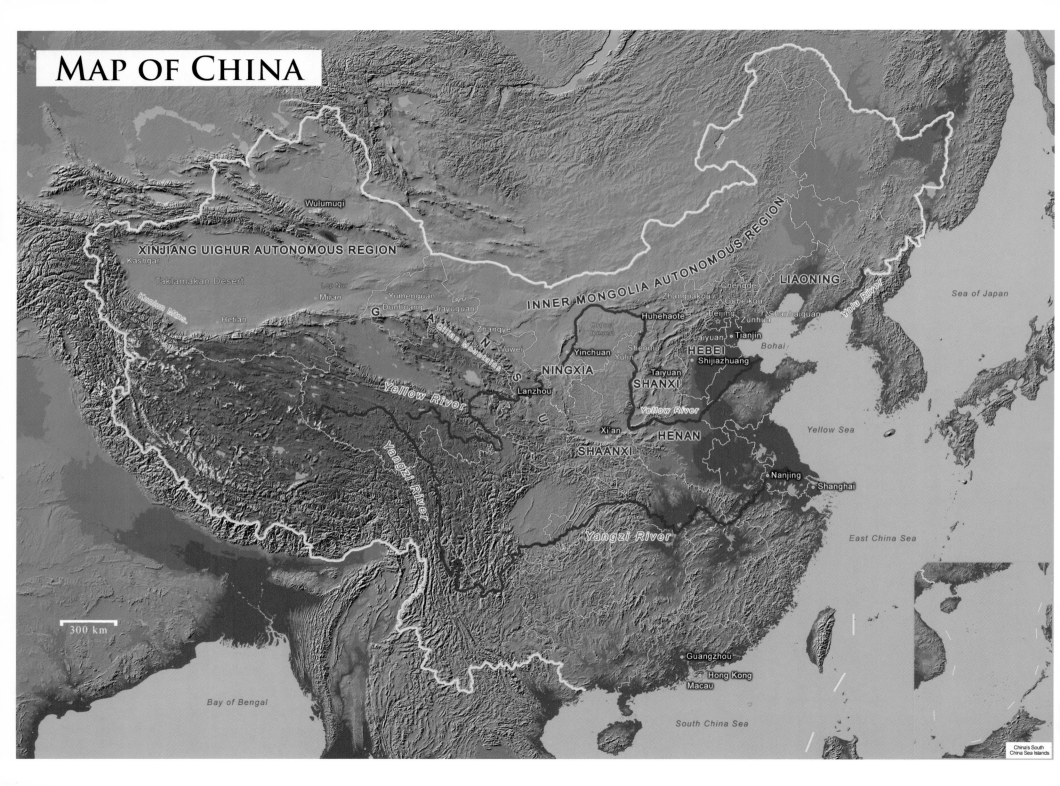

MAP OF CHINA

XINJIANG UIGHUR AUTONOMOUS REGION

INNER MONGOLIA AUTONOMOUS REGION

LIAONING

Sea of Japan

Kashgar

Taklamakan Desert

Lop Nur

Yumenguan

Wulumuqi

Kunlun Mtns.

Hetian

Miran

Dunhuang

Jiayuguan

Zhangye

Nan Shan

Wuwei

Qilian Mountains

Yellow River

Lanzhou

NINGXIA

Yinchuan

Yulin

Ordos Desert

Shenmu

Huhehaote

Zhangjiakou

Chengde

Gubeikou

Beijing

Zunhua

Shanhaiguan

Laiyuan

Tianjin

Bohai

HEBEI

Shijiazhuang

Taiyuan

SHANXI

Yellow River

Xi'an

HENAN

SHAANXI

Yellow Sea

Nanjing

Shanghai

Yangzi River

Yangzi River

East China Sea

300 km

Guangzhou

Hong Kong

Macau

Bay of Bengal

South China Sea

China's South
China Sea Islands

INDEX

Wm Edgar Geil

W. H. Parish

M. Aurel Stein

Arthur de C Sowerby.

Juliet Bredon Laura.

L. Newton Hayes

Roy Chapman Andrews

H. G. Ponting

A Mildred Cable.

Hermann Consten

Smyth